D1458806

MY WAY WITH A CAMERA

Victor Blackman

MY WAY WITH A CAMERA

ADVENTURES AND LESSONS OF A CAREER IN PHOTOGRAPHY

With a Preface by R H Mason MA FIIP FRPS
Editor of *Amateur Photographer*
Past President of the Royal Photographic Society

FOCAL PRESS · London & New York

© FOCAL PRESS LIMITED 1973

ISBN 0 240 50817 3

All Rights Reserved. No part of this publication may
be reproduced, stored in a retrieval system, or
transmitted, in any form or by any means, electronic,
mechanical, photocopying, recording or otherwise,
without the prior permission of the copyright owner.

First published 1973
Second impression 1974
Third impression 1976

Printed in Great Britain at
The Pitman Press, Bath.

Preface

I have known Victor Blackman for many years and got to know him especially well over the past ten years during which he has written a weekly column for the *Amateur Photographer.*

Three things have impressed me about him. First, he is one of the few professionals I have met who thinks like an amateur and displays as much enthusiasm for photography in his leisure time as he does for his work on the *Daily Express.*

Secondly, he is a no-nonsense photographer who believes in a straightforward approach which has little to do with false sentiment or imitation of other arts. His photographs look like photographs and are not dressed up with canvas screens or other dodges to make them look like etchings or paintings.

Thirdly, and probably more important, he has the capacity for putting his ideas into words in a way that any layman can understand. His weekly column, sometimes controversial but always highly informative, has a great following and provides entertainment and instruction for both beginners and advanced workers.

In this Victor Blackman is maintaining a tradition started by his illustrious predecessor, the late Lancelot Vining, whose book *My Way with the Miniature* was the bible of many an amateur cameraman. He too was a professional press photographer and an *Amateur Photographer* columnist.

For this reason I welcome and commend this book. It fills a gap left by Vining and it is unique because it deals in a general way with many aspects of amateur photography but always with the emphasis on pictures rather than cameras. A basic knowledge of both apparatus and technique is of course essential but sometimes they become an obsession and their ultimate purpose is almost forgotten.

This book should lead you firmly but pleasantly back into the path of picture making.

R. H. MASON
Editor, *Amateur Photographer*

Contents

Contents

Introduction

The trouble with many photographers is that they are more interested in technicalities, gadgets and obscure processes than they are with actually making pictures. If you are one of these, this book isn't really for you, although I hope you might read it and perhaps gain an interest in what photography is really all about—picture-making.

If your primary aim in photography is to discover whether one sort of developer gives you a 1.85 times increase in film speed over another; or whether Lens A is capable of delivering three lines per millimetre more than Lens B, you are more of a technician than a photographer. This book is for photographers, whether they be absolute beginners owning nothing more sophisticated than a simple snapshot camera, or advanced experts with the very latest in complex and expensive equipment. I hope that even fellow-professionals may get something out of it.

This doesn't mean that I shall not mention equipment, technicalities, and maybe even a tiny bit of theory here and there. But the main emphasis is on practical photography. If theory helps, we'll use it. If practice goes against theory—and you would be surprised how often this happens—it's practical advice I'll be giving. We are more concerned with what *actually* works than what *should*—in theory—work.

My entire aim is to show how you can get fun and enjoyment out of photography; how to produce pictures which will give you and others pleasure; and to indicate how you can maybe get a little profit into the bargain.

I'll take you behind the scenes on many of the press assignments I have carried out. Some of my experiences may give you ideas for pictures, because press work, unlike almost any other branch of professional photography, covers just about every facet. Apart from anything you may learn from my experiences, you will certainly be better able to appreciate some of the pictures you see in your newspaper when you know what went into taking them and getting them published.

Some readers may be interested to know what my qualifications are for writing a book on photography. So far as letters after my name go, the answer is—none. I am not an associate, fellow or licentiate of any learned body. Nor do I boast a string of certificates indicating that I have passed

Introduction

various exams. The fact that I have never applied, even for an associateship in the Royal Photographic Society, of which I am an ordinary paying member, might be put down to inverted snobbery on my part. But this would not be true.

It is simply that I have never felt the need for letters after my name. In the highly competitive world of newspaper photography—particularly working for a top national paper like the *Daily Express*—all the letters in creation count for nothing. With literally thousands of photographers after staff jobs on our national papers, all that counts is ability. So I reckon I must have something (if its only craftiness—and you need that as a newspaperman!) to have survived this long.

Perhaps my best qualification for writing this book is that I freely admit to having an amateur outlook on photography. By that I mean that, although I am a professional, I also love photography for its own sake. Which means that I have a lot in common with the 14 million camera owners there are in Britain today.

If there is one theme running through this book, it is a commonsense outlook on photography. I have never been a believer in making something difficult if there is an easy way of doing it without loss. Thus, you will find that, unlike many experienced photographers, I am not at all averse to cameras with automatic exposure mechanisms—so long as they are reliable.

Nor will you find here any details of obscure processes such as gum bichromate, or Mortensen's method of overlaying a print with a mixture of charcoal and pumice and then bringing up the highlights with an indiarubber. That sort of photography is not for me. My main concern is always to produce a picture containing the maximum of subject interest—not a product for admiration because of its complex technical processing.

One final point which I think is worth making in this introduction. Whatever opinions I might express about equipment, materials, pictures, personalities or whatever, are entirely my own personal views. They may be biased on occasions by my own likes and dislikes and experiences, but they are what I sincerely believe, and are entirely uncoloured by any commercial influences.

Victor Blackman

1

How it all Started

I am not one of those who, from early childhood, had the unswerving aim of becoming a professional photographer. For as far back as my memory goes, my one ambition was to become a pilot in the RAF. However, I was interested in photography as a hobby, and I well remember that my favourite aunt was top of my list, simply because she was the only one I knew who possessed a camera. But my real interest in photography started on my eleventh birthday.

On that day I was given a camera as my main present. No, it wasn't a Leica or a Contax, but a simple box-camera of unknown make bought at a departmental store, and which I clearly remember cost 3s 9d, for which, in those days, you could have bought four packets of 20 cigarettes—or seven or eight pints of beer.

That camera marked a most important point in my life. Because it fired me with enormous interest in photography, though still only as a hobby. Flying for the RAF remained my sole ambition as a career. I became fascinated with the whole concept of making pictures. Even at that early age I quickly developed a preference for action pictures, and I painted three diverging lines on the side of my box-camera so that I could use it at eye-level. This was far superior for capturing moving subjects than the tiny, half-inch square viewfinder which was common in those days.

First publication

I could do nothing about the slow shutter-speed (I suppose it was about 1/25 sec) which was designed purely for static pictures of family groups staring stonily into the camera on holiday beaches. But it taught me more about the art of careful panning on a moving subject (see page 232) than any amount of formal instruction could have done.

With my burning passion for flying it was natural that I should take pictures of aircraft whenever possible, and the big event of the year for me was the annual Royal Air Force display which was held at Hendon aerodrome, in North London. One of these displays in the mid-thirties was attended by the Duke and Duchess of York (later King George VI and Queen Elizabeth), and I squirmed my way through the crowd at the railings, so that I could get a good view as they drove past in an open-backed car. Using my painted-on lines as an eye-level viewfinder, I picked up the car as it approached,

followed it through, releasing the shutter just as the car was opposite to me. Not only had I taken my first royal picture but also my first "car shot", a type of picture which every press photographer has to be able to take. Later, I also fell into the trap which snares so many amateurs anxious to see their work in print. A neighbour—a very smart young man—ran a local picture-agency, which is a rather flattering term for one of those "any pics for a quick buck" outfit. I had developed and contact-printed my film that same night and my mother, proud of her son's royal picture, had shown it to friends living around. Word reached our smart lad and he called round asking if I would like to see my picture published in a paper.

Of course, I was delighed at the prospect. I even offered to pay him if he could get it published! My picture duly appeared in our local paper, *The Kentish Mercury* with a highly flattering (but entirely untrue) story of how a local

The first picture I ever had published. Taken on a 3s 9d box camera when I was about eleven years old at the Hendon Air Pageant. As the then Duke and Duchess of York (later King George VI and Queen Elizabeth) drove by, I panned with my camera and snapped them as they were almost level. The picture was published both in my local newspaper and also in one of the London evenings.

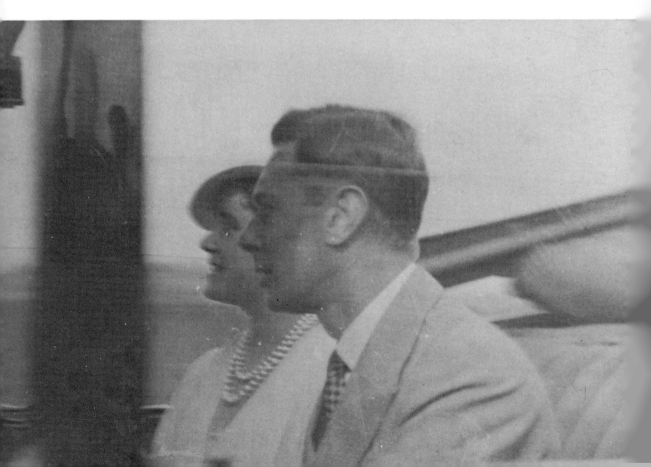

schoolboy beat the national press. Subsequently it was published in one of London's evening papers when the Duke and Duchess were in the news and a stock picture was required, and may have appeared several other times for all I knew. My total remuneration for this was precisely nothing. Not even the cost of the film and processing. This experience points a lesson which all amateurs should learn. Never surrender a negative to anyone for publication without knowing you are going to be paid for it.

Securing the payment

If your picture is published, you have a right to a fee, unless it is perhaps entered for some competition and one of the rules state that entries may be reproduced without fee. Even so, you should never enter any contest which involves you in the surrender of your copyright unless there is adequate payment. However, it is quite common for *prizewinners* to surrender copyright of their pictures in competitions, and I don't consider this to be unfair.

Apart from photo contests where publication of entries during the run of the competition is often done without fee, if you allow your work to be published without payment, you are not only being foolish yourself, but you are also being unfair to the local professionals. They are struggling to earn a living, and if a tight-fisted local paper editor—there are plenty of them—can fill part of his space with free photographs, there is that much less space for the professional.

Many amateurs have written to me complaining that they have had pictures published in local papers and then the editor has refused to pay them "because it is not our policy to pay amateurs". The remedy here is to telephone the editor and ask him what his normal reproduction fees are. Then, whenever you submit pictures, mark the back clearly: "Reproduction fee £1.50", or whatever it is. You might feel that by following this policy you will fail to get publications because the editor knows he will have to pay. Maybe so. But you will get far more satisfaction when some of your work is published in spite of the editor knowing that he is going to have to pay for it. Perhaps I should mention that you will be shattered to discover just how small is the "normal reproduction fee" of most weekly local papers. And that goes for our photographic magazines too. That's fair enough.

If you don't like the tiny fees, then don't submit pictures. But when you do get pictures published, make sure you get that fee, however small it is. I think you will find that the photographic magazines, although they don't pay much, never try to get pictures for nothing. It is some of the smaller local newspapers that you have to watch.

Fun and flashpowder

But back to my photo career. I had enormous fun with that simple box camera, even using it to take flash pictures by setting it on "time" and firing off a quantity of flash-powder. However, my exploits with this technique were brought to an abrupt end when I told my mother I could photograph the family gathering one Christmas. The lights were switched out so that ambient light would not affect the film during the long time the shutter would be open; the camera was set; the fuse leading to the flash powder was lit; and the entire family stared stonily, not at the camera, but fascinatedly at the smouldering fuse.

They were not disappointed. The flash-powder duly ignited with a magnificent "whoosh". And so did the paper Christmas decorations. Now if only I'd been able to take pictures during the ensuing scene, as buckets of water were hurled about—one pailful caught grandma right in the face—that would have been a picture set really worth having. I think only the fact that it was the season of goodwill saved my camera from a sudden end. But it was certainly the last time I was ever allowed to use flash-powder.

Recalling this incident reminds me of the famous story about the late Charlie Bowrie, who became chief photographer of the *Yorkshire Post*. Charlie started his career as a press photographer by being a "boy assistant". This meant that he had to carry out many of the menial tasks for the real photographers. One of these jobs was firing off the flash-powder for his senior whenever a flash picture was being taken.

Old hands will remember that the procedure was for the camera to be set up on a tripod with the shutter open, but a cap over the lens. At the appropriate moment the assistant would call out "Caps off!". The lens covering would be removed, the flash-powder fired by a small fireworks-type

cap, the lens cover replaced, and the picture would be in the bag. When there were several photographers taking the same picture it was obviously sensible to have just one flash fired for everyone. Charlie's first assignment as an assistant was the enthronement of Dr. Temple as the Archbishop of York, and all the press photographers had gathered at the great West Door of York Minster for a picture of His Grace blessing the City. I am told that there were scores of cameramen, balanced on chairs, packing cases, steps and even supported on the shoulders of the reporters. All in one, huge, swaying group.

It was a dark, dank day, and little Charlie Bowrie was given the job of firing the flash-powder. He had never done this for a crowd of cameramen before, but he knew the correct number of spoonfuls to take from the tin to give a flash of the right power. At this early stage of his career, Charlie was anxious not to make a mistake—particularly over such an important picture. So he counted the number of photographers and then put the correct amount of powder for each photographer in one enormous heap! As the Archbishop came to the door and raised his hand for the Blessing, little Charlie called "Caps off!" and fired the powder.

I am told that the resultant holocaust might well have put Hiroshima to shame, and a gigantic cloud of smoke mercifully covered the scene. When it drifted away it could be seen that the entire pyramid of photographers had collapsed into a blackfaced shambles of cursing men (miraculously, no-one had been burned), vainly searching for slides, cameras and broken tripods amidst the wreckage of chairs and boxes.

To his eternal credit, I understand that the great Dr Temple hesitated only a moment to allow the highly irreligious oaths being directed at Charlie to die away. Then he carried on with the Blessing, although it was punctuated by the occasional expletive emerging from the heap of newsmen as some unfortunate discovered the mangled wreckage of his precious camera.

It was later gently explained to Charlie that it is unnecessary to increase the power of a light source just because more than one photographer is using it. But I really cannot leave this subject without relating another incident

which has become one of the famous legends of Fleet Street.

Some years before World War II, there was a big story about a suspected murder, and word reached the newspapers that there was to be an exhumation. The police, not wishing to have the press there, had arranged for this to take place just before dawn. However, the secret leaked out, and about an hour beforehand, half a dozen cameramen hid themselves in the bushes around the grave. They had previously arranged between themselves that one of their number would, at the appropriate moment, call out the traditional "Caps off!" and would then fire the flashbulb. This was in the days before shutters were synchronised for flash.

It was still dark, and the wind was howling in an eerie way when the coffin was finally lifted out. And at that moment the cry "Caps off!" rang out above the wind, followed about a second later by the flash. Without waiting for any recriminations which might follow, the photographers scuttled back to their various newspapers and developed their plates. And discovered they had a most unusual picture. The whole gathering of police, gravediggers and officials were standing with a slightly surprised look on their faces, and every one was raising his cap or hat!

Starting in photography

But this has nothing to do with my personal story. I had reached my early teens and discovered that I needed to wear spectacles. I knew that this meant a complete end to all hopes of being an RAF pilot. So I immediately switched ambitions to my second love—photography.

I did three years apprenticeship in a darkroom. Then, war having broken out, I volunteered for the RAF at the age of eighteen. Because of my knowledge of, and interest in, photography, the expert selectors made me a flight mechanic. I can hardly think of a less suitable job for me because, to this day, I cannot even knock a nail in a wall without it falling out or bending. And as for a complicated job like changing a sparking plug on a car. . . . But mechanic I was, and a little later, by some miracle of misguidance, aided by the fact that I had the knack of absorbing theory, I was promoted to the higher grade of fitter.

To all those brave lads who flew in the aeroplanes I ser-

viced, I can only say: I did do my best. But boys, you did get good practice at "wheels up" landings and engine-failure drill in my aircraft, didn't you? Later, I became an instructor, which isn't quite as laughable as it might seem to those knowing my lack of mechanical ability. I may not have been able actually to *do* the various jobs, but I discovered that I wasn't bad at telling others how to do them!

I think the rest of the war can be glossed over, except to mention that, during the four years I spent in Burma and India, I managed to wangle myself a posting as film-cameraman, going out with bombers and supply-dropping aircraft and shooting film. I obtained this job by telling the most atrocious lies about my ability as a newsreel film cameraman, although my total experience had been putting four cassettes of 9.5mm film through a cine camera I had bought just before the war. But in an organisation which was of the type which thought I would make an efficient mechanic, it wasn't difficult to convince them of my prowess with a cine camera. And here I was nearly on my home ground of photography. So I soon picked up the rudiments, and thus partially satisfied my craving to fly, besides getting half a foot in the door of photography.

When the war ended, like a lot of others who had left the services I went through a variety of jobs. These included crane-driver, transport foreman, civil servant, coach driver and eventually I went to college and became a schoolteacher. That was a job I loved. My subject was mathematics, but I maintained a lively and active interest in photography. In my spare time I started operating a photo business, shooting weddings, portraits, child pictures, banquets, dances and so on. I also discovered that it was not too difficult to get pictures published in the local paper—that same *Kentish Mercury* which, so many years before, had given me my first-ever publication.

The school at which I was teaching was a secondary-mixed, and I very soon learned that a pretty girl leaving school to become a model, or merely hoping to be a model, or emigrating with her family to Australia, or winning a cookery contest, was sure to publish. I discovered that, provided the subject was an attractive girl, the excuse for getting her in the paper need be only the very flimsiest. In fact, so many of my pupils and ex-pupils were published,

that the *Kentish Mercury* once ran a feature article on south-east London's Gordon School— the school which must have the largest number of attractive girls in London!

There was no truth in this, of course. It was simply that I was developing my nose for what made a publishable picture, and was fortunate in having a headmaster who was not averse to publicity. Any large school of girls could turn up the same number of publishable pictures. But note that I said *girls*. Rightly or wrongly, the fair sex has an overwhelmingly greater chance of being published in a paper than we poor males, whatever our achievements.

Why, even when man made one of his greatest-ever achievements by landing on the moon, the picture which received the page-one splash in many papers was of—his wife!

However, if any teacher is thinking of following in my footsteps, a word of warning. Before you submit any picture of a schoolchild for publication, make sure that you have the parent's permission. In my case this was never once refused, but it must always be obtained first.

It wasn't long before I discovered that many of my pictures were saleable to the London evening papers as well as the local. Up to now I had been using a Leica IIIA and a $3\frac{1}{2} \times 2\frac{1}{2}$ in plate TP Reflex. But my publications had brought in enough extra money for me to afford an MPP Micro-Technical camera, taking 5×4 in plates. I also invested in a roll-film adaptor so that I could use 120 film on occasions when I didn't require the full 5×4 in coverage. Perhaps the most important lesson I learnt at this time was what forms the real basis of any form of photojournalism: give the editor the type of pictures he wants; not what *you* consider to be a good picture and think that he *should* want, but which is never selected by him.

The big break

In 1954 one of those small events occurred which change the whole course of one's life. I went to my first motor-race. It was August Bank Holiday and I had been persuaded, much against my will, to go along to London's Crystal Palace circuit with a fellow-teacher who was a racing enthusiast. Naturally, I took my camera, and as soon as I had seen the first race I realised that this was a subject with great picture

possibilities. But not from where we were sitting in one of the public stands. So, brandishing my impressive-looking MPP camera, I scrambled over the fence, saying to a slightly suspicious official, "Press. Just been giving my first pictures to a dispatch rider". I was passed on and positioned myself on the inside of one of the bends with the roll-film back on my camera.

Not one pictureworthy incident occurred during the whole afternoon—until the time for the last race. The real press photographers, who had been standing with me, then all left, obviously to get away before the main crowd. This seemed wrong to me, and at that moment I established a policy I have followed until this very day, and which has paid off on many occasions. Whenever edition times permit, I never leave an assignment until it is completely over. And then I stay a bit longer.

A most significant picture. It shows a crash at Crystal Palace which I took on the last lap of the last race. I sold it to the *Daily Sketch*, and it provided my entrée to the world of Fleet Street.

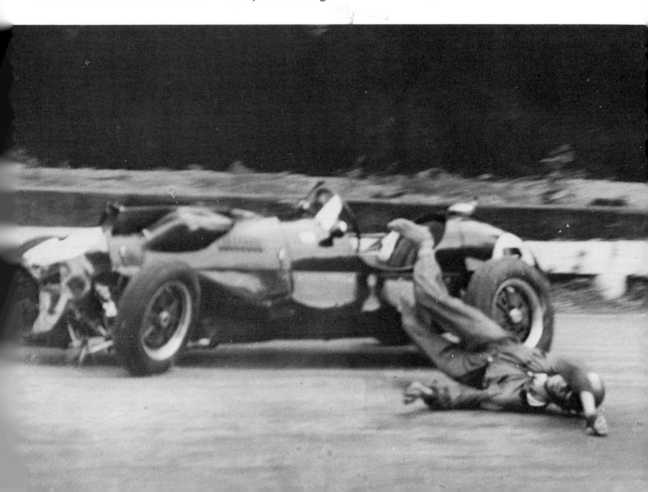

On this particular occasion, on the last lap of the last race, the leading car went out of control and overturned, throwing out the driver. The light was so poor that my exposure was 1/50 sec with the lens wide open at *f* 4.5, but I knew that if I was lucky I should have a spectacular picture.

I met up with my friend, dashed back to my home dark-room and processed the film. The negative looked good, so without waiting to dry the film we leapt into my car and away to Fleet Street, with my friend's wife holding the precious film out of the back window to dry it as we went along!

For some reason which I have never known, I chose the *Daily Sketch*. When their darkroom had made a print, Len Franklyn, who was the picture editor, did not hesitate. He bought it on the spot, and I watched it being measured up for a splash across the entire front page. Definitely one of the most thrilling moments of my life.

Flushed with my success, I chanced my arm and said to the picture editor: "Any chance of any work for you?"

"What equipment have you got?" he asked.

"Five-four MPP" I replied.

"O.K. Come in tomorrow at ten o'clock and do a day's shift."

And thus was launched my career in Fleet Street. Even now I blush when I think of the naive way I tackled my assignments, but I did manage to get two pictures published on that first day. As this was the height of the holiday season, I was asked if I would like to work again the following day. And the next. And so on. This suited me perfectly because, being a schoolteacher, I was in the midst of the long summer holiday and had plenty of free time.

I started out knowing nothing about press photography from a national newspaper point of view. But I learnt from my mistakes; by listening to the others; and from watching their methods and the sort of pictures they produced. Especially am I grateful to Geoff White, one of the top *Sketch* staff men. For some reason I have never discovered, he took me under his wing and guided me on many assignments when I ran into difficulties.

When the school summer holidays finished, I was reluctant to finish with the magic world of Fleet Street, so I told the picture editor that my "business" meant that I would not be available during the day. I had not told anyone that I was

a teacher, and it was assumed that I ran some sort of photographic shop.

"That's all right" he told me. "You can come in and do the night shift starting at six if you like."

So I commenced a routine of finishing teaching at about 4.30 and driving straight to Fleet Street where I would work until 1 a.m. On Saturdays I covered football matches at either Millwall or Charlton for the *Kentish Mercury*, with the occasional spectacular picture making the *Sketch*. And I still continued to pump out the stories and pictures from my school. Yes, I did manage to squeeze in the teaching of maths as well! But it was obvious that this could not last.

Taking the plunge

The crunch came some months later when it leaked out that I was a teacher, and the National Union of Journalists quite rightly stopped the *Sketch* from giving me any more employment. However, I continued to work on a freelance basis, selling pictures and stories I had found myself. But I missed the feeling of working for a big national paper, so I decided to take a chance and resign from teaching to become a full-time press photographer.

By now it was the middle of winter, and I couldn't have picked a worse time to start. No holiday reliefs were required at the *Sketch* and another photographer had taken over the shifts I had previously been working, so I was required for only a very occasional duty. And, of course, having left school, the source of so many of my pictures ideas had vanished.

Things became very tough indeed, and I turned my hand to photographing anything from machine parts to babies. Many is the time I literally had to choose between buying film or food. I always chose film.

Meantime I established a working relationship with the *Kentish Mercury* and carried out many of their assignments. The profit margin was not very high as they never paid for an assignment, but only when a picture was actually published. This fee was only just over a pound per published picture, out of which had to come my film, processing, printing and travelling expenses. Still there was consolation in that some of the stories I covered were saleable to the national and evening papers after the *Mercury* had published them.

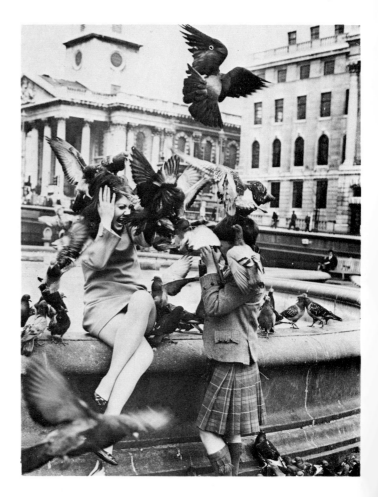

Trafalgar Square is a popular place for pictures and a few pence worth of corn can be guaranteed to provide some amusing shots if you have your camera at the ready.

I would also scan the papers to see when a new play was opening, or there was to be a film premiere (there were usually two or three a week) which I could attend to shoot pictures of the various starlets.

A fairly typical day would start at eight in the morning with me printing pictures taken the previous day for the *Mercury*. These I would deliver to their offices by ten and set off to cover perhaps four or five stories for them during the day. I would then process this work and drive to central London to cover a film premiere. Back to my home at Greenwich where I would rush-process and print. Then up to Fleet Street to sell the pictures wherever I could. The negatives

would leave over for the evening papers, possibly to use in their first edition the following morning when they were hungry for pictures. I would get home at around midnight, sort out the *Mercury* pictures to be printed in the morning, type out captions and finally get to bed.

Certainly they were tough times. But I was learning the hard way what press photography was all about. I was gaining experience which was to prove invaluable in that I knew that if I wanted to eat, then I *had* to sell pictures. It was as simple as that: if I couldn't sell my pictures, then I couldn't eat.

I can think of no finer school of press photography than this form of pure freelancing, and really it provides the answer to all those young hopefuls who write asking me how to become a press photographer.

You just go out and become one. If you have the knack of recognising saleable pictures and don't mind hard work you will make a living. Otherwise you are better off keeping photography purely as a hobby, and finding some other occupation. But this is a subject I will deal with in greater detail later in this book when we will also see how you can sell pictures for publication in your spare time.

As for me, having ridden the storm and nearly thrown in the towel two or three times, the tide started to turn (how's that for a good bag of mixed metaphors!) and my finances improved.

When the summer came along I started to be given more assignments by the *Sketch*, and what with some lucky breaks which enabled me to come up with a few scoops, my name became noticed in Fleet Street. Towards the end of 1956 I was invited to join the *Daily Express*, and I have been a staff photographer with them ever since.

Qualifications and suchlike

So you see that, although I have no qualifications so far as letters after my name are concerned, I do have hard-won experience. You would have to sift through Fleet Street's press photographers very carefully indeed to find an associate of the Royal Photographic Society or a fellow among them. I believe there are about three who have that distinction, but that's all. Most of us haven't the time to go in for such furbishments which are not necessary to our job.

Perhaps one day, when I have the time, I will concentrate on getting some letters after my name. I don't know though. I might get turned down by a panel, most of whom have never had a picture published in a national newspaper in their lives. That has happened. An ex-colleague, Bob Haswell, twice winner of the title Royal Photographer of the Year, and one of the best all-round press photographers of his time, applied for an associateship of the Royal Photographic Society and was rejected on grounds of print quality.

That would be fair enough in most other categories of the Royal Photographic Society, but as Fleet Street photographers are not permitted by union rules to do their own printing, the rejection showed total ignorance by the panel of newspaper work. After the fuss that caused (quite a lot started by me!) the rules were changed so that the photographer had only to provide evidence of his ability as a photojournalist, and not as a printer as well. This is much more sensible, but the slight on Bob Haswell is still remembered, and perhaps regrettably, few national newspaper photographers concern themselves with qualifications in the Royal.

2

Choosing a Suitable Camera

"You can take just as good a picture with the simplest of cameras as with an outfit costing hundreds of pounds. It's the man behind the camera that counts; not the equipment."

How often have you read or heard that? Scores of times probably. And its usually said by somebody who himself owns a battery of Leicas or Nikons. I once even wrote it myself in a misguided moment. But that was when I had equipment of my own worth a thousand pounds or so. Not when I was struggling to produce pictures with that first, simple, box-camera.

It's one of those clichés that have been used so often that they have become accepted as truths without anyone dreaming of contradicting them. Well, I do. Of course, you *can* get quite good results from inexpensive, simple equipment so long as you work within its limitations. But, generally speaking, the simpler the camera, the more will be the limitations you will have imposed upon you. Subjects and lighting situations which would be well within the scope of a more sophisticated camera are denied to the owner of the simple camera, however skilful he might be. Big enlargements are generally unacceptable in quality unless taken by a camera with a reasonably good lens. Nevertheless, not even the cheapest camera with a fixed-focus lens and a single shutter speed (the whole lot costing less than the case only of its more advanced cousins) should be dismissed as rubbish.

It all depends on what you want out of photography —what you want the camera to do. If, like many millions, you want only to keep a record of family holidays, the youngsters growing up, and the odd special personal event, you would be foolish to spend any more than the absolute minimum on a camera. In fact, it is almost certain that the simple, non-adjustable camera will produce better pictures in your hands than an expensive and complex one. If you aspire to make photography a hobby or profession, or to specialise in a branch such as sport, nature work, or photomicrography, you need equipment more advanced in specification—and in price too.

There is no best camera

The most important point to bear in mind when considering equipment is that there is no single make or type of camera that is ideal for *every* picture situation. I emphasise this point

because it answers the question I am so often asked: Which is the best camera? There is no "best camera" for every purpose. Take one of the most expensive 35mm cameras in the world, the Leica. The best? In some situations, certainly. But we don't have to look further than simple "synchro-sunlight" work (using an electronic flash to put detail into harsh shadows on a sunny day) to find that most of the non-interchangeable lens rangefinder cameras costing a fifth of the Leica's price will do the job far better. This is because they are equipped with "between-lens shutters" which can be synchronized with electronic flash at all speeds. Cameras such as the Leica and with just a few exceptions, most single-lens reflexes, have focal-plane shutters with a top synchronising speed of about 1/60 sec. Some models can synchronise flash at speeds up to 1/125 sec, but that is about the limit with the present range of SLRs (single-lens reflexes). And these shutter speeds are too slow for the light of a bright sunny day when you want to use the synchro-sunlight technique. Nor can these speeds stop rapid movement.

I did say "most" SLRs cannot flash-synchronise at their fastest shutter speeds because there are a few exceptions. For instance, the Hasselblad has separate Compur shutters built into each of its interchangeable lenses, and so can synchronise at any speed up to 1/500 sec. The 35mm Topcon Unirex can also synchronise electronic flash up to 1/500 sec, but a disadvantage to some is that it has a limited range of lenses and accessories available as compared with more conventional SLRs such as the Nikon, Canon, Leicaflex, Pentax, Minolta, etc.

Choosing the camera type

So, when making up your mind which camera to buy, first try to decide whether you intend to take photography seriously (this doesn't mean that you won't get a lot of fun out of it), or whether you just require a camera for family records. If the latter, then I suggest that you buy an inexpensive model. But if you can afford the extra cost, preferably one with a fully-automatic exposure system.

This might appear to be obvious advice. And yet I have known countless folk with more money than sense who have bought themselves an advanced camera costing

16

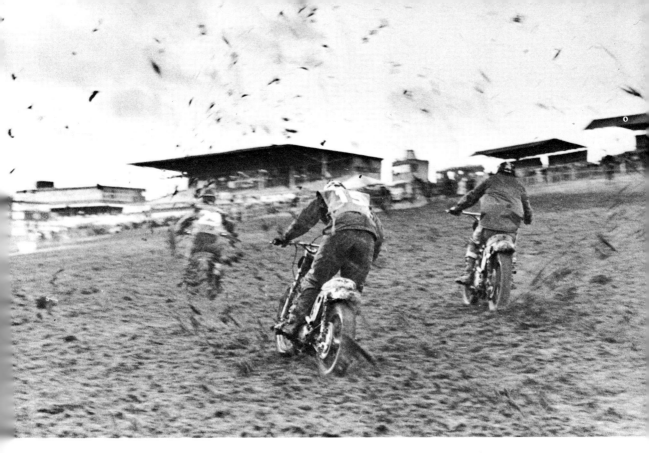

The start of a motor cycle scramble at Brands Hatch, a particularly suitable subject for the 35mm camera and ultra wide angle lens. By shooting as the bikes set off, I captured the effect of all the mud spraying around—and on—me.

several hundreds of pounds, just for holiday snapshotting ("It *must* be the best as it costs the most"). They then wonder why the chap next door with his ridiculously cheap camera seems to get better and more interesting pictures.

The more advanced the camera, the more know-how is required to get the best out of it. And if you are not particularly interested in photography you could spend more time working out the various settings on an advanced camera than actually taking pictures. So first get your priorities right.

But let us assume that you *are* interested in photography as a hobby. You do want a camera which is capable of taking pictures you will not be ashamed to show to fellow photo-enthusiasts. Or maybe even sell to magazines or newspapers, or enter for photo-contests and exhibitions. The first problem you will encounter is deciding which size of film your camera should take.

Deciding on the film size

Many writers on photography recommend that if you can afford only one camera and are unlikely to require interchangeable lenses, then a twin lens reflex is the finest choice.

There is a lot to be said for this point of view. The larger

17

film size means that scratches and blemishes do not show up so much on enlargements; if your processing technique is not quite as clean and meticulous as it might be (and few of us would claim perfection here), you can get away with more errors on the larger format; nor does grain pose so great a problem. The square format also means that you do not have to waste time deciding whether to shoot a particular subject upright or landscape. The larger image tends to make colour easier to sell to certain magazines if that should be one of your aims. And secondhand Yashicamats and Minolta Autocords can be bought very cheaply. Even used Rolleicords and Rolleiflexes are not prohibitively expensive.

But my advice—and I write as the user for many years of, unarguably the best-ever twin lens reflex, the Rolleiflex—my advice is for you to plump for 35mm. This is not the advice I would have given just a few years ago. But the use of the computer in designing lenses, combined with better glass

Even the standard lens on a 35mm camera can take spectacular motor racing pictures if you are near enough to the track. This incident at North Tower Crescent, Crystal Palace, was caught with a 58mm lens on a Minolta SLR. Its particular interest is that the driver (who was unhurt, incidentally) is clearly visible. That ensured it big treatment in my paper.

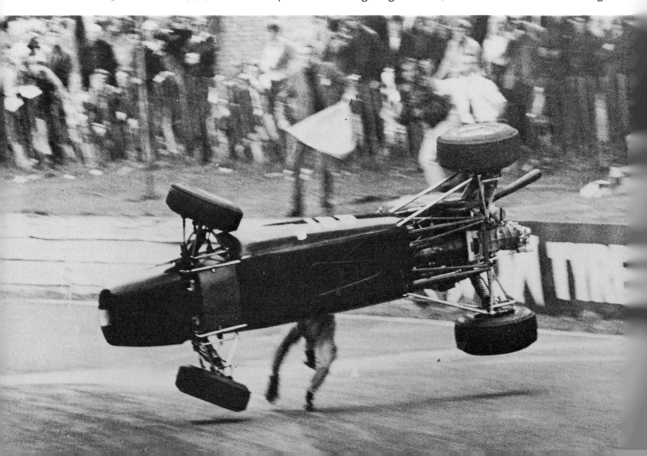

Paddock Bend, Brands Hatch. I used a Leica M3 with 135mm Canon lens to get this picture of Albert Gay crashing in his Peerless car with the car breaking up completely. Purists might say that if I had delayed pressing the shutter for another 1/10 sec Albert, who is just being ejected through the door, would have been filling that blank space at the top left of the picture which would have been pictorially more correct! Incidentally he was completely uninjured and after the crash I got him to smile by saying "Give a wave, as your wife is worried". He duly waved and smiled and I got my picture. Then he turned to me and said "But I'm not married".

and manufacturing technology, together with better film emulsions, has improved 35mm enormously. The situation today is that most picture magazines have had to accept that 35mm is here to stay, so they will accept colour in this format. Though it is only fair to say that an editor, presented with two equally acceptable transparencies, one on 35mm and the other on 6 × 6cm (2¼in square), will probably select the larger transparency.

It might be argued that these technological improvements apply as much to larger formats as to 35mm, so the bigger film-size will still produce better quality. Possibly this is so, though I wouldn't be so sure that the same amount of research and development has gone into these larger cameras as has been devoted to 35mm. In any case, the proof is always in the product. And most good 35mm cameras will produce prints that are virtually indistinguishable from those taken on a 6 × 6 camera.

I have proved this for myself by shooting the same sub-

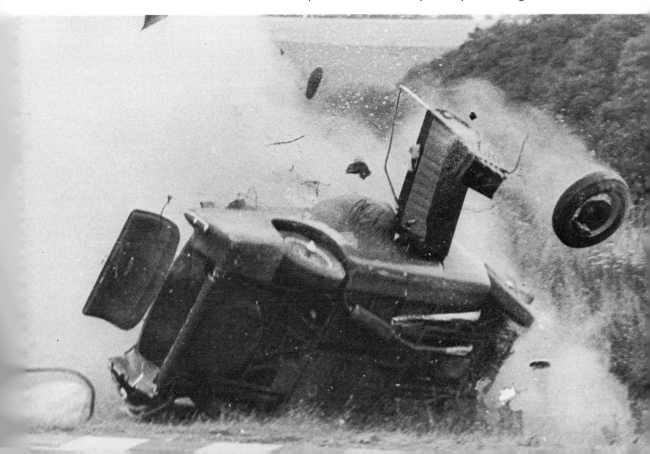

ject on both a Rolleiflex and on a 35mm camera, then making 20 × 16in prints from both negatives. In order to distinguish between the two, it is necessary to hold the prints just a few inches from the eye—and this is hardly the way any normal person would view a 20 × 16 print! In fact, if you shoot with a slower, finer-grained film, taking advantage of the higher speed lenses available for 35mm cameras, it is possible to get prints which are quite indistinguishable, even at close viewing distances.

For the benefit of beginners, I should add that by "higher speed lenses" I mean those with a bigger maximum aperture (indicated by a *smaller* f-number, such as f1.8) which are thus capable of transmitting more light to the film than a lens with a maximum aperture of, perhaps, f3.5. The larger format 6 × 6cm cameras are usually equipped with lenses having a maximum aperture of f2.8 or f3.5, while still larger formats have lenses with even smaller maximum apertures. Thus the 35mm camera is capable of working in lower lighting levels than its bigger cousins, or with a finer grained (but slower, of course) film, without having to give longer exposures.

Formats smaller than the conventional 36 × 24mm negative do not warrant consideration for our purpose. At one time there was an upsurge of activity in the so-called "half-frame" size, which gives a negative measuring 24 × 18mm, but this soon died as "compact cameras" arrived on the market, no bigger than the half-frame models, but able to deliver a full 36 × 24mm negative. Curiously enough, the half-frame cameras remained popular on the Japanese home market for a considerable time after the rest of the world had virtually discarded this small size.

What about 16mm and other tiny film sizes? I think we can safely leave those for the exclusive use of the heroes in spy films. Incidentally, it's amazing how these spies in films manage to copy secret documents by hand-holding ultra-miniature cameras under the most atrocious lighting. I wish they'd explain their technique some time.

Advantages of 35mm

Among the indisputable advantages of the 35mm camera are its portability and speed of use, though one or two 35mm SLRs when they have their various attachments

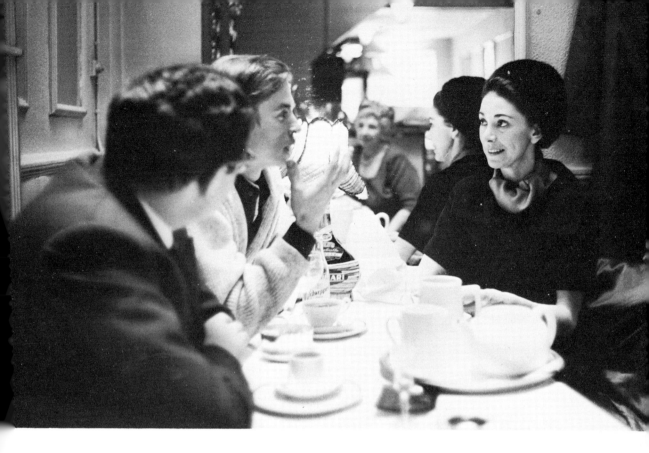

The advantages of both a wide angle and a wide aperture as Margot Fonteyn talks to Nureyev in a West End restaurant. Minolta with 21mm lens.

fitted, have started to rival larger format cameras in both size and weight. In general I have found that I can shoot just about twice as fast with a 35mm camera as I can with, say, a Rolleiflex. And that's without the use of a motor-drive, which is available for many 35mm cameras.

Traditionalists might argue that this "machine-gun technique" is not true, *thinking* photography. Let them argue. All I am ever concerned with is the finished print. And I will use whatever method and equipment produces the best pictures. This is not to say that, just because I am able to shoot quickly, I always use this rapid-fire technique. It's just that it is the right method for certain subjects, and the 35mm camera lets me have this facility up my sleeve for those occasions when I require it.

The wide-aperture lenses available for 35mm cameras enable pictures to be taken with the camera hand-held in lighting situations which would demand the use of a cumbersome tripod for larger format cameras.

There is also the vast range of interchangeable lenses and other accessories available for 35mm SLRs and for the Leica rangefinder camera, enabling the photographer to shoot pictures under almost any specialised circumstances, and to get the special effects which different focal length lenses can give.

"Ha!" the big-camera boys say. "But there are 6 × 6 and 6 × 7cm single-lens reflex cameras with all the facilities of interchangeable lenses, bellows, and so on." True. But just compare the price, the size and the weight of an average 35mm SLR with through-the-lens metering, with any of its 120 or 220 film-size big brothers. I know which I would rather pay for and carry about.

So my choice is unreservedly 35mm. As for the extra care needed in processing as compared with larger formats, it is true that one cannot take quite the liberties with 35mm as with a larger format. But you would be amazed at the results we obtain in press work, when time counts before all else,

Action coming straight at the camera has far more impact than that going horizontally across the field of view. Olympic hurdler Ann Wilson taken with a 135mm lens on a Minolta.

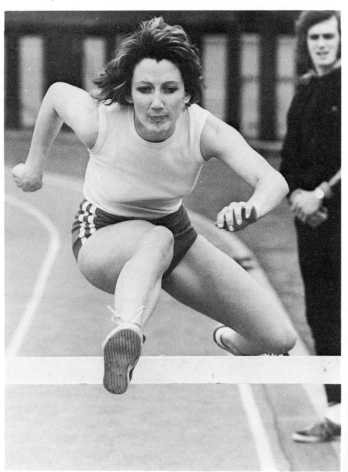

and processing is not exactly as laid down in manuals of 35mm technique. In any case, a little extra care about dust and scratches puts the majority of people to hardly any more trouble than being slapdash in their work.

As for colour, shot for projection in the home or at clubs, 35mm transparencies mounted in 2 × 2 mounts cannot be beaten for convenience and cost. Just take a look at the prices of 6 × 6 projectors and you will see why, when you go visiting, you will seldom find one available.

Choosing the camera model

So, having decided that 35mm is the size, which camera in particular should we select? That is a choice that no-one can make but yourself. The way a camera feels, handles, looks and operates is something you must judge for yourself, comparing one model with another. However it is possible to lay down some guiding principles to help you in your selection.

In general, 35mm cameras can be divided into three main categories:

1. Single lens reflexes.
2. Coupled rangefinder cameras with non interchangeable lenses.
3. Coupled rangefinder cameras with interchangeable lenses.

In category 3 about the only quality camera now being manufactured is the Leica M series. Nevertheless it is still possible to buy second-hand Leicas with screw mounts that are first-rate value for money, as they were built so well that they are virtually guaranteed to give you lifelong service. There are also a few Canon interchangeable lens rangefinder cameras still about in the secondhand market. These also were very good models.

But before considering specific cameras let me answer the question I am asked more than any other. This is, if I had a limited budget and could afford only one camera, which would it be? I have no hesitation in giving my answer. Even if I didn't have a limited budget and could afford the most expensive camera available, a "one and only camera" for me would undoubtedly be one of the comparatively inexpensive non-interchangeable lens rangefinder cameras which are fitted with automatic exposure mechanisms. Preferably, I would choose one which would enable me to have manual

exposure settings as well as automatic when I required them.

It's interesting to note the very high quality of lenses fitted to these comparatively inexpensive cameras. I once carried out a test photographing a subject with plenty of fine detail all over, using three relatively inexpensive rangefinder cameras (the Olympus 35SP, Canonet QL19, Yashica 35GT) and three high class SLRs (Leicaflex, Minolta SRT101, Nikon F). The results were quite illuminating.

Stopped down to f4 or f5.6, 20 × 16in prints from each camera were quite indistinguishable in quality. But used with the lenses wide open, the two cameras which produced

The depth of field provided by a wide angle lens is useful for combining two stories in one. Mary Rand trains while her husband feeds the baby in the foreground.

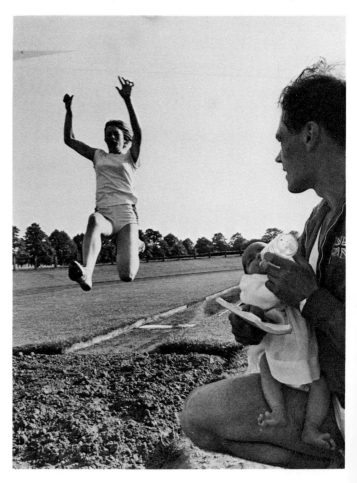

pictures marginally better than any of the rest were the Minolta and the inexpensive Yashica 35GT! The rest of the cameras gave pictures which were about equal in quality, although the Canonet was rather poor on its edge definition. However this should not be taken as a condemnation of the Canonet as I subsequently tried another model and found that the results it gave were up to the standard set by the other cameras. It is possible to get the odd lens which is below par from any manufacturer. Even those perfectionists at Leitz have been known to let a not-so-good lens slip through their hands on rare occasions.

Thus you can see that one of these comparatively cheap rangefinder cameras will give you good quality results. It will also give you electronic flash synchronisation at all shutter speeds. Focusing with a rangefinder is very easy for inexperienced photographers (and also for experienced ones!) as the subject can be seen to be quite definitely "in" or "out" on the rangefinder. The fully automatic operation also means that the camera is ready to take pictures instantly, without any setting other than focus having to be made.

I myself use one of these cameras extensively, although I also possess a comprehensive Minolta single lens reflex outfit with two bodies and a vast selection of lenses. But the little rangefinder camera is always ready for instant use, and has captured for me many pictures which I would have missed, had I had to set up one of my single lens reflex cameras.

I would go so far as to suggest that one of these cameras should be the first choice for anyone taking up photography and who wants to progress a little further than the snapshot stage. Even if, at a later date, you decide to go in for an SLR, your rangefinder automatic will still be invaluable for quick shooting and for synchro-sunlight work. Thus the money you have spent on it will not be wasted when, at a later date, you decide to invest in more sophisticated equipment.

Reflex or rangefinder

So now we come to a direct choice between SLRs and rangefinder cameras (and this of course means the M series Leica) with interchangeable lenses. Let's have a look at the advantages of the SLR.

First of all, the SLR takes lenses of any focal length, and exactly what the lens sees appears in the viewfinder. There

is no question of parallax. Attachments for macro and micro photography are simple. And it must be admitted that there is an indefinable pleasure in focusing on the screen of an SLR.

The Leica M5 is the only surviving top-quality rangefinder camera to have interchangeable lenses, but it does have very many advantages. For a start there is a virtually silent shutter as compared with that of the SLR. The lenses are less complex and so is the mechanism in the body, so there is less to go wrong.

It is well known that any automatic diaphragm lens can have diaphragm blades that stick, and the photographer does not learn that he was shooting at wide aperture until he develops his film. This sticking can be caused by moisture or minute particles of dust getting into the lens. It is a disadvantage that does not apply to lenses used on a rangefinder Leica, because the diaphragm is manually operated.

I don't think anybody would deny that focusing with the shorter focal length lenses (say up to about 90mm) is very much quicker with the rangefinder of an M series Leica than it is with any single-lens reflex camera. It is also very positive because you can see by the double image whether the subject is in or out of focus without any doubt at all. A disadvantage is that the normal range of lenses for the rangefinder camera goes only up to 135mm. Leitz do make reflex attachments for the use of longer lenses, but it must be addmitted that these attachments are rather clumsy when compared with the ease with which long-focus lenses can be fitted to SLRs.

But do you really want to use long focal length lenses? Are you going to take up macro work? Are you going to require to fit bellows? Unless your answer to these questions is "yes" you should consider an M series Leica if you can afford it. They are superb examples of engineering and very easy and quick to use. It should also be borne in mind that, except for specialist photographers, the vast majority of pictures are taken with focal lengths of not more than 135mm.

So think very carefully before deciding that you *must* buy an SLR simply because it appears to be the fashion. It might not be the best camera for you.

Before making your mind up I suggest that you go along

to a dealers and actually handle some SLRs and rangefinder Leicas. Hold them up to the eye, try focusing, and get the feel of them to see which you like. It is all-important that the camera should *feel* right to you. One that seems right for me might not be right for you. Everyone is an individual and knows the sort of thing that feels right in his hands. So try the cameras out in the dealers, and get to know them before making your choice.

Don't be too influenced by the advertisements. Most reputable makes are about the same quality these days and possess roughly the same features, so you won't go far wrong whichever one you choose. I don't propose to give you results of any tests I have carried out because there are not any bad cameras from the top manufacturers. They all produce excellent pictures and they are all well made.

Reading the equipment reviews

Many amateurs wonder just how much faith they can put in the reviews of equipment which appear in photo magazines. How well qualified are the reviewers and do they really handle the equipment in practical conditions? Are they influenced by advertising considerations?

So far as I am concerned I never give two hoots about advertisers and what the various importers might think of me. That is a problem which can be fought out by the advertising manager of the magazine. I write about equipment just as I find it, and say exactly what I think about it. This policy hasn't always made me the most popular writer with the big importers, but I have tried to give an honest appraisal of the equipment which I have used. Certainly I have made mistakes, but at least I've done my best to tell amateurs what I personally think of a piece of equipment when I have been using it.

Reviews of cameras and lenses by technical experts are often less practical but they are extremely useful for anyone considering buying a new piece of equipment. For a start they give a very detailed description of the equipment and the way it works. From this the reader can often draw his own conclusions—especially if he reads "between the lines" and deduces what the reviewer *really* thought about the equipment, but which he didn't want to put into words.

So here's the exclusive "Blackman Guide to Reading

Between Reviewers' Lines''. And if you think my tongue is in my cheek, well, you may be right.

Sturdy construction: Hefty and unwieldy.

Has a somewhat functional appearance: Plain ugly.

A tried and tested design: Old fashioned and out-of-date.

Light output quite suitable for the home with this projector: Don't draw too hard on the cigarette or the screen image will disappear completely.

Lens has great depth of field: Nothing is dead sharp.

Quality we would expect for this price: Dreadful results.

Gay colours: Makes you feel sick to look at it.

Shutter speed quite accurate for this type: Hopelessly slow.

Good results within the limitations of this type of camera: Useful for snapshots on the beach only.

Even complete beginners should get good results from this: They should try it on my wife.

A controversial camera: Nobody wants to buy it.

Has many interesting features: Gimmicky.

Should prove extremely reliable: How the devil does the reviewer know this when he has probably put only a couple of reels of film through the camera?

I'm not suggesting that reviewers of equipment are deliberately trying to mislead their readers, but they are working under a handicap and it has nothing to do with advertisers. They have to judge the product in relation to its cost and possible acknowledged limitations and, moreover, they are fully aware that the item they test may not be truly representative of the range. There is still a good deal of hand assembly work in cameras.

But if you read several appraisals by the same reviewer you will gradually get the feel of the way he writes, and when he genuinely likes something or when he doesn't. You will be able to make up your own guide for reading between the reviewers' lines, and thus get an accurate picture of what the reviewer really thought of the apparatus he was writing about.

A look at the system cameras

Once upon a time, the only equipment needed by most photographers consisted of one camera, one lens, and either a box of slides or a roll of film. With that he could tackle most subjects. Nowadays, the amount of equipment and

accessories has proliferated so much that it is common for one of the SLR systems to boast of up to three hundred different items to be used with a particular camera.

Personally, I think there is a lot of nonsense talked about the good old days when a photographer had a comparatively simple camera with a limited number of exposures he could make. A pressman might carry just half-a-dozen double dark slides, and with these he claimed that he captured pictures superior to those obtained today. The fact is that we don't hear about the great pictures he missed.

Today's equipment enables us to tackle subjects which were far beyond the capabilities of those photographers of not-so-many years ago. For instance, motor-driven cameras enable us to take a sequence of pictures at a rate of anything up to nine a second with some units, showing the entire action of a fast-moving event such as a racing car crashing. Without our modern wide-aperture lenses and high-speed films the photography of floodlit football and many other subjects under poor lighting conditions would be quite impossible. The quick action winding and exposing mechanism of the modern 35mm camera enables even those without motor-drive units to take pictures in such quick succession that they have to be either unlucky or very bad photographers if they do happen to miss that one moment in time which makes the great picture. And of course, quickly interchangeable lenses mean that we can fill our 24 × 36mm frame with the subject, and produce pictures of a quality virtually indistinguishable from those taken with the massive equipment but inferior emulsions of a few years ago.

This doesn't mean to say that I advocate that every photographer should weigh himself down with all the accessories, electronic gadgetry, and instant miracle picture-making gimmickry that is put on the market. Not a bit of it. It is still a fact that the majority of pictures can be taken with just one simple camera and a standard lens. But it is also true that the various accessories available provide new picture ideas which otherwise would be impossible.

Viewing and focusing facilities

One of the most important items in any camera is the method of viewfinding. With a rangefinder camera this is quite simple, and usually consists of a "suspended line"

frame in which the subject can be easily positioned. In single lens reflexes, however, there is a tremendous variety of focusing screens and many cameras enable us to change to a different type of screen in a few seconds.

Which are the best? Well now, that is question entirely of personal preference. I know some photographers who very much like the tiny rangefinder spot which is fitted into some focusing screens, but my favourite is really a plain ground glass screen. I find I can focus much more accurately and quickly with this than with the microprism type, but of course that is my personal preference, other people preferring the microprism system or the rangefinder spot. So before you buy a camera, do check that you can focus it accurately, and that you are entirely happy with the type of focusing screen fitted. If you are not happy, have a look round at other makes of camera, or enquire whether the focusing screen can be changed by the importer to one that you prefer.

There is an easy and quick way to check how accurately you are able to focus with the different systems that are available. Just pick on a subject or object about fifteen feet or so away, focus on it as accurately as you can, and then make a tiny pencil mark on the focusing ring of the camera opposite the focus setting mark. Now spin the lens to infinity and again focus as carefully as you can on the same subject (obviously without changing your position). Then see if your pencil mark is again in its same position. Do this several times and see how often you manage to get the focus dead-on in the same position. Try it with several cameras and you will find some with which you can do it much more accurately and easily than others. Obviously these are the types which will suit you.

Another point to check when buying a camera is to ensure that the eyepiece is suited to your particular eyesight. Personally, I have no difficulty in seeing the whole view-finder area with any sort of camera while wearing spectacles, although there are some photographers who find them a physical encumbrance. In any case you should be able to see the focusing screen clearly and without having to strain your eye. If you do have to strain your eye, the chances are that you will not focus accurately every time and the remedy is either to look for a different camera, or to get an eyepiece correction lens fitted which suits your par-

ticular eyesight. This is most important for accurate focusing of SLRs. Particularly for those of us who have reached middle age and whose eye muscles are not quite so active as they once were.

The Novoflex pistol grip type of focusing is one of the most useful methods for the sports photographer, or anybody who has to change focus very rapidly. The only trouble is that it does look rather like a gun, and there have been at least two photographers who have been killed while shooting war pictures through their use of Novoflexes. They have been mistaken for men with guns, and the photographers have suffered a fatal bullet.

I myself had one or two unpleasant incidents in this respect in the Middle East when I was photographing some rioting in Amman. I raised my Novoflex and an Arab soldier immediately dashed up and knocked it out of my hand, obviously thinking it was a gun. I'm lucky that was all he did!

Motor drive units

Motor-drives are generally the realm of the professional, although there are some amateurs who are willing to pay out the rather high prices asked for them. They have a use quite apart from sequence photography in that they are ideal for remote control, so many nature photographers tend to use motor-driven cameras.

There is little doubt in my mind that the Nikon gained its popularity because it was the first system-camera to have a motor-drive. Because of this, many professionals bought the Nikon, and quite naturally built up an outfit round the motor. Amateurs looked at the professionals, noticed that many were using Nikons, did not stop to think why, and promptly jumped on the bandwaggon. Hence the popularity of the Nikon.

However, nowadays there are many SLR camera systems which incorporate motor-drives. Some are very reliable indeed, while others—well the least said about them the better. But in general I would not go for a motor-drive where the battery is held in a separate container and connected to the camera by a cable. This system gave a lot of trouble on the early Nikons and later was superseded by a battery compartment built into the camera, as was the case with most of the other motor-drives which followed.

I remember in 1969 I was in Barcelona, covering the Spanish Grand Prix. I was at the bottom of a hill, the top of which the cars were breasting at a speed which we later worked out to be about one hundred and sixty-five miles per hour. Suddenly Graham Hill's Lotus came over the crest of the hill, something happened to his aero-dynamic "wing", and the car simply took off and went flying through the air. This is going to be a great picture, I thought, as I pressed the button of my motor-drive. But nothing happened. It just failed to fire. By the time I had got my finger on the manual button the car had hit the ground, and the great spectacular picture had gone. I fiddled with the camera but it seemed perfectly all right and started working again.

Ten minutes later, Jochen Rindt in a similar car came over the brow of the hill, same speed, same trouble, and his car also took to the air. I pressed the button. Again nothing. Another great picture gone. To say I became disenchanted with that particular motor-drive is putting it mildly.

To be fair there was nothing wrong with the actual motor-drive. It was just a matter of poor connections. With those early motor-driven cameras I had the feeling that the motor-drive had been designed by a genius and he had slung the connections to the newest apprentice to design. Later designs of motor-driven cameras profited from the troubles that befell the early ones and I have been using a Minolta motor-driven camera for the past three years during which time it has never faltered.

3

Buying Extra Lenses

The real question you should concern yourself with if you are getting together an outfit, is which extra lenses to buy. Generally, you will have a "normal" focal-length lens of around 50mm with the camera when you buy it. But which are the most useful extra lenses? I would suggest that if you just want to buy two extra lenses you go in for a 28mm and a 135mm. With those three lenses, you can cover almost any situation. Any other focal-length lenses you buy, such as a 21mm, 200mm, or 300mm, will get very little use from you unless you are a specialist of some sort.

As a press photographer I cover a vast variety of subjects, and yet I find the majority of my pictures are taken with lenses within the range of 28mm to 135mm. So these are the lenses I think you should go for to start your outfit.

Later, you can think of investing in something really long, such as a 300 or 400mm lens. This need not necessarily cost you a lot of money because there are plenty of lenses of this focal length on the market at quite low cost. Provided you don't want a wide aperture and are satisfied with something in the range of $f6.3$ you can get one of these useful lenses very cheaply indeed.

How good are they? Well I have found that even those of unknown makes give first class results. This is because the construction of a long-focus lens is so much simpler than that of a wide-angle. Therefore, when going in for a wide-angle lens, it would be better if you paid rather more in order to get a good quality one. But where the long focus lenses are concerned, the simple construction means that good results can be obtained with minimum outlay.

Standard or wide-angle?

Most photographic subjects can be taken with the ordinary standard focal length lens fitted to your camera, which might be anything from 35mm to 58mm. Extra long or extra short focal length lenses should be reserved for pictures which would otherwise be impossible with a standard lens, or in order to obtain special effects. Not merely to save yourself the trouble of changing your camera position.

Lord Snowdon once told me that he took about ninety per cent of his pictures with a standard focal length lens. And he hasn't done so badly out of photography! I myself often use a 35mm lens on my Leica as a general purpose objective in

preference to the more usual 50mm. Of course, a 35mm lens does not give a particularly wide coverage, so for special, wide-angle effects I use either a 28mm lens or the ultra-wide 21mm, which has an acceptance angle of just over 90 degrees.

These very wide angle lenses confer certain advantages, but great care is needed in their use because these advantages can only too easily turn to disadvantages. For instance, they give an enormous depth of field, which is often desirable if one wants foreground objects to be sharp as well as those in the background. But unfortunately, it is perfectly natural to concentrate your attention on the main subject when looking through the viewfinder. The result is that when the film is developed, all sorts of distracting objects that you did not notice at the time of shooting may be sharply defined in the background.

This is because our eyes, like our ears, are naturally selective. They observe only what they want to observe. If you want to try an experiment, get three people to talk at once and try to listen to only one of them. You will find it comparatively easy to understand him. But if you make a tape recording of the three speaking together, the non-selective microphone will record them as an indecipherable babble. A similar sort of thing happens with our eyes, so an important rule with using wide angle lenses is: make doubly sure that the background is as you want it recorded in your final picture.

Another advantage of the wide angle is that it enables you to get the whole of a subject in when space is restricted. But again care is needed. Ability to move in close can give a most unpleasant effect, particularly to faces. This is not caused directly by the wide angle lens, but simply because of your closeness to the subject.

Particularly when you are photographing buildings, it is essential that the back of the camera should be kept absolutely upright when using a wide angle lens. Otherwise that familiar "falling over backwards" effect will make itself unpleasantly apparent. This seems much worse when a wide angle is used, but again it is not the fault of the lens. Because of its wide acceptance angle you are able to shoot closer to the building and therefore you are probably tilting the camera back more than you would with a longer focu

An unusual angle can add impact to a frequently photographed subject. Daily Express colleague Norman Potter gave this treatment to Bobby Moore, England's long-serving football captain.

lens when you would be standing further back from the building.

There is no doubt that a wide angle lens does seem to give some pictures impact. Because of its wide coverage, it forces the photographer to move in on the subject, and this often has the effect of making the person viewing the print feel that he really is in the picture. This particularly applies to shots containing a lot of action such as street demonstrations and sports like football. Additionally, having moved in to get your main subject as big as you might have got it with your normal lens, you can include a wide view of the back-

ground, and this can often be utilised to give "atmosphere" to the picture.

There are two types of wide-angle: a normal short focus, where the rear element is quite close to the film plane; and what is called a retrofocus, which gives exactly the same effect as a short focus lens, but is actually separated from the film plane by a distance greater than its focal length. This design can allow even ultra short focus lenses to be used with single lens reflex cameras without impeding the mirror action. At one time some of these lenses could be used only with the mirror locked up out of the way, thus blocking the viewfinder so that the camera was no longer a reflex. Even the widest of modern wide-angles, however, does not require the mirror to be raised out of the way. They are all of the retrofocus type, even those with focal lengths as little as 16mm, and the "fish-eyes", which cover, in some cases, over one hundred-and-eighty degrees.

Using ultra wide-angles

Ultra-wide angle lenses (shorter than 28mm) are useful for specialised picture situations, but I am flatly against their indiscriminate use for all types of subjects. There are many photographers (at least they call themselves photographers) who use lenses of 21mm focal length for almost every picture situation, including glamour shots. The results are dreadful to look at, especially when a picture of an attractive girl has been taken. The apparent distortion caused by these lenses causes all semblance of beauty to vanish. This doesn't mean that I am completely against their use. As I said, they are invaluable for specific picture situations. like to think of these ultra wide-angles as being lenses which enable a photographer to put the viewer of his pictures right in with the subject. I use them to try to give readers an impression of the experience I was having when I took the picture.

When I photographed some cheetahs at Windsor Safari Park, I didn't want just ordinary pictures of cheetahs which can be taken anytime with a long focus lens. I wanted to give readers the impression of what it was like being actually in the midst of a pack of racing cheetahs. So I fitted my camera with a 21mm lens and shot pictures from the back of the truck which is used for feeding the animals. The truck

goes along at about thirty miles an hour while one of the game wardens throws dead rabbits from the rear. My idea was to shoot from the back, the camera being literally within inches of the pursuing cheetahs.

The first time I tried it was a disaster. One of the cheetahs, obviously a little annoyed at having a camera poking at him instead of getting his ration of food, snapped at the lens with his teeth and badly damaged the outer rim. I'm glad his teeth did not snap together just about six inches further on, or not only would he have been digesting a perfectly good Leicaflex, but I would probably be looking round for a new sort of camera which I could operate with my feet!

Anyway I called in at Leitz in London and asked their chief mechanic if he could repair the lens for me. It was certainly looking rather chewed up and the worse for wear.

"What happened?" he asked giving me that rather hurt

Cheetahs after the chuck wagon at Windsor Safari Park. My favourite animal picture, taken with the camera dangling out of the back of the truck on a pole. The story is in the text.

look which Leitz reserve for people who have maltreated Leica equipment. "Did you drop it?"

This was the moment I had been waiting for.

"No. Actually it was bitten by a cheetah."

He didn't produce a breathalyser bag, but he did give me a look which held a load of suspicion.

"A cheetah? Are you trying to have me on?"

So I told him what had happened. To this day I am certain he didn't really believe me.

The second time I tried for this particular picture I was still out of luck. The game warden deliberately held up the throwing out of the food for the cheetahs to get them in a good pack so that I would get the picture I wanted. And naturally, this didn't please the cheetahs. So a couple of them tried to get in the Land Rover with us. In the resulting commotion I found myself lying on the floor amidst a lot of dead and bloody rabbits, and hoping the cheetahs wouldn't decide I was a better dainty morsel!

Not only was I feeling rather secondhand after this episode, but my camera was also distinctly "shopsoiled". Again, picture-taking was out for the day.

The third time was lucky, and I got just what I wanted, using a Minolta motor-driven camera mounted on the end of a pole, and fired remotely from inside the truck. The 21mm lens really did put the readers right among those cheetahs and gave me the different picture I was after.

There was another occasion when the use of an ultra wide angle lens got me into a certain amount of embarrassing trouble. The incident occurred many years ago, so I think it is safe for me to tell the story now. For some time I had been doing a lot of acrobatic flying in RAF Hunter aircraft, and had loved every minute of it. But I had developed an ambition to fly in the, then new, supersonic Lightning aircraft of the RAF. I wanted to be the first "ten ton man" (1000 miles per hour) in Fleet Street. After a lot of scheming, pleading, and persuading, I managed to get my contact in the facility branch of the Defence Ministry to arrange a trip for me. I had made it. Although I wasn't to be the first press man (a freelance in East Anglia beat me to it by a couple of days) I was the first man from Fleet Street to get a supersonic ride in a Lightning.

Now, as I have said, I regard the main value of an ultra

wide-angle lens to be its ability to put the reader right in the picture where the action is. So, to simulate as near as possible my experience and feelings as I took the picture, I had a 21mm lens fitted to my camera when I climbed into the Lightning. At the time, such a wide-angle was quite new, and relatively unknown to the lay public.

As an aside I should mention that a reheat take-off in a Lightning is an experience which can never be captured on film, whether it be still or cine. It is simply fantastic. With the reheat going full blast, and creating enough noise outside the cockpit to make Concorde sound like a Rolls Royce Silver Ghost whispering past, we screamed down the runway in our two-seater Lightning. Then the pilot lifted it just off the deck a few feet, but held it down until the speed built up to about 450 knots. Then he pulled back on the stick and, quite literally like a rocket, we were pointing straight up into the sky, and within seconds were at 40,000 ft. It was truly the most fantastic experience of my life. But to return to the photography.

After a few minutes the other aircraft of the flight—I think it was 56 Squadron—joined up with us in formation. They couldn't have been more co-operative, and under my instructions over the radio, positioned themselves so that I could get a shot showing the whole of the cockpit of my own Lightning and the other Lightnings in formation by our side. Thus, I was going as far as I could to give readers who would see the picture the feeling of what it was like to be in one of these great aircraft.

After I had shot my pictures we broke away and the pilot took me supersonic, so that I could officially become one of the members of the Ten Ton Club.

Back at the *Daily Express* I processed my film and had prints made. Then I suffered one of those frustrations which frequently beset all press photographers. The picture they printed in the next morning's paper was not the one I had taken so much trouble to get, and which was really historic in that it was the first one taken by a pressman in a Lightning. Instead they used one of the pictures I had taken earlier in the day from the ground. One which could have been taken by anybody.

Certainly it was a good picture in its way, but in my opinion did not compare with the one I had taken in the air. I

thought this was a great picture, and when I showed it to the editor of *Amateur Photographer* he shared my enthusiasm and, very unusually, used the one picture spread over the whole of two pages. When the picture appeared in *Amateur Photographer* I was delighted with the presentation, and I was sure the RAF would be too. So I wasn't surprised when later on that Wednesday morning I got a telephone call from the RAF press officer.

"Good morning Vic. About that picture of yours in the AP."

"Oh, yes, did you like it?"

"Yes, I think it's a great picture. But there's just one thing. It shows the entire interior cockpit layout and some secret radio frequencies. It is strictly forbidden to photograph these things in a Lightning."

Speed cop and racing motorcyclist Graham Bailey shot at Brands Hatch from the boot of a car. I used a comparatively slow shutter speed of 1/125 sec combined with a 28mm lens on a Minolta.

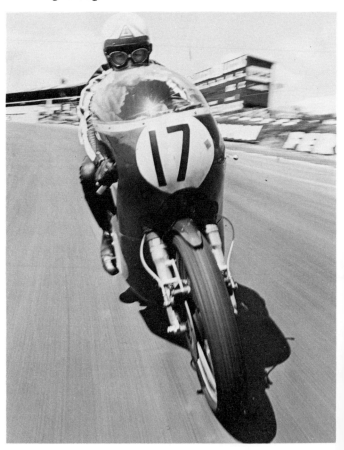

"Oh I'm very sorry about that. I wouldn't have dreamed of taking it if I had known. But no one mentioned this to me before we took off."

"Yes I know. It's not really your fault. We should have warned you beforehand, but we didn't know that cameras could take in such wide angles as yours did. The trouble is that our security has been taking a bit of a knock from the Americans lately. This is giving them good material to feed on."

There was a pause while he thought things out.

Then he said "Still, maybe it's not so bad. I don't expect many of the top brass read AP. And certainly not the American intelligence people, so perhaps it will go unnoticed."

I really hadn't the heart to tell him that only the previous day I had been told by the *Daily Express* syndication department that this particular picture had been so liked that a national American magazine had bought it and were going to give it full double-page treatment the following month.

It may be a pure coincidence, but ever since that day, all those years ago, I have never been able to get myself a ride in a Lightning, in spite of many applications. If anyone in the RAF reads this, *please*, I would love to have another ride in a Lightning. I promise, I really do, that I will not take a 21mm lens with me.

Anyway, those are my general feelings on the use of ultra wide-angle lenses. To put you among the subject. And very occasionally—I insist upon sparingly—to produce a special effect, such as having one object very close to the lens to give apparent distortion.

I made use of this idea once to photograph a multi-millionaire. I got him to put his feet up on the table and noticed that, in spite of all his millions, he had a hole in the sole of his shoe. So I used a 21mm lens to get the shoe sharply and big in the foreground of my picture with the millionaire's face in the background. It was the hole in the shoe that really "made" the picture.

Perspective distortion effects

One of the biggest complaints against the ultra-wide lens is the apparent distortion of objects on the edge of the negative, and there is some justification for these objections.

Perspective distortion can be used deliberately. I used a 28mm lens and a close viewpoint to show Yvonne Orme, one-time Miss United Kingdom, in her home-town street of Nantwich.

A typical 135mm lens shot. A low viewpoint near one of the "jumps" on a motorcycle scrambling course provides plenty of opportunities for good pictures.

However you can't really blame the lens designers for this. If with a good quality wide angle lens, you photograph a flat surface with circles drawn at the extreme edges of the picture area, the image produced shows perfect circles. However, if instead of circles on the edge of the frame you put solid spheres, the resultant picture shows them considerably elongated and distorted. This effect is very unpleasant when, in an ultra wide angle shot, you have people's faces on the edge of the frame.

It would probably not be impossible for lens designers to eliminate this effect, so that solid objects on the edge of the frame would not appear distorted. However, you would then be faced with the fact that objects on a flat plane at the edge of the picture would appear compressed and distorted. Lenses have therefore been computed so that, ideally, a print made from the whole of the negative should be viewed from the distance that gives the same angle between the edges of the print and the eye as was the acceptance angle of the lens in the camera. Then there is no apparent distortion. Your eye sees just what the camera lens saw.

In other words, a 10 × 8 print made from the whole of the negative shot with a 21mm lens should be viewed from about five inches, while a 5 × 4 print should be viewed from

42

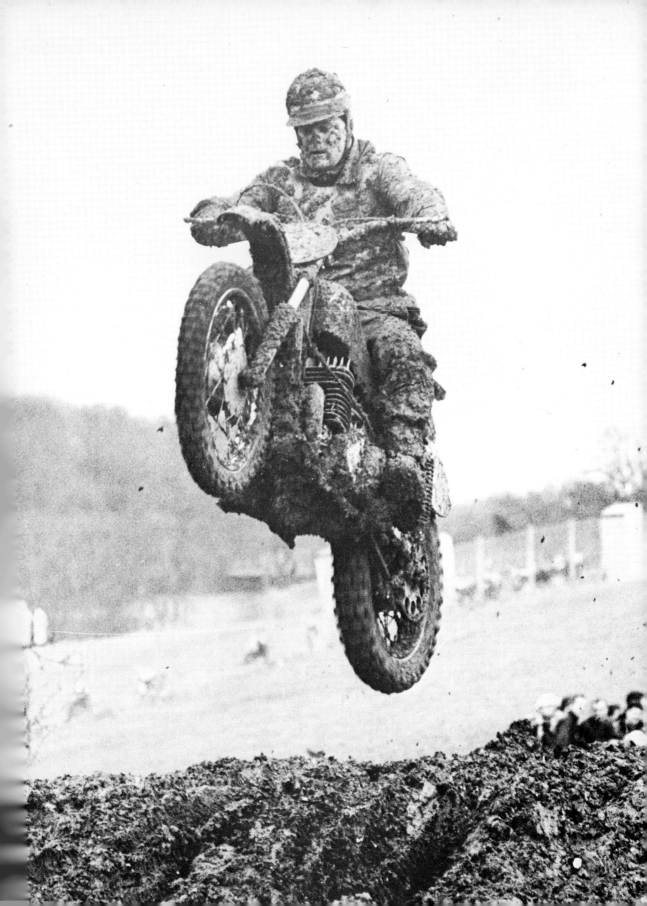

only about two and a half inches. Do this and the edge distortion disappears. But of course, few people look at prints as closely as this, so the edge distortion is only too apparent.

It is not, however, so unreasonable to expect people to look at a 20 × 16 print from a distance of about ten inches, or a six foot print from a distance of three feet. So the odd fact emerges that the bigger the final print from a negative taken with a wide angle lens, the less will be the apparent edge distortion. Always providing this "close viewing" is carried out from the centre of the print. Also, close viewing of those apparently distorted facial features, which look unpleasant through being shot with the camera too close, will make them seem almost natural.

Next time you see a picture which has obviously been taken with a a very wide angle lens, just try the experiment of putting your eye close to it. You will be surprised at the realism—almost a 3D effect, in fact.

Very often the first extra lens bought by amateurs is a long focus objective. I suspect that this is frequently because it is physically rather large, looks impressive, and so is regarded by many as some sort of a status symbol. I specifically said amateurs, because professionals, to whom photography is a business, are usually careful to buy only equipment which will earn its keep. If they have made a mistake and bought equipment which is not being used (and we must all admit to having done this at times), then it very soon gets the old heave-ho and is sold. I am a great believer in cutting losses, and although I might lose money by selling something that is getting very little use, I think it is better than keeping it merely because I have made a hefty outlay for it.

But let us differentiate between telephoto and long focus lenses. Although they both have exactly the same effect: i.e they produce a bigger image of a subject than a standard lens used at the same distance from the subject, optically they are quite different.

A long focus lens is often bulky, and will extend from the film frame at least as far as its focal length. Thus, an ordinary 300mm long focus lens projects a good twelve inches in front of the camera. But a telephoto lens of the same length is much more compact and might only project four or fiv

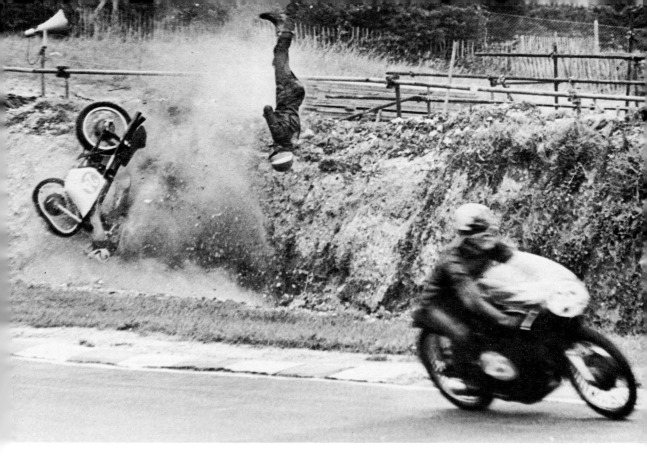

The 135mm lens again catches an astonishing mid-air headstand at Paddock Bend, Brands Hatch.

inches, although it produces the same image size on the film as the long focal length lens.

Why then are not all long focal length lenses made of telephoto construction? Apart from certain other technical considerations the straight long focus tends to give better definition than the telephoto. However, as they both produce the same effect, it can generally be assumed in this book, that where I use the term long-focus, telephoto would also apply. And, of course, the converse applies too.

The first and obvious use of long focus lenses is to take close-ups of people without going near them. Too often, however, this is merely a leg-saver. The real use for a long-focus lens is that it enables the photographer to move away from the subject and thus change the perspective, yet still get a good-sized image on his negative.

I must emphasise that the long focal-length lens does not alter the perspective, but it does allow the photographer to increase his distance from the subject. And it is *this* that changes the perspective. This property is useful with many subjects, not the least in portraiture, where too close a view-point produces an unpleasant effect. Moving back a long way and shooting with a telephoto lens also has the effect of apparently compressing distance, and this technique is often

45

used to make pictures of traffic jams look worse than they are, if that is at all possible.

Always remember that you control the perspective, not by the lens you have fitted, but by the distance you are away from the subject.

One of the most successful freelances in the world is undoubtedly Terry O'Neil. He usually likes to use a lens which is rather longer than a normal focal length, whenever this is possible. But of course, with the types of subjects he specialises in, he does have some control over the distance he can work from the subject.

Extra long focus

Other specialised lenses which are not really in the field of the amateur, but are of some interest, are the 1000mm and the 2000mm ones which we use for special press jobs, such as photographing royalty. I don't mean that we use them for obtaining the sneak pictures which certain unscrupulous photographers have gone in for, but for taking pictures of royalty on public occasions, such as at the Derby. It is here that I have had some of my most successful royal pictures.

I usually get myself positioned near the finishing post and right opposite the Royal Box, although I am about 75 yards away from it. I like to use a 1000mm lens and concentrate on the royal party rather than on the horses. Often this policy doesn't pay off if the royal party is not particularly excited at the results. But there are occasions when one can capture some amusing and interesting expressions. And during the 1970 Derby I was lucky enough to catch the Queen literally jumping up and down with excitement as the horses passed the winning post.

This picture got me an award in the *British Press Pictures of the Year Contest*, but in order to get it I had to take a calculated gamble. As the horses passed the two furlong post I had to decide whether to concentrate on the finish of the race, which obviously was going to be a very exciting one, or on the Queen up in the Royal Box. If I concentrated on the Queen and she viewed the race with an impassive face, I would have neither a good royal picture nor a good race picture. However, I have always been one to take a gamble, and taking a quick glance around I saw that every other photographer had decided to concentrate on the finish

The extra long focus lens has specialised uses. Here a 1000mm lens was focused on the Royal Box at the Derby from about 75 yards away and caught the Queen pointing out an amusing incident to her sister, Princess Margaret.

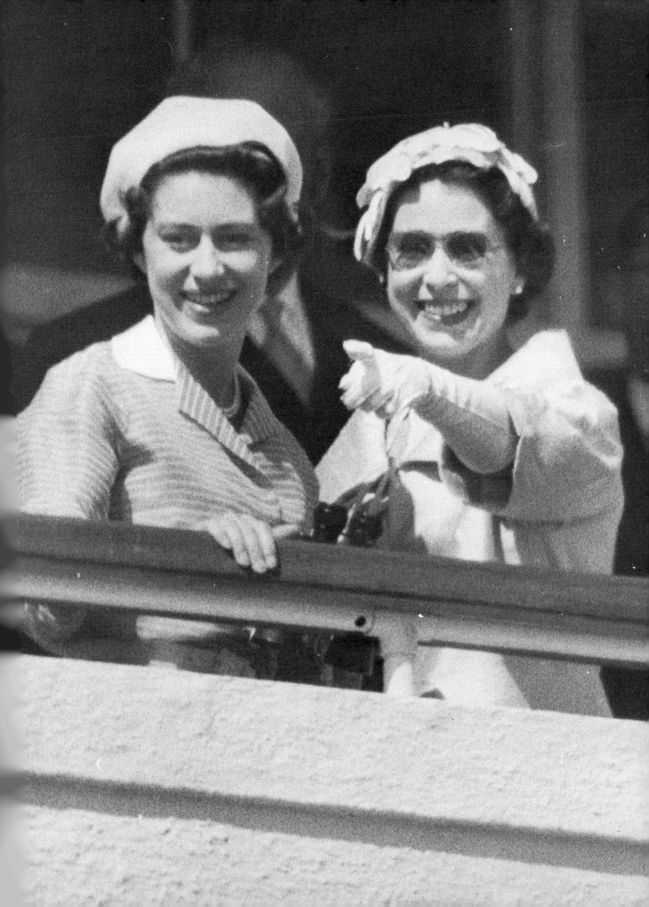

of the race. I swung my camera onto the Royal Box and ignored the race.

The gamble paid off.

As I said the Queen was literally jumping with excitement and made a great picture for me.

Hazards of zoom lenses

There is a lot of controversy about zoom lenses and their use. Every now and again a manufacturer comes out with a new zoom lens which he claims will give definition equivalent to that obtained by good prime lenses. At the time of writing, I have never encountered a zoom lens as good as this. No zoom that I have ever used—and I have tried quite a number of different types—ever gives results as good as prime lenses. My personal opinion is that their use is very much restricted, and my advice is not to buy a zoom unless you need it for a specific type of subject.

The type of subject where the zoom is most useful is where you have no way in advance of knowing what distance away the subject will be when you want to make an exposure. This applies particularly in aerial photography.

When photographing a subject on the ground or at sea (sinking ships are a common aerial press subject) you can never be quite sure how big the subject will be in the viewfinder until you have flown over it. And it can be quite time-consuming if you have to get the pilot to make several runs until you are shooting at just the right distance. This is where a zoom lens really comes into its own, as the subject can be framed exactly as you want it.

Zooms are also useful in colour photography, where it is not usually possible to enlarge part of a colour transparency at a later stage, as one can do with a negative when shooting in black and white.

But in general I have found that zooms are slow to handle, and the additional complication of having to set the zoom and focus, at the same time watching the subject while picking the right moment to shoot, can often mean that the peak moment has been missed. In fact, I would hazard a guess that more pictures have been lost by the use of zooms than most photographers would care to admit. Certainly I know that I have missed more than one good shot through having

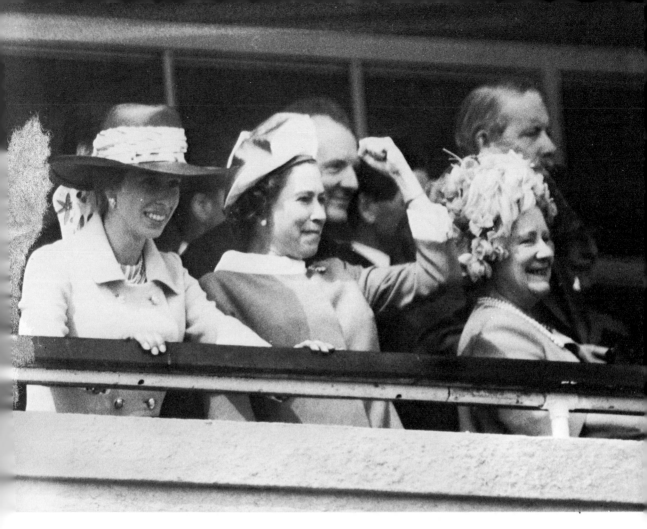

The 1000mm lens produced a series of pictures. This shot of The Queen with Princess Anne and The Queen Mother was taken as the horses passed the winning post in the 1971 Derby. It gained an award in the Royal section of the British Press Pictures of the Year contest.

zoom fitted, until I stopped using them for general picture-taking.

So if you are wondering whether to buy a zoom or a couple of prime lenses my advice is: go for the prime lenses. The definition will be better; you will probably have wider apertures; they will not be so heavy and bulky; and they are much quicker and better to use for action photography.

Uses of tele-extenders

I can't leave the subject of lenses without discussing the popular tele-extenders. These are fitted between the lens of an SLR and the body, and have the effect of magnifying the image two or three times. Thus with a 50mm lens and a 2× extender you have the effect of a 100mm lens. With a 200mm lens and a 3× extender you have the effect of a 600mm lens. But there are most definite disadvantages with the use of tele-extenders.

For a start they involve considerable light loss. For

instance when using a tele-extender giving a 2 × magnification there is a light loss of two stops. When you consider that you now have an effectively longer focal length lens, and therefore it is more difficult to handhold, requiring a higher shutter speed, the loss of these two stops of light is quite important. Add to this that the use of an extender means that the lens must be stopped down in order partially to correct the extra aberrations which the extender introduces and you have still more light loss.

Even if you are prepared to accept this, the definition of a picture taken when using a tele-extender is not so good as if the lens had been used without any extender, and then just part of the negative was given extra enlargement. This is a

You don't get too near a Lightning fighter when it takes off with full reheat, so I used a 400mm Novoflex on a Minolta.

A zoom lens can be useful when you cannot be sure how close you will be able to get to the subject. Contestants in the Cowes–Torquay–Cowes powerboat race. We flew alongside the boat to about 50 yards ahead of it, when my pilot banked steeply so that just for a moment I had a head-on shot.

fact that I have found with side-by-side tests. If you are shooting black and white you are far better off using slow, fine-grained film without an extender, than you are using an extender and faster film.

However these are the disadvantages. There are some definite advantages in having one of these inexpensive means of extending the focal length of your existing lenses. I have one myself which I keep for emergency use.

For a start, when using black and white film it is not always convenient to take out the film you have in your camera and reload with a slower film in order to be able to do big pull-ups at the enlarging stage. And if you are shooting colour transparencies, you possibly have little

opportunity to do selective enlargements, so an extender can be very useful in these circumstances.

So my conclusion about extenders is that they do have a definite use and it is worthwhile having one in your gadget bag as an emergency. But do always realise the limitations that they impose.

A famous long-focus lens

It isn't always necessary to get just the right factory-made lens for a particular picture. Very often you can make-do with modifying some ordinary piece of equipment to do a specialised job. For instance, back in the dark war days of

Another Derby shot of Princess Margaret taken with a 1000mm lens focused on the Royal Box. This relatively static long-range work could be handled by a tele-extender and a 200mm or 300mm lens

1942, a *Daily Express* photographer, Alan Allam, conceived the idea for a real scoop. He started working on a scheme to photograph the enemy-held coast of France from Dover, twenty-two miles away. Security between one newspaper and another was just as strict as national security. In newspapers, careless talk may not cost lives, but it can certainly cause one newspaper to scoop another. So Alan Allam started carrying out secret tests with various "long toms" in a deserted part of the country, well away from Dover.

The reason for this was that the landlord of the hotel where the press always stayed in Dover was a real dyed-in-the-wool intelligence agent for Fleet Street. As soon as

Alan Allam and Henry Bush setting up their Big Bertha lens in London before transporting it to Dover.

he heard of any unusual activities of a newspaper man in his area, he immediately telephoned the opposition that "something was on".

So Alan continued with his tests in complete secrecy. Unfortunately he found that even the longest of our telephotos didn't have the power to do the job. Walking rather despondently around the secondhand section of a photographic dealers one day he noticed an ancient Plaubel 9in cine lens for sale at just over two pounds. He remembered once reading that by changing round the elements in this particular lens, it's focal length could be altered. He decided to sport the small amount of money it cost (hoping he would get it back on his expenses) and bought the lens.

For many weeks he experimented with different combinations of the various elements, and eventually, somehow combined them to produce a lens, the focal length of which the manufacturers never dreamed of—ten feet no less! He

The occupied coast of France in 1943, pictured from Dover by the extraordinary, home-made 10ft focal length lens dreamed up by Daily Express photographer Alan Allam.

built the whole assembly into a housing which made the finished lens rather resemble an anti-aircraft gun.

Alan then enlisted the aid of another *Daily Express* photographer of the time, Henry Bush, and they loaded the whole contraption into a van and took it to Dover. They did not dare let it be seen by the landlord of the hotel where they were going to stay, or they would have had the opposition down to see what was going on before they could have said "Snapshot"! So they scouted around Dover until they found a farmhouse about four hundred yards from the cliff edge, and they arranged with the farmer to install their "Big Bertha" in his loft.

They carried out many experiments, trying out different plates and filters, and developing them in the loft, until they found the right combination: two minutes exposure using infra-red plates and, of course, an infra-red filter.

You can well imagine how excited they were when they held the wet plates to the light and looked at the first clear

FORTIFICATIONS

MEMORIAL TO DOVER PATROL

press pictures of the enemy coast for three years—it was now May 1943.

Leaving Big Bertha in the loft, Alan and Henry carefully wrapped the still wet plates and carried them furtively into their hotel room, where they put them in the bathroom to dry, having booked themselves in by phone an hour earlier. They then ordered drinks in their room and settled down to celebrate their success.

They hadn't been celebrating very long when the door burst open and in rushed Dixie Dean of the *Daily Mirror,* obviously having received a tip from the "intelligence centre" that two *Express* men were down on some secret job. Dixie did all he could to discover what was going on, while Alan and Henry literally sweated, in case he went to the bathroom and saw the negatives drying. However Dixie eventually went out and the scoop was safe.

You might wonder what harm there would have been in letting Dixie know what they had done, as he could not possibly get a picture as good as theirs without special equipment. The point is that is that he could have got a picture of *some* sort of the enemy coast, but by no means as clear and detailed as theirs. However, although it would have been very inferior, it would still have taken the edge off the *Daily Express* scoop. The eventual picture which Alan and Henry had published went right across the whole of the *Daily Express* page. It showed nine miles of the coast of France north of Boulogne, and in it, fortifications, trenches and the village of Wissant can be seen. It consists of five separate photographs put together as a join-up.

4

Practical Exposure Metering

There are basically two types of exposure meter: the separate handheld one; and the built-in through-the-lens metering system which is fitted to most SLR cameras these days.

Of the different types of handheld meters, undoubtedly the Weston is the most famous, having given reliable service to hundreds of thousands of photographers for many years. However it relies on a selenium cell which, although giving very accurate readings, is not particularly sensitive when compared with the cadmium sulphide cell type (CdS for short) which was introduced later. The Lunasix CdS meter, for example, is so sensitive that it is able to indicate an exposure by moonlight, something which is far beyond the capabilities of any selenium cell meter.

The CdS cell does have one disadvantage, however. Its spectral response (by which we mean its sensitivity to different colours of light) is not the same as the spectral response of the films we use. It is, in fact, more sensitive to the red end of the spectrum than to the blue end. The result is that it tends to cause under-exposure when readings are taken in warm artificial light, unless compensation is made. Built-in filters on the meter largely correct for this, but it is still not quite such an accurate method of exposure assessment as the old fashioned selenium cells. Nevertheless, much research has been going on to bring the spectral response into line with that of modern film emulsions, so that for all practical purposes the difference can be ignored.

Most through-the-lens (TTL) meters use CdS cells, and a common bit of advertising blurb is that they "automatically take into account any filter which is fitted over the lens". That is simply not true. If you put a red filter in front of the lens of a camera with a through-the-lens metering system, and work exactly according to the indications of that system, you will find that you get an under exposed negative. It is that old question of spectral response. Depending on the individual metering system, you might find it necessary to open up one or two stops more than the exposure indicated by the TTL system when using orange or red filters.

Through-the-lens meters

There are many different types of TTL metering systems, variously described as fully integrated, centre weighting,

bottom weighting, contrast light compensating, and spot metering. My experience has been that they all work well, and in at least ninety per cent of the cases can be followed without adjustments being made to give perfectly exposed pictures. The systems with a very narrow acceptance angle, such as that on a Leicaflex, do need more skill on the part of the photographer, because he must carefully select the right part of his subject to meter. Preferably he should choose a mid tone. It's no good just pointing the camera at a general scene and taking the reading indicated. The spot that affects the meter could be a patch of bright sky, which would result in the whole picture being under-exposed. This type of restricted-angle metering is extremely useful to a skilled photographer, but it does need care and experience to get the best out of it.

I mentioned that the vast majority of subjects will be correctly exposed when the meter indication is followed exactly. But there are certain subjects where a little juggling is required to get the correct exposure. For example, if you shoot into the light, or if your subject is in front of a very brightly lit background, a meter with a fairly wide acceptance angle takes more notice of the background than your subject. It will say to itself "Ha! there's a lot of light here so I'll cut down the exposure required". The result is under-exposure of your subject. Remedy: open up a couple of stops in these situations.

Conversely, if your subject is against a mainly dark background, for example a performer spot-lit on the stage, the meter is not sufficiently influenced by the small bright area occupied by the subject, and causes over exposure if its indications are followed blindly. The remedy, of course, is to reduce the indicated exposure slightly.

Even if you have a meter with a sufficiently narrow acceptance angle to measure only your subject, it is still capable of giving a false indication. Remember that the meter is always calibrated to give a mid tone to anything it is pointed at. So if you aim it at a snow scene, it tries to reproduce all that white snow as grey. Result: under exposure. Remedy: open up two or three stops when metering large light expanses. The converse applies when you are shooting very darkly coloured subjects. If all this sounds complicated, don't worry overmuch. Remember, as I have already said, the vast

majority of pictures will be right without any adjustment to the indicated exposure.

Working without a meter

A point worth bearing in mind with regard to all exposure meters, whether they are through-the-lens or separate handheld ones, is that if you use too much you become completely dependent upon them, and your judgment of exposure vanishes completely. This means that you can waste time while taking a meter reading, and in consequence miss a good picture. I'm not decrying the use of meters, but I prefer to use them for difficult lighting situations, or perhaps I should say, uncommon lighting

Not an easy subject for an exposure meter. Scottish singer Lulu on a film set apparently lit by candles. The set lighting is, of course, helping and the exposure had to be kept short to retain the candlelight effect.

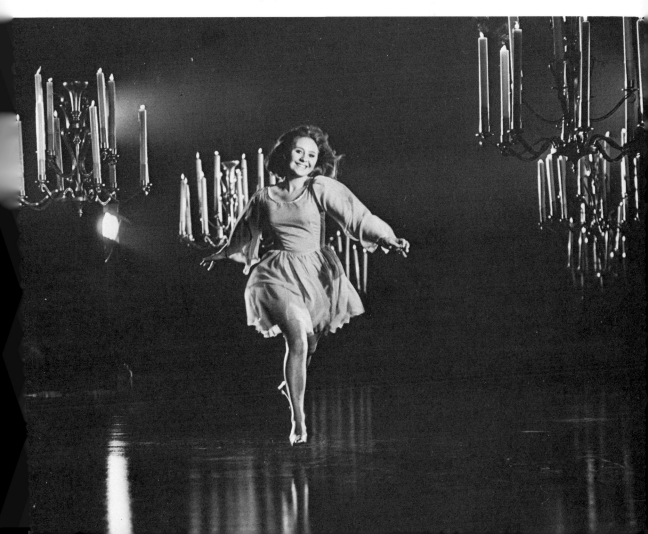

situations. For all normal subjects I think it is a good idea if you try to get into the habit of judging exposure.

This isn't as difficult as it seems, even if you are using colour. With black and white it is simple, as the extra latitude of these films will often cover any errors you make in your estimation. Correct exposure is important, but it is not as important as capturing the right moment to make a great picture. It is no good having a perfectly exposed shot which has just missed the peak moment. Better to capture that moment, although the exposure might be slightly off.

The way I trained myself to judge exposures was to take some common lighting situations and memorise a set exposure for these situations, always using the same type of film. In my case it was one of the fast films, rated at 400 ASA. Thus I know that if I am shooting in bright sunlight, my exposure will be 1/500 sec at *f*16 for distant shots. But for the close-ups, where there are deep shadows in which I might require detail, I will open up a couple of stops and make my exposure *f*8. I use this same exposure (1/500 sec at *f*8) for bright overcast skies, while for what we generally term "a bit on the dull side" I use 1/100 sec at *f*11. Interiors with light coming through the windows usually enable me to use 1/60 sec at *f*2.8.

So if you memorise correct exposure for the particular film you are using for distant subjects in bright sunlight; bright sunlight but a subject with harsh shadows; bright overcast; dullish overcast; and interiors with daylight coming through the windows; you will have all the exposures necessary for the vast majority of your shooting. Of course, if you have the time, and you are not shooting an action picture, by all means take a meter reading. And always use your meter when the lighting is tricky, or outside the conditions which you have memorised.

If you're in the habit of using films of different speeds, there is one tip which might be helpful to you in assessing exposure. By a coincidence, it so happens that the correct exposure in optimum lighting conditions (bright sunshine with no harsh shadows) happens to be a shutter speed which is the reciprocal of the film speed expressed as a fraction of a second, and an aperture of *f*16. Before you shudder at the thought of apparently complex mathematics, let me put it in simple language. If you are using 400 ASA in

With heavy backlighting, a straight exposure-meter reading might give you something like this. You would have to give two or three stops more for detail in the subject. I had actually rejected this particular negative but a photo-technician at the *Daily Express* saw its possibilities. It was used over half a page in the *Express* and also won prizes.

optimum conditions (say shooting pictures on the beach or a brightly lit view), your exposure would be 1/400 sec at *f* 16. If you were shooting on a slow colour film with a speed of 25 ASA then your exposure would be 1/25 sec at *f* 16. A medium speed film such as Plus X which is 125 ASA would require 1/125 sec at *f* 16.

You will not want to work at *f* 16 on all occasions, but having got the basic exposure right you can vary the aperture and shutter speed and still keep the same exposure. Thus, 1/125 sec at *f* 16 is the same as 1/250 sec at *f* 11 or 1/500 sec at *f* 8. The rule is that for each stop you alter the aperture then you must either double or halve the shutter speed.

You can carry this system a little further. Knowing the correct exposure for optimum lighting conditions, with a little experience you will be able to judge when the light is nearly optimum, in other words about one stop difference. Thus you can take your reciprocal of the film speed and say the exposure will be this at *f* 11. If the conditions are a little

Sir Francis Chichester returns to Plymouth after his round-the-world trip. The type of subject where you can easily persuade yourself that there is more light than there really is. The meter is affected by the large reflecting areas.

duller it will be this at ƒ8 and so on. This is a little dodge which I often use as a method of assessing correct exposure, and it is sufficiently accurate, even for colour transparencies.

I have indicated that exposure meters should be used with intelligence. You should also not try to make them produce more light than there is. You think I am joking? Well I was amused to watch the procedure adopted by a professional cameraman who was taking a reading on his Weston meter some time ago. The light was very dull, and he was quite correctly pointing his meter slightly downwards, so as not to include the sky. But he was obviously unhappy about the long exposure indicated. He therefore gave the unfortunate meter a couple of sharp taps, but the needle obstinately indicated the same amount of light. So then he pointed his meter up at the sky. A look of satisfaction passed over his face as he saw the now highly optimistic reading, and he set his shutter and aperture to whatever it was the reading showed.

Although this is rather laughable, the procedure of trying to deceive oneself is not all that uncommon. Indeed, I myself have been guilty of it. At football matches in the depth of winter, when the light is virtually non-existent and yet 1/500 sec is called for, I used to find myself pointing my meter more and more towards the sky in an effort to get a better

reading before I realised what I was doing and forced myself to take a true reading.

Incident-light metering

All the meters I have mentioned so far have been of the reflected light type. In other words, they measure the amount of light being reflected from the subject. But there is another type of exposure measurement that is worth knowing about, although it generally applies only to separate handheld meters. It is known as the incident light method, and is often to be preferred, especially when using colour reversal film.

With this method you don't measure the amount of light

The type of aerial shot that depends on the skill of the pilot. He has to judge his speed so that he is in line with both powerboats and liner at exactly the right moment. Exposure has to be carefully judged, too, but this is where experience of the conditions soon teaches you the correct settings.

being reflected from the subject, but you hold the meter in the subject's position and measure the amount of light falling on the subject. A specially shaped piece of translucent material is fitted over the front of the exposure meter and it is then held near the subject and generally pointed at the camera's position. The reading it gives indicates the amount of light that is falling on the subject, and it is so calibrated by the meter manufacturer, that none of the highlights will be over-exposed. Which is why it is so valuable for reversal transparency work, where over-exposure is totally disastrous.

But with this method, again some adjustment is necessary according to the subject. Certainly it will give you correct exposure of the highlights, but if there are some dark shadow areas, and the range of tones which are acceptable by the film you are using are insufficient to cover both highlights and the dark areas, then your dark shadows will be under exposed. Therefore in cases like this it might be necessary to open up one, or perhaps two, stops more than the exposure indicated by the meter.

5

Using Flash

Except for the small flash bulbs and flash cubes used on snapshot type cameras, almost everyone who uses flash these days has an electronic unit.

When they first came out, electronic flashes were very heavy, bulky and expensive. They were also extremely dangerous on occasions. I well remember one big unit I had (it was actually the first electronic flash I ever owned) which I switched on after I had been out in the rain and it had got wet. It delivered to me one of the biggest electric shocks I have ever had, and quite literally burned the skin from my fingers where I had been touching it.

Small modern flash units of reputable manufacture are absolutely safe, provided you do not tamper with the "works", and many are so small that they can be carried in the top pocket of a jacket. The price has come down dramatically, too, so that some of the less powerful units can be bought for little more than the cost of a bulb flash unit.

Of course modern flash bulbs are extremely reliable but just occasionally one does get a bulb which malfunctions, and it can be quite embarrassing for the photographer concerned. I remember once when a member of the Shakespeare Company at Stratford was being married. At the reception were all the notables of the theatre world, including Lord Olivier, and the moment for cutting the cake had arrived. There were about a dozen press photographers present, all using electronic flash, except for one who preferred bulbs.

As the knife sank ceremoniously into the cake, all the flashes fired, except for the bulb, which picked that moment, literally to explode. But instead of shattering, its glass envelope broke away from the brass cap and shot with great force right into the middle of the wedding cake, where it embedded itself in the icing and remained as an additional decoration!

I myself once had an embarrassing experience with bulbs back in the days when I was working as a freelance. I had been assigned by the *Daily Sketch* to photograph the personalities attending a reception at the Royal Opera House, and I was using my MPP Micropress camera, Kobold flash gun, and big PF38 bulbs. These were rather cumbersome, but they gave a good light output.

I had posed Margot Fonteyn (this was my very first

meeting with her) and a beautiful dancer, Violetta Elvin. I focused on two yards, moved into this distance, and pressed the shutter release.

The big PF38 shattered with what seemed a colossal explosion, and my two subjects, resplendent in shimmering evening dresses, were showered with bits of glass. I didn't know where to hide my face until Margot Fonteyn, still in the act of picking glass out of her hair, looked up and, without the slightest tremor in her voice, asked "Would you care to take that picture again?" I think that was the moment when I became a fervent fan of hers.

I should emphasise, however, that these two incidents are completely isolated. Bulb malfunctioning is so rare that the majority of photographers will go through their life without ever having a bulb explode.

The great advantage of electronic units is that the flash duration is very fast (usually about 1/1000 sec) and is thus able to stop high-speed action. The colour temperature is also similar to that of daylight, so that it can be used with daylight colour film without any correction filters being needed. However, in this respect I have found that just a touch of warm filtration is helpful when using electronic flash and colour film. This is possibly a personal idiosyncrasy, but I prefer the warmer look which a CC10R filter gives.

Exposure without guide numbers

So far as exposure is concerned, it is surprising how many people are slightly frightened about it. They are timid about the apparent complications of getting the correct exposure. I think a lot of the trouble stems from all those instructions about "guide numbers", and I well remember hearing an experienced photographer at a club giving some hints on flash work to a beginner. "First look on the back of the packet of flash bulbs" he said "and you will find the table of guide numbers. Look along the top of the table until you find the speed of the film you are using, and then go down this column until you are level with the shutter speed you want. Where these two intersect you will find two figures, one in red and one in black, ignore the red as this is in metres but remember the black one, as this is your guide number.

"Next divide the distance in feet you are from your subject into this guide number, and the answer will give you the aperture you should set your camera at for a normal subject in an average room. Of course this might have to be varied if you are in a very large room or your subject is particularly dark."

Well, as you can imagine, by the time the poor beginner has gone all through this he is just about ready to give up all thoughts of flash. I strongly advise that you use flash in the same way as press photographers, most of whom wouldn't know a guide number if it popped up in front of them in top-hat and tails.

Always stick to the same flash, whether it be bulb or electronic. And, except for very special reasons, always use the same shutter speed. If you are like me, and want to make picture-taking as effortless as possible, you will always be using the same type and speed of film. So you have now standardised your working as much as possible, and the only variable left is the distance your flash is from your subject.

For the actual setting of the camera aperture, I suggest you forget all about guide numbers and remember just three basic settings. They will, of course, vary with different types and speeds of films but you can find them out by trial and error for just the expenditure of one film. I consider this test to be a good investment for the future.

The distances worth remembering are: those for close-ups at around 6 ft; full length pictures taken at about 10 ft; and groups of people taken at about 15 ft.

Photograph somebody at each of these distances using a variety of apertures. It is essential that you note these down at the time you are making your tests. Then when you examine your film you will see which aperture gave you the best result. In future you can forget all about guide numbers and stick to that aperture when you are working at around that particular distance.

So all you have to remember are three apertures. These settings will not give you perfect exposures every time, but modern films, particularly those designed for giving prints, possess enormous latitude, and your exposure can be way out and yet you will still get an acceptable print. And while someone else is carefully working out his flash factor you will have your picture in the bag.

A single flash beside the camera gave ample illumination for an early freelance picture of Folies Bergere girls pushing over a pile of coins saved for charity in my local Greenwich pub. The picture appeared in the local paper and two of London's evening papers.

As I said, different films will require different settings, but the important thing is to have just three in your mind and stick to them. Later on, when you have more experience, you can make slight variations for more accurate exposure. But in the meantime you will not be missing any pictures. And this is a particularly valuable technique for candid shots, such as you will take at a party. Make a test first to find your three basics, and then away you go.

There are many electronic flash units on the market incorporating a sensing device which gives the correct flash exposure automatically. All that is necessary is to set a predetermined aperture, according to the sensitivity of the film you have loaded into your camera, and then the flash will give just the right amount of light without any adjustment by the user and at whatever distance the flash is from the subject. This is achieved by a narrow acceptance angle sensor which measures the amount of light falling on the subject as soon as the flash commences operation. Obviously the further away the subject is, the less light will be on it.

The sensor measures this and then cuts off the flash just at the moment enough light has fallen on the subject to give correct exposure. When you consider that this device is able to measure the light which is on the subject and then to cut it off a mere 1/40 000 sec later (when the subject is very close indeed to the flash), you will appreciate the intricate and clever circuitry which is in these units.

Methods of use

There are three basic ways of shooting pictures by flash: conventional with flash mounted on camera; bounce flash; and multiple flash. Each method has particular advantages—and disadvantages.

For instance, although flash-on-camera usually gives the most uninteresting type of lighting, it is unbeatable for working in crowded locations, such as at parties, or where pressmen are concerned, on fast moving or unexpected subjects.

A single flash, operated some distance away from the camera, gives more interesting lighting. Even held just at arms length it is an improvement on camera-mounted flash. It is also the method adopted for working in smoky atmospheres, where flash-on-camera can give a flat, fogged look to pictures. But it can also result in harsh shadows and excessive contrast.

Bounce flash has become much favoured by press photographers, and although I use it sometimes I have never really *liked* the results it gives. It is really more a matter of convenience in that it is the easiest way to get a fairly natural "unflash like" look to pictures. But I have always felt that bounce shots seem to have a flat and uninteresting look. I know it is supposed to be good for portraiture, giving soft outlines, but here I really prefer a more definite type of lighting, such as is provided by using more than one flash unit.

Incidentally, I must say that I have never agreed with the frequently given advice that when one uses bounce flash it is necessary only to open up one stop more than with direct flash. Depending on the size of the room and the colour of the surface from which the flash is to be bounced, I have always found that at least two extra stops are required, often three, and on occasions I've had my lens wide open.

And don't forget that the ceiling isn't the only place from

which you can bounce flash. Walls, floor, even nearby people's faces all make suitable surfaces. But don't do what I once did while shooting the cutting of the cake at a film-star's wedding reception.

I was one of a bunch of photographers, and I intended bouncing my flash from the wall behind me. Without my noticing it the group of us moved round, and I was happily shooting away with my flash pointing out of an open window which was then behind me! But Dame Fortune was kind to me that day. My shutter picked up the light from two other photographers' flashes to give me a most interestingly lit picture. I've always said that one of the most important qualities a pressman should have is that he should be lucky, and I was certainly lucky that day.

Lord Snowdon and Princess Margaret with their first baby. A typical car shot, the aim being to get camera and flash as close as possible to the window so that the picture appears to have been taken from inside the car.

Multiple flash techniques

Multiple flash (firing one or more flashes simultaneously) is just a little bit tricky, in that only experience can tell you what sort of effect you will get in your final picture. So if you want to try your hand at this sort of lighting don't sit down studying books on the subject; but play around with a couple of lights, take plenty of pictures and see the sort of results you get. This is better than assimilating all the theory—you will learn more from one roll of film than twenty articles can teach you.

When you come to use more than one flash, especially if you are shooting colour where exposure is critical, it is worth considering a flash meter. These resemble conventional exposure meters and are put in the subject's position, where they measure the amount of light from the flash and indicate the correct aperture. An ordinary exposure meter cannot be used for flash, and you have to buy one specially designed for this purpose. These range in price from about £40 to £200, and all the ones I have used work perfectly. The difference in price appears to be in portability and convenience of use. Of course you don't *have* to use a flash meter when lighting by multiple flash. The correct aperture can be calculated mathematically, but you should beware of taking the advice of the technical experts in this respect.

I remember once reading such an expert advising (and here I quote): "The simplest method of calculating the exposures for two flash bulbs is by taking the square root of the sum of the squares of each calculated *f*-number."

If anything was calculated to scare the pants off a beginner who was contemplating playing with two flashes, that is. In fact, never mind the beginner, it makes me wonder how I would ever manage two flashes with any success without taking a slide rule about with me.

Other advice which I have read, and which is rather simpler, is that you should add the two calculated *f*-numbers together, and multiply by 0.7. Or even easier, add the two *f*-numbers and then take three-quarters of the total. But even this I find unnecessarily complicated, particularly for those of us who left school many years ago and would like a pencil and paper to work out what three-quarters of anything comes to.

The same expert I referred to just now also said "If the

A carefully-set-up picture that has to put across a point. Flash was necessary to bring out the details. I had kept the "Dogs must be carried" sign in mind for an incongruous picture. When Cruft's dog show came round, I sought out a pretty girl taking a giant mastiff along, and there was my picture.

calculated apertures differ by two (or more) stops, the resulting aperture is the same as the smaller one (the resultant apertures corresponding to calculated apertures differing by half to one and a half stops are evident too)."

This isn't photography, the making of pictures. It's mathematical gobbledy-gook, and though it might be of absorbing interest to some people, it is entirely unnecessary for successful picture taking.

So what is the answer? I suggest that those who want to take pictures without using a slide rule do what poor ignorant Blackman does. When using two flashes and one is extra bright or much closer than the other to the subject,

completely ignore the weaker one and work at whatever aperture will be about right for the stronger or closer one. If they are about the same power and distance from the subject I still assess the aperture for just one of them and then close down one more stop.

Three flashes? Well the third one is almost certainly for lighting the background, or giving a backlighting effect, so I totally ignore it.

I know this is all highly inaccurate, against correct theory, and apparently slapdash. *But it works!* Of course I am relying on the fantastic latitude allowed by modern film emulsions. But that is exactly what the manufacturers spent millions of pounds on research for, so why not make use of it? Again I say, the less you have to fiddle and calculate, the more time you will have to concentrate on your subject. And that way lies success.

6

Films and Processing

Colour is a subject on its own, and this I will deal with in a completely separate section. So the films we are going to talk about here are entirely monochrome.

There are two distinct and separate schools of thought on the use of different types of film. One body of opinion feels that the right type of film should be selected according to the subject being photographed. Thus, if you are photographing action on a dull day, you should choose one of the high-speed (very sensitive to light) films. But if you were shooting a pictorial scene in bright sunlight, you would use one of the fine grain emulsions. And for general use, this school of thought advocates having a medium speed film loaded in the camera.

Stick to one film type

The other idea, and the one to which I subscribe, is that, except on special occasions, you should always stick to the same emulsion. I believe that this gives you a much better chance of success, because you will get to know that emulsion so well that you will be able to judge exposure easily and accurately. You will know how far it can be "pushed" in the developer, and you will be able to predict just the sort of results you will be able to get with it under varying conditions.

My personal favourite is Tri-X, which is rated by the manufacturers at 400 ASA. I use this film in all sorts of conditions, ranging from poorly lit interiors to bright sunshine shots. I find that I can get 15 × 12in and even 20 × 16in enlargements which are entirely satisfactory to me from a grain and resolution point of view.

Why Tri-X, and not one of the fast emulsions from another manufacturer?

Frankly I didn't carry out any scientific tests in order to decide on Tri-X. I simply said to myself that if ninety per cent of the world's photojournalists use this film, then why ask for trouble by using another? Perhaps not a very valid reason, but it has worked out in my case. However this does not mean that other makes of film are in any way inferior. If they were, then Kodak's would be the only film which is sold, and we know that this isn't true.

I am not suggesting that you should use the same film as myself. Tri-X just happens to be a sort of film that suits me,

and the sort of subject I take. For you, another type or another make of film might be better. Modern films are of such good quality that you can't go far wrong with any of them. So I suggest that you try out several of them until you find one that suits you. If the one that you have chosen as your basic film happens to be one of the fast emulsions, I would suggest that you also sort out a slower one for those special occasions when you do need a finer grain. After this you should never stray from the two films chosen: the fast and the medium speed. Once you start chopping and changing films, you will never know where you are as regards exposure, or the sort of results you are going to get.

In general it has been my experience that the fast films are easier to handle and have more latitude, both in exposure and development, than the slower ones. You can take dreadful liberties with one of the fast films, but if you treat a slow film, such as Panatomic X or Pan-F, in the same way, you will get quite unacceptable results.

With the very slow, ultra fine-grain films, development is particularly critical, and if you over-develop, the negative can easily become unprintable through being too contrasty. Faster films have much more latitude and can stand abuse at the developing stage with less painful results. This doesn't mean that I am advocating sloppy processing techniques, but none of us is perfect. It is also true that if you have under-exposed and want to "push" a film by giving it much longer development than normal, then a faster film will stand up to this much better than a slower one.

Advantages of large format

Ignoring the Instamatics, which are really aimed only at the family snapshotter and not at the serious amateur, you have only two film sizes to consider: 35mm or 120. I have already discussed the advantages of 35mm, but it is worth bearing in mind that the larger format does have one advantage over the small gauge.

Certainly with modern materials and equipment it is possible to produce prints from 35mm which are virtually indistinguishable in quality from those taken with a larger format. But, and this is a most important "but", you can achieve top quality by using a larger format, with far less trouble and a more carefree technique. The mistakes, which

on 35mm would cause a significant loss in quality, will still allow you to get good results in the larger format. Scratches and dust are not so much of a problem. Nor is grain, so your exposure need not be so critically accurate.

In other words, by using a larger format, you can produce the same quality as a 35mm expert technician, but with a lot less effort and trouble.

One film, one developer

In photography, there are so many variables—such as the type of lighting, the subject, film type, shutter speed, aperture—any of which can spoil our final picture. So wherever possible we should standardise a procedure so as to minimise the risk of failure.

Film processing is one important part of phototechnique where we can, and should, standardise. For it is here that the negative is produced, and if this is spoiled, nothing in the world can make it right again. Certainly there are treatments which can improve a spoiled negative, but nothing is as good as one that has been processed properly.

So make this a firm rule: get a method of processing your film which you can follow every time in exactly the same way. Always have your temperatures the same, and always use the same developer. You may like to keep one other speed-increasing developer up your sleeve for emergencies, when you know you have under exposed and wish to gain some increase in speed, but two developers are quite enough for anyone to get to know thoroughly.

Remember I suggest that you stick to one film with perhaps just one other for special purposes. Well the same applies to developers. Get to know one developer inside-out and the way it affects the film you have chosen, *and then stick to it*. If you are constantly being taken in by the blandishments of advertisers who claim to have produced some new miracle brew, you are going to be constantly disappointed. In all the years I have been practising photography I have never yet encountered a miracle developer. My experience in every case has been that, if you gain in one direction, you lose in another.

For instance, there are several developers which give a speed increase and enable you to rate, say a 400 ASA film at 800 ASA. But you don't get this increase in speed for

76

Dr Fisher, Archbishop of Canterbury, in the wilderness of Judea. A subject with a long tonal range such as this demands that you know exactly how your film and developer will react to a given exposure.

nothing. You will always get either increased granularity or some other loss of quality. You get nothing for nothing in this world.

Many, many years ago, I standardised on the old fashioned D76. This is made by Kodak, though there are other versions with different names, but which are identical and are made by other manufacturers. ID 11 from Ilford for instance is identical to D76.

Testing the wonder brews

I have carried out careful practical tests with just about every "wonder developer" which has appeared on the market, but I have never yet found one that will give me better results than D76 without a loss in some other direction. There are ultra fine grain developers which give a finer grain than D76, but they involve some speed loss in the film. There are also speed increasing developers, but they cause an increase in apparent grain. For this reason I settled on D76 as my standard developer, and whenever I need a

speed-increasing developer I use Microphen, which I reckon to give me one stop extra speed. So far as I have been able to discover, fantastic claims about developers which enable you to expose Tri-X at a speed rating of 1600 ASA, or even more, without loss of quality, are just so much boloney. A side-by-side test will always show that you have not gained any increase in speed without a significant loss somewhere else.

And of course, there are many photographers who unwittingly deceive themselves about the speed of a film with which they are working. They will point their meter at a subject with the film-speed setting on the meter at say, 3200 ASA, shoot a picture at the indicated setting, and then claim that they are successfully uprating to this high speed. What they fail to take into account is that although they might have pictures which are recognisable and which might indeed be quite effective, they have not actually increased the speed of the film, because there is probably no shadow detail whatsoever in their pictures. You can certainly upgrade the speed rating of your film for special effects, but this is not a genuine increase in speed. Quite frankly, I doubt very much whether there is any developer which will give more than a genuine one stop increase, and there will still be loss of quality to be taken into account.

I have always thought it strange that such tremendous progress should have been made with emulsions and equipment, but so little with developers. In an effort to find if I was being really fair, or whether I was being predjudiced against some of the more recently produced developers, I once carried out some tests on several of them. These were to see which ones would give me an increased speed, and also to see how they compared with each other for grain.

First I exposed several rolls of Tri-X from the same batch, and HP4 also from the same batch, at ratings of 2400 ASA and 1600 ASA respectively on various subjects with controlled lighting.

I knew this would give under-exposure, but this was what I wanted, as it is only when working at the absolute limits that slight differences in density can be spotted easily. Next I processed the films in various developers at the times listed below. Photopress and DN13 may not be familiar to amateurs. The first is a rapid acting but soft working

developer, marketed in powder form by Johnsons. The second, a Kodak long-life brew, much used by the D & P trade.

Developer	Developing Time Tri-X (min)	Developing Time HP4 (min)
Acufine	7	7
D76	11	13
Diafine	5 + 5	5 + 5
DN13	7	7
Microphen	15	15
Photopress	$2\frac{1}{2}$	

There was no doubt whatsoever which developer achieved the utmost speed out of both Tri-X and HP4. Head-and-shoulders above the rest, and giving much greater density in the highlights with far more detail in the shadows, was Johnsons Photopress. The developer which gave the least dense highlights and the least shadow detail was the wonder-brew of the time, Diafine!

I was so astonished at these results, having myself been partially taken in by the glowing advertisements and accounts of Diafine in the American press, that I carried out the whole test again; but the results were exactly the same, both with roll and 35mm film. The order of merit where speed alone was concerned was (1) Photopress (2) Microphen (3) Acufine; D76 and DN13, all equal (4) Diafine. But, as I said, Photopress was way out ahead of the rest. However it also produced the most objectionable grain, which I checked by making 40 diameter enlargements. The finest grain was given by D76 (remember Ilford's ID11 is the same developer). Diafine and Microphen were next best, followed by DN13 and Acufine, with Photopress at the bottom, giving by far the most grain.

But—let's be honest—apart from D76 giving distinctly finer grain, and Photopress much coarser, there was not a lot to choose between any of the developers where grain was concerned.

Although this was not a scientifically controlled laboratory test, it was a strictly practical one, and I feel was all the more valuable for that. I have sometimes been labelled a cynic, but if I am, my cynicism is born of seeing the results of tests like this on so-called wonder products.

Suiting technique to circumstances

I have had to learn two distinct techniques of development, as our method of processing at the *Daily Express* is not one that I am able to follow at home. At the *Express* we have D76 in deep tanks, in which the films are suspended without agitation. The developer is kept at a constant temperature of 21°C, and over the years I have learned to give just the right amount of development for a particular lighting situation. For instance, if I have been photographing a very flatly lit subject, or one that was shrouded in mist, I will probably deliberately under. expose by up to a couple of stops, and then give half as much development again as I would do for a normal subject. And if I have been photographing somebody in bright contrasty sunshine I will give extra exposure and then reduce development by about a third.

Back at home, of course, I do not have deep tanks, so my method here is to use a Rondinax daylight loading tank. This uses very little solution so I can afford to throw away the developer after each film has been processed in it. It also requires constant agitation so this is another variable which is cut out. Intermittent agitation is all very well, but the trouble is that it is difficult to make the agitation identica for each film you develop, and this can cause spoiled film: on occasions. If your agitation is constant throughou development, it will always be the same for every film you process.

I suggest that you find a fairly neutral form of develope such as D76, Unitol or Microdol-X and then get to know thoroughly by using it constantly for all your films, for a least six months. When you know it inside out and ever effect it can produce, then you might try out one of th speed increasing developers which you can keep in reserv for special occasions. But do keep your temperatures exact the same each time you process, and do not have too muc difference in the temperature of your other solutions.

At the *Express*, our films do not get much of a wasi because the pictures are usually required very quickl However it is surprising that the negatives seem to last fe many years after receiving only a couple of minut washing. But for real permanence you do need to give least half-an-hour's wash. Or so the theorists tell me. And this, they are probably right.

Some photographers do not believe in squeegeeing their films after the final wash because they feel that this can cause scratches. However I do like to get mine dry as quickly as possible because, against this slight possibility of scratches, there is the danger that a film is most vulnerable to dust while it is wet or damp. So my procedure is to squeegee the film down after its final wash with a piece of damp chamois leather. This is so effective that the film is pretty nearly dry after just one squeegeeing. And as I keep the chamois in a plastic bag, no dust gets to it, and I have never yet scratched a film. There are tongs with rubber blades or sponges attached to them which can be used for squeegeeing, but I have not found these so successful as the simple chamois leather.

Some of you reading this may be tempted to skip doing the film processing yourselves, and pop your films into the local chemist. Please, *please* don't! The local chemist will probably take your film and send it through to a factory-type lab, where it will be processed along with thousands of other films, all of different types, and the result could be disastrous. It simply isn't worth it. Far better to do your own processing where you can control everything, and where you know that the job is being done right.

If for some reason you cannot possibly do your own processing, then find a reliable lab advertised in one of the photo magazines which will individually develop your film in a good developer such as Microdol-X. It really is most important that your film processing should be right, because all the effort you have put into setting up or securing a picture can come to nought if your film processing is wrong. It's no good getting exposure, aperture and subject right, if you are going to mess up the results (or get them messed up for you) at the processing stage. Printing is not so important (by this I don't mean that any old print will do) because if a print is wrong it can be done again. But you cannot reprocess your film. Once this has been done you are stuck with the result. So do get it right.

Storing the negatives

If you keep your negatives in heaps, or coiled up in rolls and then stuck into tins, you must expect scratches, dust and all sorts of other horrible effects to appear when you make

prints from them in the future. Also, if you are haphazard about your storage of negatives, it's very difficult to find one you want at some time in the future. Where my own personal negatives are concerned I keep them all neatly cut up into lengths of six exposures in a file-book especially made for the purpose.

Opposite each set of negatives is a contact sheet, so that I can see at a glance the subject on the negatives. And at the start of the book is listed all the subjects which are contained inside. I do not have an elaborate filing or cross index system, but with this simple method I can quickly find any negative I have taken when I have an approximate date for it.

If you are pulling out negatives to print, and find that there is a scratch on them, there are special "scratch-filler" solutions which can be used to minimise the effect of scratches. They are rubbed into the negative and fill in the space occupied by the scratch. But if you don't want to bother about such solutions, one way of minimising them was told to me by an old professional photo-technician. He simply rubbed the outside of his nose with his finger, so picking up the "nose grease", and then rubbed this into the negative. This really does work, and cuts down the effect of scratches on the negative.

7

Your
Camera and
You

So far in this book we have concentrated on technicalities, equipment, materials and so on. Certainly it is essential to know about these things, but it is vital that you don't allow them to become an end in themselves. Too many photographers take too much notice of equipment, yearning to possess the latest gimmick-laden camera which they imagine will, in some miraculous way, produce pictures that will be the admiration of everyone else. In the event, it has been my experience that this type of man takes very few pictures. And the ones he does take are not usually worth looking at. To him, equipment is a form of male jewellery, to be hung round the neck and displayed for all to see and admire. He simply *must* have the very latest and most expensive camera, regardless of whether it is the most suitable for his needs.

Using the right camera

I have a friend who owns both a Ferrari and a Rolls-Royce. He also has his own aeroplane and a yacht in the Mediterranean. You know the type? Well, he told me that he wanted to get a new camera, and what would I advise as being the best. Obviously expense was no object. I asked him what sort of photography he thought of doing. Did he intend making it into a hobby, and so wanted a camera on which he could base a system? No, he just wanted one for taking colour pictures of friends and places he visited. But he did want the very best, and was prepared to pay for it.

Few would deny that the Leica is probably one of the best 35mm cameras ever made—it is also one of the most expensive—but I told my friend that I wouldn't suggest the Leica as I thought he would get far better results from a good, but simple and fairly inexpensive, auto-exposure camera. I recommended one that I had used myself with considerable success, and which cost but a small fraction of what you would pay for a Leica.

Totally ignoring my advice, he bought himself a Leicaflex, complete with a 50mm *f*1.4 lens. And obviously having been recognised by a not particularly scrupulous salesman as a potential mug, he had also bought a 28mm and a 135mm lens. An excellent outfit. But just for taking snapshots of friends it was ridiculous. And on top of that, the metering system of the Leicaflex, although excellent for the

knowledgable photographer, does require experience and photographic know-how to use it properly.

When he showed it to me I commented that it certainly was a beautiful outfit. But I told him that I didn't understand why, in the running of his business, he would almost always take the advice of his stockbroker or other experts whom he employed, but in the choice of a camera he had totally ignored my suggestion. He said "Well frankly, old boy, you were probably dead right from a 'value for money' point of view. But I just felt it would look all wrong for me to be seen with a cheap camera round my neck. People might even start to think the companies aren't doing so well, and the shares could take a knocking!"

See what I mean about male jewellery? Anyway, I met him a month or so later, after he had spent a holiday cruising round the Med. I asked him what his pictures were like.

"Not so good" he told me. "In fact, I think there's something wrong with the camera. The shots are definitely not as sharp as they should be, and that damned exposure system is hopeless. My pictures are all over the place, some too dark and the others too light. And what really annoys me is that those blighters at Leitz told me there was nothing wrong with the camera. I can tell you, I told them a thing or two. If I buy the best camera in the world I expect the best pictures. So I'm selling it and I'm going to get a Nikon or a Minolta outfit, as I've noticed a lot of professionals use them."

I thought it was time to tell him a few home truths. Even at the risk of losing a rich friend.

"Look" I said. "I have both a Leica outfit and a Minolta. use them all the time for my pro work. But when I went on holiday with the wife and kids I took with me the very camera I recommended to you. Here are a few of the results which you can see are as good as anyone could want. And can tell you that I took almost two hundred pictures while we were away, without making a single adjustment to the camera other than to focus it through the rangefinder —which incidentally is much simpler for an inexperienced photographer than the focusing screen of an SLR—and no one of my shots was a failure. Not through any skill on my part I was simply using the camera for subjects within its limitations.

"Obviously I couldn't fit a telephoto or a wide-angle for special effects. But for the sort of holiday photography I was doing, which is the same as the photography you need a camera for, I didn't need the facility of extra lenses. Now, *will* you take my advice and forget about the snob value of a camera and get one like mine? In fact, I'll lend you my one, and you can try it for a month."

He rather reluctantly borrowed it and went off on another of his continental trips. When I next saw him he didn't wait for me to ask how he had got on. He produced a bunch of colour prints and said "Just look at these—they're terrific! The damned thing is so quick to use I was getting off-the-cuff shots which I'd have completely missed with the Leicaflex. Will you sell it to me?"

I've related this true story in detail because I think its moral is most important. The facilities offered by high-class equipment are useful only if you have the interest to

The automatic camera can cope perfectly with a good mixture of tones and generally has a sufficiently short-focus lens to give good depth of field. Shirley Temple at the Tower of London with a group of schoolgirls who had recognised her.

For the strongly backlit subject you can generally override the automatic exposure control by switching to manual, changing the film speed setting etc. These bathers at an Isle of Wight pop festival insisted that the cameramen undress, too. Sometimes press photography does become a difficult job.

acquire the skill to make the most of them. Otherwise you are far better off with a simple "point-and-shoot" camera. In fact, as I mentioned, I frequently use one of these cameras myself, as they are so quick to operate. And these days their lenses are excellent. I even used one on an important royal assignment when Princess Margaret visited London's Antique Fair.

As she wandered around I was able to shoot her in a variety of lightning situations without having to think about camera adjustments. I was able to give all my concentration to the subject. If you have to worry about camera settings, you will often miss the best picture.

This doesn't mean that I am against the sophisticated "class" camera. But if you own one you shouldn't keep it as an expensive bit of decoration. Get to know it so well that you can make adjustments automatically and without even thinking about them.

Operating instinctively

One of the basic essentials for shooting good pictures especially candids and quick off-the-cuff shots, is a thorough knowledge of your camera. I don't mean being able to make a setting properly and then taking a shot without having to

You have to know your camera well to get grab shots of famous people. I wanted to show what the glamorous Brigitte Bardot looked like when she was not posing for the camera. I doubt if this is her favourite picture.

hurry, but having an instinct for operating your camera. Remember it should be so much a part of you that it is, for all practical purposes, an extension of your arm.

How well do you know your camera? Try this test and see. Without cheating by going to have a look at your camera, see if you can answer the following questions right now:

Which way do you turn the lens to focus on infinity?

Which way do you turn the shutter speed dial to give a shorter exposure?

Which way do you turn the aperture ring to obtain a smaller stop?

Which is the fastest speed at which you can use electronic flash on your camera?

At what shutter speed can you get full coverage using a flash bulb?

How accurate is your viewfinder, bearing in mind that very few single lens reflexes show *exactly* the field of view which will be reproduced on the negative?

Do you know how to keep your camera ready set for an unexpected picture?

What size filter does your standard lens take?

If you can give the right answers to all these questions

without having to refer to your camera, then you do indeed know it well, as all photographers should.

Now let me set a few exercises which will help you to know your camera even better.

Exercise 1. While walking along, and *without stopping*, unload a film from your camera and put another one in. Owners of cameras with completely detachable backs will find this difficult, and they will pray for a third hand; but it can be done with practice.

Exercise 2. Again while on the move, change from your standard lens to another of a different focal length. Practising this is well worthwhile, as the speed with which you can change lenses may often mean the difference between getting an unrepeatable shot and just missing it.

Exercise 3. In *total* darkness, unload a film from your camera and put another one in.

Exercise 4. Again in total darkness, set your camera to 1/125 sec at *f* 5.6, and focus the lens on approximately 15 ft.

All these exercises will be of use to you at some time, and are worth practising. There's nothing difficult about any of them—press photographers have to carry them out in real life almost every day, but too few amateurs ever take the trouble really to know their equipment.

I know that we press photographers depend for our livelihood on not missing pictures, but any amateur worthy of calling himself a photographer will be just as keen not to miss any either. So practise, practise, and practise again.

Judging distance

There is one big difference in the shooting techniques of amateurs and pressmen—the time taken in focusing. It can often mean missing a picture, and although this may seem odd, I blame the arrival of the single lens reflex for it. Because we have a focusing screen, we feel bound to use it, and indeed this is right, when there is time. But when action is fast and furious, I suggest you take a leaf from the professional's and pre-war amateur's book—learn to judge distance, and then use the scale on your camera. This is far more rapid than focusing by screen, or even rangefinder, and skill at it can be acquired with very little practice. With today's miniature cameras, absolute accuracy is not

A quickly-taken shot of Gina Lollobrigida doing some still work on a film set at Pinewood. You cannot take too much time focusing and setting aperture and shutter speeds for this type of shot.

essential as it was when we all used large-format cameras with their shallower depth of field.

Years ago, when the Speed Graphic and MPP Micropress were the standard cameras for press work, it was necessary to be able to judge distances up to ten yards to within an accuracy of a foot. And for close-ups, taken at about two yards, one's judgment had to be right within inches. In spite of this, few pressmen used the rangefinders with which these cameras were fitted (probably wrongly, we never really trusted them), preferring to rely on our judgment of distance.

For a start, I suggest you learn "standard" distances such as two, four, seven and ten yards. Check how many paces you need for these distances, and then practise in your garden, your home, or even at work. First make your estimate, and then pace out the distance to make a check. Just one day of this, and you should be spot-on in your judgment. Then, with this ability, you can be ready in a moment for the unexpected shot. But first check the accuracy of the scale on your camera—some are not as true as they ought to be.

It is a good idea to keep the camera set at, perhaps, 1/250 sec at f8, when loaded with 400 ASA film; then when a picture suddenly presents itself you have merely to focus and shoot. Under most daylight conditions you will get a negative which will print (thanks to the latitude of modern films), and you can make the correct exposure-setting for subsequent shots.

This is the practice I always follow, and it has paid off many times, enabling me to capture the unexpected picture.

Breaking the conventions

Another aspect of knowing your camera is knowing what it can do. One of the biggest dangers facing photographers is that they may become slaves to the established rules of photography with the result that their work assumes a standard mediocrity. We learnt most of these rules when we were starting out, and very useful they were too in tracing out paths that were to be followed. But I believe that photographers, particularly amateurs with their complete freedom, should be prepared to break the accepted conventions as they increase their experience. There are many ways in which this can help to produce more interesting pictures. For instance, we are told always to put the camera on a

tripod when exposures of more than about 1/30 sec are about to be used. Agreed. An excellent rule—when you have the tripod with you, and when you have time to use it. But if for some reason you cannot use a stand, do try handholding even for quite long exposures.

With care, perfectly acceptable pictures can be taken with an exposure of a quarter of a second and the camera handheld. No particular skill is required, just concentration and holding your breath while making the exposure. I have even got away with handholding for a one-second exposure, but of course you cannot always be certain that you are going to get a good result with such a long exposure. Therefore you should take several and pick out the best one at the enlarging stage. But don't be afraid to experiment. That's the important thing: have a go. Don't fail to take a picture, merely because some rule says you shouldn't.

I have no reservations in stating that, if I didn't have to think about subsequent newspaper publication, I would almost always prefer to work by available light. Not only does available light enable a photographer to be more inconspicuous and unnoticed by his subjects but I feel the pictures have more of a feeling of naturalness about them. In fact, available light photography is often referred to as natural light work.

Of course, even pictures taken in bright sunlight are technically "available light", but when we use the term we generally mean pictures taken, probably indoors, by whatever light there might be. In other words, often poor-light photography.

Natural-light work will often mean long handheld exposures and wide apertures. Consequently, focusing must be extremely critical, but I think the results are worth the extra care.

Perhaps one of the greatest exponents of available light photography is Lord Snowdon. I don't ever remember him using flash for any of his pictures. The studio he designed for the *Sunday Times* is unique in that it relies almost entirely on natural light. He has shutters which open and admit daylight from either side so that he does have some control over the light although it is natural daylight.

The advantage of the available light technique is that it enables the photographer to move around, change his

Posed, of course, but it went in the paper. I wanted, as always, a different picture of Miss World. She is relaxing at the end of her first exhausting day. Flash would not have conveyed the right atmosphere.

angles, and get just the right position. He can see the effec of the light without being encumbered with cables, wires and extra equipment. On top of this it helps the subject to b natural, as he is not suddenly startled by a flash, or mad self-conscious and uncomfortable by having powerful light roasting him.

Obviously, the wider the aperture of your lens the easier will be to take pictures in poor light with a reasonably fa shutter speed. If you have a camera with a maximum ape ture of only $f4$ you might have to shoot in a particul lighting situation at about a quarter of a second, while if yo camera had a maximum aperture of $f2$ you would be able work at 1/15 sec—a much easier handheld shot. Again, tl faster the film you employ, the better your chances success. This is one reason why I have standardised on Tri with its speed of 400 ASA.

When you are shooting by available light, though y have no control over the lighting, you do have control ov your shooting position, and angle. So move around, che how the subject looks from different positions. See if would be better if you moved both your subject and yours into a different angle. However I prefer not to interfere t

much with my subject as it is easy to lose naturalness if too much posing is carried out.

Focusing a lens under poor lighting conditions is not easy, and it does require practice. Try it every now and again without a film in your camera, or at least without taking any pictures. Personally, I have found the easiest way is to set an approximate distance on the camera and then move closer or further away from the subject until it is sharp. This is quicker for me than turning the focusing ring continually, while standing in a fixed position.

What sort of shutter speed can you use? My experience has been that it is possible to get successful pictures, even with a shutter speed as slow as one second, handheld. Of course you shouldn't do this out of choice, but only when there is no other alternative. If it is at all possible, and you *have* to give a long shutter speed, try to wedge the camera or yourself against a wall or some support. But if there is no support and there is no alternative but to give that shutter speed then do it. You will be surprised at what you can get away with. But don't expect to be able to get a shot with a one second handheld exposure successfully every time. Therefore take plenty of pictures when you are shooting long exposures.

With a little care, nearly everybody should be able to handhold a 1/15 sec, so don't be afraid to use this sort of exposure.

If it is possible, fill your frame with your subject so that you don't have to enlarge just part of the negative later on. Naturally with a long exposure your pictures are not going to be as crisp as they would have been with shutter speeds of around 1/250 sec. So enlarging just part of the negative will emphasise any blur caused by shakiness of your handheld exposure.

My own procedure when shooting long handheld exposures is always to hold my breath at the moment of exposure. In fact this has become such an instinctive reflex that I do it every time I take a picture, without having to think about it. Don't grip the camera too tightly, but hold it in a firm, though relaxed grip. Holding it tightly tends to make it shake and vibrate.

I would suggest that you get to know the approximate correct exposure under some common available light

situations. Use your meter to find out what the right exposure would be with the film you normally use and your lens wide open in an average well-lit room at night; in a dimly lit pub; a brightly lit stage; and a subject in a room lit by normal daylight coming through a window. Memorise these exposures so that you don't have to waste time and attract attention to yourself by getting out your exposure meter or fiddling about with the TTL mechanism on your camera when you come to shoot pictures.

With sufficient practice you should be able to look at a situation and judge the exposure fairly accurately at a glance. Certainly for black and white photography, if not for colour.

And another point: if you have a wide-aperture lens, don't be afraid to use it wide open. Many photographers like to go one stop down from the widest aperture whatever the circumstances. They call this, "taking the edge off the lens" to improve its definition. This is a bad policy. They would have been better off buying a smaller aperture lens in the first place if they were never going to use it wide open. If you've got the glass, use it.

Of course, if it is possible to find some sort of support for the camera rather than pure handholding for long exposures, this should be done. The type of camera makes a difference too. My experience has been that it is much easier to handhold long exposures with a coupled rangefinder type of camera than with a single lens reflex. With the SLR, when the image blanks out during the exposure, it is difficult to know just how much you have shaken the camera during the time the shutter is open. But with a rangefinder camera where you can see your subject all the time, you can sense when you have taken a satisfactory picture.

But if you are using an SLR for long handheld exposures you can get round this problem by fitting a homemade, open framefinder in the accessory shoe. This can be cut from cardboard and, after focusing with the normal lens, use the framefinder during the actual exposure.

A point worth bearing in mind is that the wider the angle of lens you are using, the longer the handheld exposure you will be able to take successfully. For instance, if you find that the longest exposure you can handhold with a 50mm lens is a quarter of a second, you would probably be able to get a

sharp a picture at a half-a-second handheld exposure with a 24mm lens. Conversely the longer your focal length the shorter must be your exposure to get equivalent results.

Most subjects which require very long exposures are taken at night, or in badly lit rooms. There is a great temptation to over-develop pictures taken under these conditions, but this is a temptation which must be resisted. Nearly all these types of picture are highly contrasty, and any extra development can easily give you an unprintable negative.

Handholding long exposures is certainly a technique worth practising as it opens up an entirely new field of photography for you. With very little practise you should be able to guarantee success every time with exposures as long as 1/8 sec. The important thing is always to be prepared to have a go and try for a picture, however impossible it seems.

Know yourself and your motives

Apart from knowing your camera and its capabilities, it is as well to know yourself and why you want to take pictures. There is a type of enthusiast who calls himself a photographer but seldom takes pictures. And that is the man who has an over-riding interest in technique, and often in obscure processes as well. He is always trying out some new process which is supposed to give extra resolution or less grain, or some other marvellous improvement. And he is obsessed with testing different lenses to find one which gives two lines per millimetre improvement over his existing lens.

His pictures are always tests. He is continuously searching for some magic combination which will produce "The Perfect Picture". Of course he will never find it, but there is no harm in anyone going on like this if it is what really interests them. These folk are not photographers. They are photo-technicians.

Photographers produce pictures. That's what photography is all about. And that's what we are concerned with in this book. From here on, technicalities are going to be kept to an absolute minimum. All we are worried about is picture-making. But before we go on to discuss this in detail, it is as well if you ask yourself: why do I want to take pictures?

If you are a professional, the answer is obvious—you're out to make a living out of photography, and every picture you take will be aimed at someone who is going to pay

money for it. You may be aiming for publication in a magazine or newspaper; to sell prints of a wedding; pictures for use in advertising; portraiture; or any number of different profit-making fields. Whatever the case, your photography will always have a fixed purpose: to satisfy someone who is going to pay you for your work. If you happen to enjoy the work as well, the rewards are doubly satisfying.

But what if you are an amateur? At first, the sheer novelty of being able to produce good pictures is a reward in itself. After you have managed the various techniques you get, for a while, much pleasure from merely producing pictures that satisfy *you*. But then, gradually, the novelty wears off. No longer is there any challenge. You *know* you are a capable photographer, and unless your work has a definite purpose or aim you almost certainly start to lose interest. And this is a great pity because you thereby discard one of the finest and most satisfying hobbies.

Photography has been both my hobby and my livelihood for around forty years, but I still find it as fascinating, as interesting, and as challenging as when I first started. To me, picture-making is never a bore. I look forward to every new assignment with pleasurable anticipation. I put this down to the fact that all the pictures I take are shot with a definite purpose in mind. I don't take a picture merely because it is there for the taking. Every time I press the shutter release I have a definite aim in mind for the picture. Many times I might not achieve this aim, but it is there just the same. My photography is never purposeless, and I believe this is the reason I still find it so fascinating.

Without some definite object in view, interest in photography tends to die away. The camera is used less and less frequently, and in the end is put away, only to be brought out at holiday times. This is a great pity, because it means not only that you have wasted a considerable sum of money on an unnecessarily expensive camera, and possibly a lot of equally pricy accessories, but you are missing out on a hobby which can be fascinating, challenging, enormous fun, and occasionally profitable.

Keeping an interest alive

How do we sustain, or indeed increase, our interest, once the initial novelty has gone? The motorist with his brand

new car, at first drives it around just for the sheer pleasure of handling it. Then, when the novelty wears off, he sustains his interest in motoring by going on journeys, but he almost always has a definite destination in mind. There is not much fun in driving round the countryside without knowing or caring where you are going, just for the doubtful pleasure of manipulating the controls. With photography, you must similarly have some end-object in view for your work. And fortunately, there are many ways of attaining such an object.

First, I do urge you to join a camera club. Whether you are a complete beginner who has still to develop his first film, or an expert with years of experience behind you, I have no doubt at all that membership of a club is worthwhile. Not only do you learn a lot from the lectures and demonstrations, but you possibly learn even more from mixing with and chatting to fellow enthusiasts. And one of the great benefits of club membership is that it provides an object for your photography.

Every club holds annual exhibitions at which your work can be shown, if it is of sufficiently high standard. There are often monthly contests, and "print battles" with neighbouring societies which give you a challenge. And some of the more go-ahead clubs organise press-type coverage of local events, with the object of putting on an exhibition. All of this provides that indispensable purpose for your photography. You are not haphazardly taking pictures and then wondering what to do with them. Your work has an aim and will therefore improve.

But clubs are by no means the only way of giving your photography a purpose. You could join the Royal Photographic Society and aim to produce a set of pictures which will entitle you to become a Licentiate (LRPS) or an Associate (ARPS), this latter requiring a very high standard. And when you are *really* good, you might aim for the Fellowship (FRPS).

However, I should warn you that, although anyone can join the RPS as an ordinary member, without having any qualifications, or even any knowledge of photography, it does tend to be rather expensive, costing at the time of writing, nine pounds a year. That's considerably more than it costs to join most camera clubs, and it is my opinion that you get far less out of the RPS than from a local club. However if your aim is to

get some letters after your name, you may consider the subscription worthwhile. There are other benefits as well as the awards. The Society has fine premises in the heart of London where frequent lectures are given by prominent photographers. Personally, I think that a lot could be done to improve the facilities offered, because I still feel that the tendency is to an atmosphere of stuffiness. But maybe that's one of the penalties of having the prefix "Royal". The very word conjures up a vision of pompous old gentlemen, and somehow everyone feels they have to conduct affairs to a standard of bygone days.

Aiming at publication

There is no doubt that for most photographers there is a tremendous amount of pleasure to be obtained from seeing their work in print. In fact I would go so far as to say that one of the greatest thrills is when you see your first picture published. Whether it is in a newspaper or a magazine, there is a feeling you can't describe about seeing one of your photographs reproduced, and knowing that thousands (maybe millions) of other people are looking at *your* picture. And this is a pleasure that does not decrease.

After all the years I have been in the business, and the thousands of pictures I have had published, I still get great satisfaction and pleasure from seeing my work in the paper. In fact, even when I have taken a simple little publicity picture for the cine club to which I belong, and it appears in the local paper, I get pleasure out of that too. So, here is another object for your photography. Aim to get your pictures published. Maybe in the local paper, a magazine, or if you are lucky and have secured a very good picture, perhaps even in a national newspaper.

Later on I'll go into details of how to get your pictures published, but there is nothing to stop you right now—before you read another page of this book—from making a start. If you belong to some club or organisation there is bound to be some event coming along which will make a picture that could possibly interest your local newspaper. Maybe the local Women's Institute is organising a concert. Or there is a flower show taking place nearby. Or your childrens' school is holding a harvest festival, a sports day, a prizegiving, carol singing, or the children are em-

Animal shots stand a good chance of publication but you have to be quick on the trigger finger to get the unusual picture. I took this one during the making of a film at Windsor Safari Park.

barking on a new or unusual project. Any of these subjects could make a picture which might be of interest to your local paper. You won't get pictures published unless you take them and submit them. So make a start right now. I guarantee that you, who are reading this book, know of something which is going to take place within the next few weeks and which would make a publishable picture. Go on, go ahead and get your first publication now. But beware once you've got your first picture published and you see it in print. It is like a drug, and you will want to go on and get more and more pictures published.

And lets face it most of us have got a bit of the show-off in us. There's nothing like having one of your pictures in the local paper or magazine and dropping the odd remark to friends "Did you notice that picture of mine in the *Gazette* today?" The chances are that they *didn't* notice it, but this will not detract from your pleasure, because you know darn well they will go back to have a look at it.

Entering photo competitions

Every year dozens of commercial organisations and newspapers run contests for amateur photographers. And quite often the prizes are very generous indeed.

Some amateur photographers have made a hobby out of doing nothing else but entering photographic competitions. They make it pay too. The art is to study the rules of the competition very carefully and try to follow them. Endeavour to visualise what the organisers are looking for, or rather their judges will be looking for, in the winning prints. Whatever you do, don't think your picture won't stand a chance because there will be thousands of others better than yours. I have been a judge in many competitions and you will be surprised at the number offering really great prizes but which have attracted only a very low number of entries.

I remember judging one once, when the prize was a trip to Japan and back, all expenses paid. There were only about fifty entries and the standard was quite low. Any amateur who had set out with the prime purpose of winning that particular competition could have walked away with the prize. And as I looked at the prints that had been submitted, I had the impression that all those who had entered had merely looked through their negative files for pictures which they thought might be possible for the competition.

How to win

The way to win these competitions is not just to look through your files (although this is a valuable source of possible pictures), but to go out deliberately searching for pictures for a particular competition. After some experience you gain an instinct for what the judges are looking for in any particular contest. For instance, in any competition organised by a newspaper, they normally look for happy pictures which give a feeling of enjoyment to the readers of the paper when they are reproduced. Old men with wrinkled faces and miserable looks might be all very well for exhibition walls, but they are not likely to win happy holiday snapshot contests.

It is essential that you read the rules of the contest carefully and follow them in every detail. It is perhaps not generally realised that when deciding between prints of approximately equal merit, the judges will refer to the exact wording of the rules to ensure that the winner does not break any of them.

These rules will often also tell you the sponsor's aim. For

A prize-winning picture many times over but it was posed with boys from a school at which I was once a teacher. It was taken purely for competition purposes. Is posing justified? Well, it did win and there was nothing in the rules against posing.

instance, a competition organised by a cruise firm might say that the pictures should depict "the joys and benefits of sea travel".

Obviously you would not submit a shot of someone suffering from seasickness! But a little thought would also indicate that a picture of passengers in raincoats would not stand much chance of success either, however dramatic the picture might appear with mountainous seas in the background. Entries in such a contest should show folk enjoying themselves; it should be clear that they were on a ship; and it must look as if they are benefiting from the voyage.

Make a real hobby out of taking pictures for contests which you see advertised. You will stand an infinitely better chance of winning if you deliberately look out for contest pictures, rather than search through the year's snapshots for "something to enter". Certainly this takes a bit of trouble, but it not only makes photography more interesting than aimless shooting, it also puts you well on the road to those worthwhile prizes.

There are certain subjects that are always a favourite with the public and therefore popular with the judges of contests organised by newspapers or commercial organisations. Children are usually a very good bet, particularly if they are active, or doing something. Don't have them standing and staring stonily at the camera. Catch them in some appealing attitude, or at play; and if you can get movement and action into your picture so much the better. Naturalness with children is all-important.

Another popular subject is animals. And if you can combine animals with children in one picture, then you are halfway to winning a prize.

However beautiful, peaceful, and magnificent a landscape may appear, it is not likely to attract the attention of judges in popular competitions. To get an eye-catching picture you want action. Try to capture movement, and a picture with impact.

Well, where do you find out about these competitions? Many of them are mentioned in the photo magazines, particularly those which are published weekly and so have a shorter time between the announcement of a contest and when they can get it into print. Contest announcements are

also often used in advertisements in newspapers and in publications such as the *Radio Times*. You have got to look out for competitions, but once you have got into the habit of keeping an eye open for them you will be surprised at the number there are. As soon as you spot one being advertised or mentioned, cut out the item giving details of it and keep it by you, with a mental note of the sort of pictures you should be looking out for to win that contest.

The important thing is to *enter*. It's no good looking at the winning result some months later and saying you could have taken a better picture than *that*, so you don't see why it should have won. It's your fault. You should have taken a picture and entered it.

Enthusiasm is the mainstay

At this point I don't think I can do better than to quote one of our most successful photographers, Lord Snowdon. And the advice he gives applies not only to competitions, but to all photography.

He said, "Photographers must experiment all the time and not be frightened of using light freely, shooting straight into it if need be—making an effort to get new angles on much photographed subjects, and also discovering the chemical properties of film itself.

"The one thing they *must* be frightened of is copying out-dated techniques, and not bothering to explore every kind of fresh approach. Many conventions have grown up over the past years which need breaking down. One sees time and again almost identically the same picture of a limited number of subjects taken by different photographers.

"Any amateur from the age of ten upwards should be able mechanically to operate a camera. It is the idea behind the picture that is important.

"Basically it is to recall a moment—a moment that is vital—to give the viewer of the final picture a sensation of liveliness, sadness, joy, excitement. Essentially imparting an impact.

"The camera must be part of one—an extra limb—capable of freezing a situation without complicated preparation. Various so-called rules have been laid down over the years, but it is when one is young, experimental and

103

enthusiastic that all these conventions should be broken; not through contrariness, but to initiate a freshness of approach."

That was said by Lord Snowdon back in the early sixties, when he was at the height of his fame as photographer Tony Armstrong-Jones. But it is the finest advice in photography that I have encountered, and I suggest that you read it again. And again. Just recently I was talking to Lord Snowdon about picture-making and I was interested to find that after all the years he has been in photography, he is just as enthusiastic and keen as he ever was.

I believe he has sustained this enthusiasm by his constant striving to experiment, and to capture that vital moment to which he referred.

So long as photography remains a challenge it will always be interesting and fun.

Fortunately, none of us will ever know all there is to know about picture making, so we should never lose our interest, as there is always another challenge ahead. In fact, I find that every picture assignment I have is always a completely fresh challenge. Even when it is of a subject which I have photographed several times before, I still try to find something different, some new approach, some new angle, some way of getting a picture better than I have ever done before, or at least a better picture than my rivals will get on the same subject. I don't always succeed, but I try.

The same applies to amateur photography. Look around you at the subjects being taken by other photographers. Think of a better way of taking them. A more interesting way. Ways which give the picture more impact. Ways which capture again that vital moment. Look always for action or movement. Don't try to imitate painters. Painting is something of bygone days. Photography is new, and is capable of producing far better pictures (or rather different pictures) than painters ever visualised. With this attitude in mind, your own photography will become ever-changing and new.

Never look upon any photograph you are going to take as a dull, routine one. Even when a neighbour asks you to shoot some pictures of her children, think of a way of producing new, better pictures than ever before of the child.

And I say it again, because it is so important. Whenever you are taking a picture, *do have an object in view*. Don't

take pictures merely for the sake of taking them. Always have a reason for taking them, and your interest in photography will not diminish. It will increase as the years go by.

I can honestly say that, after all my years in photography, I am more interested in it and more enthusiastic now than I was when I first started.

8

Thoughts on Colour

Colour photography has increased enormously over the past few years. It is now so simple that even a child can produce acceptable colour pictures or transparencies with hardly any skill. However there is much more to producing really good colour work than just taking a meter reading and then shooting the scene in front of you with a colour film in your camera.

I have no intention of delving into the theories of colour photography here. In fact many books have been devoted entirely to colour, and they are available for anybody who wants to dig deeply into the subject. But in order to get the best out of colour films you should know just a *little* about colour principles.

I think most of us know that white is not a colour. White light is a mixture of many colours ranging from red through yellow, orange and green to blue and violet. But of course these aren't the only colours there are. Any person with normal eyesight can probably distinguish hundreds of different colours or hues. These colours are measured in wavelengths, and the longer the wavelength the warmer, or redder, the colour.

For instance a good deep red would have a wavelength of about 650 nanometres, while violet would be around 450 nanometres. We don't need to delve deeply into this subject for our practical photography, but it is helpful to know something of how colour filters work, and about colour balance.

Effect of colour filters

Colour filters, as their name implies, are transparent materials which absorb certain colours, while allowing others to pass through. A pure red filter, for example, absorbs all colours except red. Thus, if white light is passed through it and shone on a white surface, the surface appears to be red because all colours other than red are absorbed by the filter. In colour photography we very seldom use *deep* colour filters, except for special effects, but we do often use lightly tinted filters in order to correct colour balance.

As a matter of passing interest, it could be useful to know the effect of using a combination of several filters at the same time. For instance, if you have three white light projectors, and you fit a red filter over the lens of one, a green filter

over the second and a blue over the third and then shine all three sources on the same white surface, it appears white. If you shine just the red and the green together the surface appears yellow; the blue and green give cyan; and red and blue a magenta appearance.

Interestingly, if we reverse the process and look at a single white light source through three filters held together (cyan, magenta and yellow) the light source is completely blacked out. Between them these three filters stop all the visible wavelengths of light. If we hold just the cyan and magenta filters over the light the result is blue; the cyan and yellow give us green; the yellow and magenta give us red.

At the moment you will most certainly not require this bit of theoretical knowledge. But the time will come when you do want to see the effect of using more than one colour filter, so it is worth bearing the previous few paragraphs in mind.

Colour temperature

All light sources, although they might appear white to our eye, are not the same degree of whiteness. For instance, a candle has what we call a very *low* colour temperature. In other words it gives quite a warm yellowish light. At the other end of the scale, the light from a clear blue sky has an extremely *high* colour temperature, and the light it gives is very cold, tending to bluishness.

We measure colour temperature in kelvins (K). The candle we spoke about has a colour temperature of about 1900K; a household electric lamp is around 2900K; photoflood lamps are usually 3400K; sunlight at midday 5400K (but if there is a lot of clear blue sky it would be up over 6000K; while light from a clear blue sky without sunshine would be anything from 12 000 to 25 000K.

Obviously we can't have a colour film which is suited to every sort of lighting situation. So what the manufacturers have done is to produce two main colour films. One is balanced for use with photoflood lamps, and is usually known as Type A; the other is balanced to give satisfactory results in daylight (sunshine and an average blue sky). If we want to use other light sources, and get as near a true reproduction as possible, we have to use colour correcting filters.

107

Shooting with fluorescent lamps

Before I go any further I must deal with the subject of fluorescent lamps of the so-called "daylight" type. I am frequently asked what filter should be used with these lamps, and the answer is that where "daylight" lamps are concerned, ordinary daylight colour film can be used without any correcting filter. However there are a number of "warm" fluorescent lamps which are used domestically, and these do pose a problem for the colour photographer. It is all a matter of personal taste. I happen to prefer using a Type A film with these lamps, together with an 81B filter, which helps to give a slightly extra warming effect.

Perfectionists should bear in mind, however, that fluorescent lights are in a class of their own, because the apparently white light they give is not pure. Certain parts of the colour spectrum are entirely missing (certain wavelengths if you like) and, as I have explained, filters do not put colour into a picture, they merely absorb certain colours. So the use of any kind of filter with fluorescent lighting cannot put in colours which were not there in the first place. Therefore it's not possible to get a true colour reproduction using these lamps, whatever filters are used. But this is being pernickety, and for all practical purposes pictures can be taken quite satisfactorily under fluorescent lighting.

Filters and electronic flash

Many photographers are puzzled about the use of colour correction filters, especially when they are used with flash. One amateur asked me: "I have always understood that electronic flash gives approximately the same sort of light as daylight. So why is it necessary to use a correction filter with electronic flash?"

The answer has nothing to do with scientific theory. Very few photographers are interested in precise and exact colour reproduction. A few scientists may be, but not those of us who produce *pictures*. We are mainly concerned with the effect of colours on the viewers of our pictures, irrespective of whether the colours we produce are exactly the same as those in our subject.

So for all practical purposes I believe it is fair to assume that there is no colour film on the market which w

reproduce all the colours of a scene exactly as they were in the original. Even if this could be achieved without too much complexity it would by no means necessarily produce the most pleasing colour pictures.

The final appearance of the colours in the prints or transparency are in any case affected by the colour of the light source with which the picture is viewed, and by the fact that any photograph is only a small area of the original scene. This means that our appreciation of the colours in the picture is affected by the colours in the surroundings in which we view the picture. And even if we view it in complete darkness (as we do with a projected slide), the conditions are different from those of the original scene. Unless, of course, we've been looking at the original scene through a small window in an otherwise blacked-out room.

Obviously this is a highly complex subject, and I am not qualified to delve deeply into it. Suffice to say that it is not possible for us to obtain exact colour reproduction. So we must aim to obtain the most pleasing colour effects.

You are at once in the realms of pure subjectivity. For instance, one man will prefer the sort of colour which Ektachrome gives; another will say that there is no film to touch Kodachrome; and yet another will say that the finest colours come from Agfa. It's all a matter of personal choice.

From my own point of view I happen to prefer the colours which Kodachrome produces, but that does not mean that it is the best film. It just happens that the sort of colour balance it achieves appeals to me personally. If you agree that colour is purely subjective and various colour scenes on films look different and are appreciated in different ways by various people, then you will know that you must aim to produce the most *pleasing* result, and not exact reproduction of the original colours.

We can now consider the results which electronic flash gives when used with colour film. It has been my experience that most electronic flashes give a light which tends to be on the blue or cold side. Especially, it seems to me, when Ektachrome is used. I know that the light these electronic units give is 6000–7000K, which approximates to sunlight in a clear blue sky. But I reckon that that gives too cool an effect, especially for glamour work. So with both electronic flash and sunshine I like to warm up the final effect with

either an 81A or 81B filter. Or maybe (especially if I am photographing a blonde) a CC10R. Incidentally, some electronic flashes have a slightly warming filter built-in. But even these don't always give just the balance which I like.

If you like shooting colour with flash—or colour in daylight too, come to that—then I strongly suggest that you get yourself a few filters. In gelatine they cost a negligible amount, and you can experiment until you get just the effect you like. Try an 81A or 81B (the B has the stronger effect) and a CC10R to start with. The CC10R suppresses blue and green slightly and gives very pleasant flesh tones, especially to blondes, but not necessarily to the type of skin which a brunette has. Here I prefer the 81A or B. What you must avoid at all costs is giving any bluish or greenish tinge to flesh tones. This just makes your subject look ill, and you will not be congratulated on the results, I can assure you!

You should always be prepared to experiment with different sorts of filters to obtain different effects. But if you want a rough and ready guide here is a little table which might assist you. Although it is based on some recommendations by Kodak, I should emphasise that not all my suggestions are. In fact, some are specifically *not* recommended by Kodak, but are ones which I have found worth using on occasions. For instance, Kodak recommend that electronic flash should *not* be used with a Type A film. However I have found that I can get satisfactory results using a No. 85 filter with electronic flash and artificial light film. Anyway here's the table.

RECOMMENDED FILTER USAGE

Lighting	Daylight colour film	Artificial light colour film
Brilliant sunshine	No filter	No. 85
Subject in shade, high altitudes	No. 1A	No. 85
Electronic flash	No filter	No. 85
Photoflood bulbs	No. 80B	No filter
Household tungsten lamps	No. 80B+No. 82A	No. 82A

The most important point is that you should be prepared to experiment. Always remember that you can never achieve perfect colour reproduction, so go out for colours which you or the majority of your friends, seem to prefer.

Using daylight indoors

You can shoot pictures indoors by daylight coming through the windows, but you must remember that if there is no direct sunshine, the light will be extremely cold, so a warming up filter (say an 81A) will be needed for the best results.

Another difficulty which might arise is the fact that colour transparency film is unable to cope with a very wide range of contrasts. And when shooting pictures indoors you sometimes have parts of the scene which are brightly lit and others which are in deep shadow. You have just got to face it that you cannot record all that you see when the contrast range is too great.

What you must be extremely careful about is avoiding over-exposure of the important parts of your subject. For instance, if you try to get a dark background correctly exposed and somebody's face is brightly lit in the picture, the face will be burned out and there is nothing at all which can be done about restoring this later. With black and white film you can get away with a lot of over-exposure, but not with colour transparency film. Here over-exposure is the biggest enemy. If you have to guess, it is better to err on the side of under-exposure. But of course try to get it right.

Breaking the rules

It occurs to me that I might have been over-emphasising the importance of colour correcting filters. There are times when you want to capture the atmosphere of a scene irrespective of correct colour balance. For instance, you might be having a candlelit dinner party. Although the colour temperature given out by the candles is very low and will give an extremely yellowish result, even when Type A artificial film is used, this will probably give a better impression of the scene than if you used a correcting filter to bring up the colour temperature to what might be regarded as normal. In a situation like this I would shoot with a Type A film and not bother with any correcting filter at all.

And before you start saying that there is not enough light from candles for colour photography, I say "Don't believe such bosh until you have tried it". Again experiment. Be prepared to have a go. Try the shot with several different

111

exposures. Be prepared to handhold your camera for lengthy exposures; just see what sort of results you get. You'll never get any noteworthy pictures if you always stick rigidly by the rules.

One of the commonest rules is to have the main light source (usually the sun) coming over either the left or right shoulder. It is said that this gives depth and modelling to your picture.

Maybe. But I prefer to play around with the light, and if necessary shoot straight into it. Very often some beautiful effects can be obtained by this *contre-jour* form of lighting as it is known in the photo-world.

The very worst form of lighting for both black and white and colour film is midday sunshine, especially if you are away from the northern hemisphere and getting down towards the equator or even the Mediterranean. This lighting is harsh and gives intense shadows in the eyes of subjects. It's also unflattering, and there is not much you can do about it. Even if you use a fill-in flash to light up the eyes the effect is not at all good. What can you do about it? The answer is really simply nothing, except to wait for the lighting to improve later in the day, or shoot earlier the next morning. Or do without the sunshine and shoot your portraits in the shade.

And don't believe that, just because you have colour film in your camera, you have to fill your pictures with lots of strident colours. Some of the most effective pictures are those which make very subtle use of colour—where you might have almost the whole picture in various shades of the same colour with just a tiny bit of a contrasting colour here and there.

I well remember one very impressive picture of a city in mist where there was hardly any colour, but here and there tiny points of yellow or red. This restrained use of colour is far more effective than splashing it all over the place as you have a compulsion to get as much colour as you can into your shots.

9

Photo-graphing People

One of the big advantages of the 35mm camera is it's ability to take unposed pictures. Unfortunately, some of the modern single lens reflexes have become so heavy and noisy in operation that you might just as well be using an old-fashioned large-format camera. However there are many compact and comparatively silent cameras on the market, and these are ideal for unobtrusive shooting. Inevitably, people confuse this type of photography with snooping. I must be honest and admit that there have been times when I have done sneak photography.

Sneaking a photograph

I remember many years ago I was sent to cover Royal Ascot on a sort of roving commission basis. I had no pass, so paid the normal entrance fee to the paddock, I had my Leica slung over my shoulder but under my coat, so it was out of sight. I should point out that cameras are strictly forbidden in the paddock during Royal Ascot week. Wandering round during the afternoon, I suddenly spotted Princess Margaret leaning over the paddock rail, completely alone except for her personal detective who was standing about twenty yards away, and apparently quite unconcerned, as there were no crowds around her.

I reckoned it would make a good picture if I shot Margaret, relaxing and unrecognised by the crowd as she watched the parading horses. So I went up to the rail about seven yards from her and myself leaned over, also apparently watching the horses.

Before taking up my position I had surreptitiously prefocused the lens on my camera, and set the shutter speed and aperture. As I leaned on the rail I let my camera come just out of my coat, then without putting it to my eye aimed it from waist level and took a picture. I waited for a few moments and then took two or three more pictures as the Princess looked around.

I freely confess that, very cockily, I felt smug about the way I was putting one over on the detective; but suddenly I felt a gentle tap on my shoulder and there he was standing behind me. I thought I was going to be for it. Not only would I be ejected ignominiously from the course, but my film would be confiscated, and there was a pretty good chance that I could be prosecuted for trespass.

Human interest shots appear anywhere—even in the Vietnam battlefields. John Downing of the *Daily Express*, managed to combine amusement, information and tragedy in the same picture.

But the detective just gave me a knowing smile and said "I think you've done well enough by now, don't you? I'm sure you've got one or two good pictures, so let's call it a day, shall we?" And off he wandered.

I took the hint, congratulated myself on my good fortune, and took myself off with my pictures. Obviously he had recognised that I was taking quite harmless pictures of the Princess and was not in any way trying to make her look ridiculous, so he had been helpful to me by turning a blind eye to my activities.

In general I have found that the royal detectives are very good to the press. Often the local police force is a little overawed by the presence of royalty, and tend to make things rather difficult for press photographers. But if possible we usually have a word with the personal bodyguard of whichever royal personage is attending. Then he, knowing us, usually smooths things out and gives us time to get some good pictures without interfering with whatever the occasion might be.

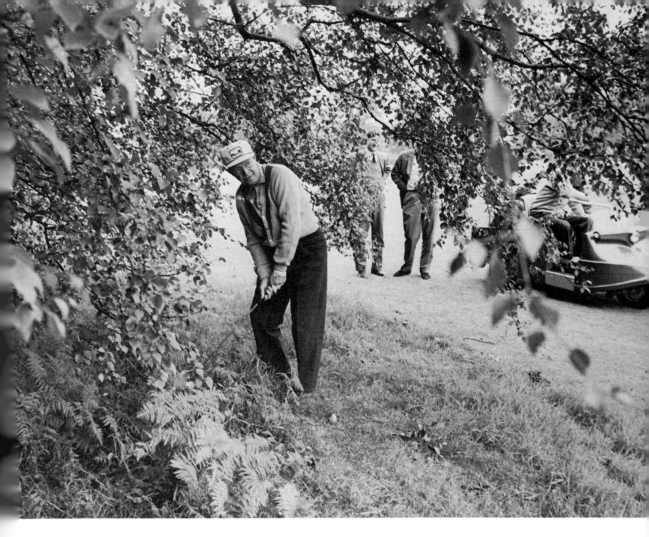

No golfer likes his concentration disturbed by clacking camera shutters, so you take your picture quickly and get out of the way, especially when the subject is President Eisenhower on a visit to the Wentworth course.

Unfortunately there are just one or two photographers —usually freelancers—who do spoil things by concentrating on the taking of really sneaky pictures in an effort to catch royalty in embarrassing situations. I do not subscribe to this sort of picture, as all of us could be caught in an embarrassing situation at sometime in our lives. I think we should try to appreciate the feelings of royalty who are, after all, only human beings when they are doing something which they would not like to see publicised throughout the world. Certainly their job is a public one and part of that job means they must expect to be photographed. But I also think they are entitled to a private life which should not be intruded upon.

This does not mean to say that I am against informal pictures of royalty. One occasion when there are often good informal pictures is at the Badminton Horse Trials, which are held at the end of the winter each year. Here the Queen and members of the royal family wander among the public, and there is a good chance of getting unposed pictures of them. Again, it is ethical not to intrude, and to let them enjoy

themselves. I always believe in getting a few pictures and then leaving the field clear for the royal family, so they don't feel that they are being constantly watched by a long focus lens.

An occasion when I found the sweet silence of the Leica shutter to be so helpful was one day after a general election. I had been sent along to the Stock Exchange to get pictures, as it was anticipated that there would be tremendous activity there as soon as the result of the election was known.

"But be careful," said my picture editor. "Photographs are not allowed in the Stock Exchange, so you will have to sneak them. Don't get yourself into trouble, or it's on your own head!"

Again I had the Leica over my shoulder and under my coat as I made my way to the Stock Exchange and went up into the spectator's gallery, which overlooks the floor. I had previously set the camera, which had a 35mm lens on it, to the approximate correct exposure, which I had estimated would be about 1/30 sec at *f*2.8.

I leaned over the edge, looking at the scene below, and after a while quietly, and again surreptitiously, brought out the camera. Keeping it covered with my coat I pointed it and took a couple of shots. I then slipped it back under my coat, continued watching the scene for a few more minutes, and then made my way to the exit. As I went out I was thinking what an easy job it had been.

But as I passed through the exit, the attendant in uniform said "Hope your pictures turn out all right sir!".

One of the finest examples of ingenious sneak photography happened in the mid fifties during the "gangster" era in London. One well-known gangster had died, and most of the underworld turned up for the funeral. Fleet Street photographers also turned up, but at the gates of the cemetery it was pointed out to us in no uncertain terms, by a group of very tough gentlemen, that if any of us took a picture or put one foot in the cemetery, he would be "slashed".

Knowing these people, we also knew it was no idle threat. These were no young hooligans, but professional gangsters. Accordingly we stood in a sheepish group watching the mourners go in, and each of us composing our individual excuses to our picture editors for not getting any pictures.

The press photographers' favourite, Princess Alexandra, with husband Angus Ogilvy at the Derby. A long shot with a 400mm Novoflex on a Minolta.

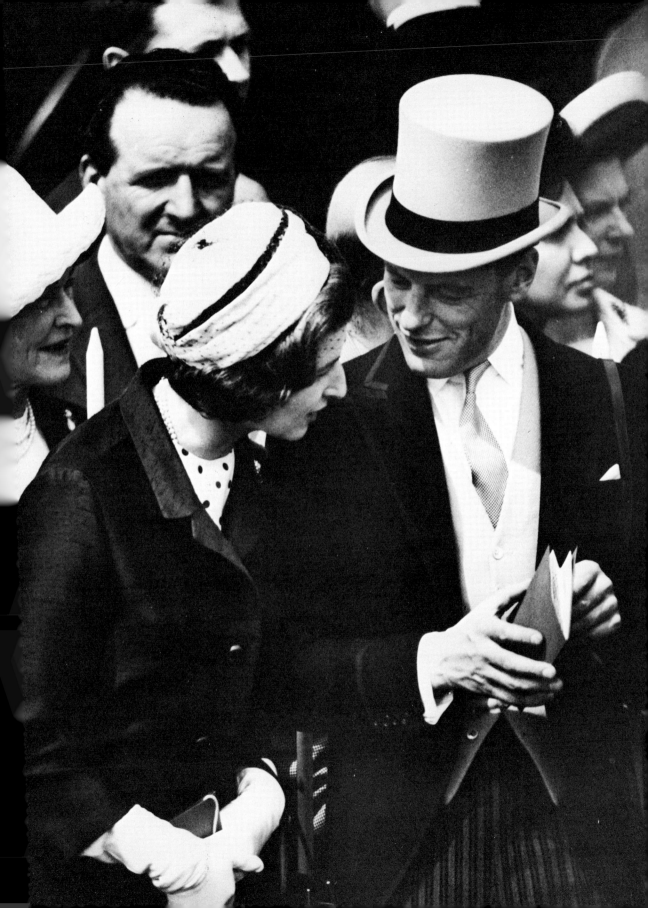

Imagine our surprise and consternation when, in a group of mourners, we spotted a familiar face. His bare head bowed, dressed in sombre black, and carrying a bunch of flowers, was Freddy Girling, the chief crime photographer for the *News Chronicle*! Not only that, but we all saw clearly the gleam of a lens shining through the flowers! Freddy looked neither right nor left when he went past us, and to our credit, not one of us said a word to the toughies.

We had been well and truly scooped by Freddy's ingenuity and he deserved to get away with it.

Unfreezing the subject

The main use of these off the cuff techniques for the amateur is to capture pictures of people, whether they be friends or strangers, looking completely unposed and natural. In my opinion it is death to a picture if the subject knows he is being photographed, and either tries to assume an expression which he thinks will please you, or just stares stonily at the camera. Even professional models and actresses, who are used to posing for pictures and getting the right expressions on their faces, often provide better and more interesting pictures if they are caught unawares.

I remember once when I was shooting pictures of Sophia Loren at a cocktail party. As I started to shoot, she came towards me saying: "No, no, no!"

"That's all right Miss Loren," I interrupted. "I don't want you to pose. I just want informal pictures," and carried right on shooting.

She shrugged her shoulders in one of those delightful ways which only the French or Italians seem able to achieve, and then started to perform the most amazing antics. I could hardly believe my luck. I was getting a great series of pictures showing the glamorous Sophia Loren as she had never been seen before. When I had run right through my roll of film, Sophia came forward, pointed to my camera lens, gave me a wink, and said "Never mind. Perhaps you will be luckier next time." What she had been trying to indicate to me in the beginning was that I had left the lens cap on my Leica!

Since that day I have never failed to check that the lens cap is off when I am using a rangefinder camera, but I have

Winston Churchill leaving the House of Commons after his last visit as an MP. I fitted a 21mm lens to show both him and the location instead of trying for the usual car shot.

118

never succeeded in getting such an interesting series of pictures of Sophia Loren as I would have got that day. Except that she knew the lens cap was on, and that I wasn't getting any pictures.

When shooting people, you should keep your apparatus to the absolute minimum. One camera and one lens is the ideal. If you have two or three cameras and a load of gadgets, not only are you more conspicuous, but you probably have the wrong camera or the wrong lens in position at the moment when the picture occurs.

If you are shooting pictures of someone who knows they are being photographed, but you still want to get informal unposed shots, you will probably do better to deliberately waste a roll of film taking pictures while you gradually let the subject unfreeze.

Choice of equipment

There are a lot of folk who think that long focal length lenses are best for informal shooting, but I don't subscribe to this view. The trouble with shooting at long range is that you are liable to get somebody else coming between you and your subject, and so blocking the view at the moment when the best picture occurs. You are also rather conspicuous with a long lens attached to your camera.

I much prefer to use either a standard lens or even a semi wide angle, such as a 35mm, for candid work. Ideally, I prefer a compact camera with a quiet shutter, but I have used single lens reflexes successfully on many occasions. Here is my technique for shooting unobserved.

First of all I do *not* try to hide the camera in any way. In fact I make it fairly conspicuous by having it around my neck and resting on my chest ready for instant shooting. People will, of course, notice the camera; but after you have been wearing it like that for a few minutes most folk will forget that you have a camera in position. You and your camera will have become part of the general scene, and they won't even notice that you are set to take a picture instantly.

For film I almost always stick to my usual Tri-X. Its high sensitivity enables me to use a fairly fast shutter speed and small aperture—both useful if there is some subject movement, and spot-on focusing is not possible.

Lord Attlee at home in
Buckinghamshire. He was a
charming man who willingly let me
shoot portraits of him. I feel that
natural lighting in such
circumstances helps to preserve the
atmosphere and keep the subject
relaxed.

Shooting unobserved

I preset the correct shutter speed and aperture, and then
prefocus on a set distance. Let us say about 12 ft. It might
even be as close as 6 ft. However the important thing is to
focus beforehand, so that when you come to actually take
the picture there will be no fiddling around with the lens
while you get your subject sharp.

Having got the camera all set to take a picture instantly, I
wander to about the right distance from my subject and
when he or she is ideally suited to my picture, I lift the
camera and shoot immediately. No hesitation. No focusing.
Press the button immediately. In this way you can guarantee
that ninety-nine times out of a hundred you will get a picture
before the subject knows that one is being taken.

Sometimes it might be necessary to shoot without even
lifting the camera to your eye. In this case the same
technique is used of presetting the camera, but then you
wander around with your hand on the camera, and once
again you will be accepted as "that bloke who wanders
round with his hand on the camera". People will forget that
you are in a position instantly to take a picture.

With a little practice you will soon find that you can point
a camera quite accurately at a subject without looking down.

121

Then you just press the button at the right moment. If you don't wind on immediately, but turn away before recocking the shutter, you can probably get several shots of your subject, and he will still not know that you have been taking pictures.

It is important at this point to make it clear that, never at any time, should you use these techniques to try to make people look ridiculous. There is no law preventing you from taking pictures of strangers in a public place, but if you try to make them look ridiculous, then you cannot blame them if they take some sort of action against you. Equally there is no law against publishing pictures without permission from the people whom you have photographed, but you could get

Your subject is not likely to be very camera conscious with a pigeon in her hair. A drastic method perhaps but Miss World contestants came to expect such treatment.

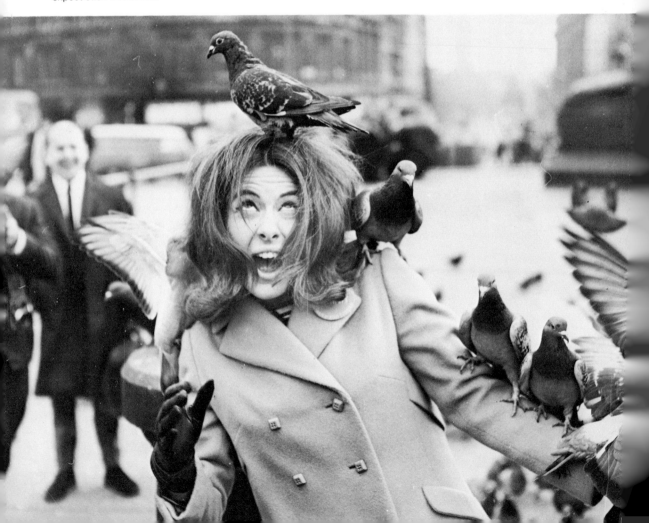

yourself into trouble if you set out deliberately to ridicule them.

Referring to the law, I specifically mean Britain. In some other countries the locals can be quite awkward about having their pictures taken—especially in Africa. There, you will often encounter a superstition that taking somebody's picture means that you are taking something away from them. However, in these situations I have usually found that a little bit of baksheesh makes all the difference!

I did have a ticklish situation once when I was in Jordan. I was off duty and wandering round Amman taking purely tourist-type pictures. Along came an old Arab sitting on a tiny donkey, and it looked to be a good picturesque shot for me, so I raised my camera to take it. But a policeman stepped forward and prevented me from taking the shot, threatening to confiscate my camera if I did not stop.

He asked me not to take pictures of the poor parts of the city, and emphasised that there was no objection to my taking shots of the modern building developments. What he didn't realise, of course, was that one thing I *didn't* want for my album was modern developments in the city. You can shoot those anywhere. What I wanted was the real down-to-earth Arab life. However this situation was easily resolved by me going round the area later with a "tourist policeman" who helps sort out these little problems.

There was another occasion in Amman when things were not nearly so pleasant. I had been assigned to cover rioting in the city by students who were against King Hussein's policy with regard to the Palestinians. The rioting was being contained most effectively by the King's tough and intensely loyal Bedouin desert troops, who certainly stood no nonsense. As I stood watching, one youngster threw some stones at the troops and then ran away, climbing up a hill of rubble. Without any hesitation one of the Bedouins raised his gun and shot the boy.

I was standing not far away watching the whole incident, and I raised my camera fitted with a 240mm Novoflex to shoot pictures. I had just taken my first picture when I felt the most agonising pain on my wrists, and the camera and Novoflex were knocked to the ground in front of me. I looked up and there was one of these giant Bedouins brandishing a pickaxe handle with which he had knocked down my camera. I made a gesture to pick it up, but he raised the pickaxe handle

again mostly threateningly. "That's all right mate," I said. "You can have it!"

As far as I know, the camera and lens are there to this day. That was no time to argue the niceties of the situation, or my rights as a photographer!

Very often people will freeze at the moment they expect a picture to be taken and then relax a moment afterwards. I generally get round this by pretending to take a picture and wind on the camera, but in actual fact I don't press the shutter. So as soon as they relax I really press the shutter and get the picture I want. Of course a motorised camera is very helpful in this respect, but it is rather noisy and does tend to destroy the atmosphere of a picture-taking session.

Rules for informal pictures

Now let's see if we can summarise the hints I have given on taking informal, unposed pictures of people:

1. Use one lens and one camera and stick to it. Don't tangle yourself up with a lot of apparatus.

2. Pre-set your shutter speed, aperture and focus, and if possible don't alter it. Get the picture sharp by moving in or away from your subject to suit the focus which you have set on your camera.

3. Have the camera always at the ready on your chest. People will then accept that you are there with a camera, and in time will not notice it, so that you can shoot un-observed.

4. Take plenty of pictures and be prepared to waste a lot of film.

5. Don't deliberately set out to make people look ridiculous because this will bring no credit to you as a photographer. If by some chance you do take a picture which ridicules your subject, don't put it on public display.

6. When a picture occurs, press the button *immediately.* Don't wait to fiddle about while you check whether focus, exposure or whatever it might be is correct. Shoot first, check afterwards. You can make any necessary adjustments after you have taken that first picture. A shot which is slightly off-focus, or a little under- or over-exposed, but has captured the peak moment, is far better than one which is technically perfect but which has missed that moment. Shoot first, check afterwards.

Don't be shy!

Over the years I have helped in the judging of scores—maybe hundreds—of amateur photographic competitions and I have noticed that unposed shots of people generally include more back views than shots which show faces. Now I know that there are occasions when back views can be more expressive, and now and again I take this sort of picture myself. But these occasions are not all that common.

In any case, study of the pictures does not indicate that the photographers concerned deliberately included the backs instead of faces, and I strongly suspect that the reason was that the photographers, in most cases, were shy. Even fairly experienced photographers sometimes feel just a little awkward about shooting pictures of strangers, head on.

I'd like to be able to give you a magic formula for conquering this camera shyness, but there is only one real cure: practice. Perhaps it will help if I tell you that I take head-on shots of perfect strangers at least a dozen times every week, and I cannot remember the last time anyone objected. Obviously, I am not referring to those who are, perhaps involved in a court case and wish to remain anonymous.

In my experience, strangers will seldom refuse to appear in a picture. If approached properly and politely the general public are most helpful, and there is no need to be at all self-conscious about speaking to them if you want them to get into a particular position for a picture. And remember, there is no law which prevents you photographing strangers in public places without their permission—always provided you do not make a nuisance of yourself or deliberately try to make them appear ridiculous.

Just steel your nerves, take your camera (unloaded if you like) out into the High Street, stand at a corner, and take half-a-dozen "pictures". Then move on and take another half-dozen at a different location. I will guarantee that hardly anyone will take any notice of you, and you will see that there is no need at all to be shy.

Just one point. Don't fiddle about and look around, making it quite obvious that you are self-conscious. Have your camera round your neck in a shooting position and be quite positive in your actions. Just one roll of film should be enough to show you that there was never any need to have been worried about shooting in public.

Making pictures with children

"Sit quite still darling, because the nice photographer is going to take your photo. Oh, just a moment! Her hair has fallen out of place. Now, *that's* better. Sit up straight and smile. Good!"

So runs many a portrait session with a small, unwilling, and probably rebellious model. And it's just about the worst way to set about shooting pictures of one of the most rewarding subjects going—children. Because the certain way to get stilted and unnatural pictures of youngsters is to pose them. When I am shooting pictures of children, I like to allow myself plenty of time and an ample supply of film. In fact, if it is a private job and not for my newspaper where time is usually limited, I will insist upon having at least a whole afternoon with the children. Patience counts for more than anything, and no-one can expect to come up with a winner in two or three minutes.

Before even taking a single picture, you should get to know the children well—unless they're your own, of course, and then you probably know them only too well! I also like them to be on their own "home ground"—in their nursery or playroom, or in their own garden. Never, so far as is possible, will I photograph children in a studio or on a location with which they are not familiar, or where they might be unhappy.

Quite often, particularly with a shy child, I don't produce my camera at all when we first meet. I try to get to know the child first, perhaps play a game with him or her, and definitely get down to their level on the ground; trying to end up with them knowing me as a friend, and not as "the man who has come to take my picture".

If I have not met a child before I like the parents to introduce me as "Uncle Vic" rather than "This is Mr. Blackman who has come to take some photographs of you". This puts the whole session on a much better footing to start with.

Even when I first produce the camera, I do not start taking pictures straight away. I like the children to see it, know it and get over the novelty of this interesting piece of equipment which they have probably never seen before. I let them look through the viewfinder; and I even take pictures of objects other than the children, so that they get used to the sound of the shutter clicking and of me putting it to my eye for focusing and so on.

Above all it is vital that you don't rush things. Wait until the child has got over his initial shyness and the novelty of the camera. Then you can start your shooting as the child plays naturally.

Don't try to pose children—that's fatal—but get your shots as they go on with their normal activities of playing, eating, and even sleeping.

If there is a party, and there is a game, or some sort of entertainment to hold the children's attention, you will find many opportunities for good pictures, particularly if you have a medium long focal length lens with a good wide aperture.

Let the children see you with the camera round your neck for some time beforehand so that you will not attract their attention away from the main object of their interest. Then you can shoot pictures of them without their knowing they are being photographed.

And do get down to the children's level, even if it means lying on the ground. They might think your antics are funny at first, but you must forget your dignity. Their amusement will probably make a good shot and you should capture it.

If you see what looks like a good picture, press the shutter *immediately*, and don't waste time focusing or setting the exposure. That "once in a lifetime" shot may present itself only for a second, and it's worth the chance of a possibly wasted frame to try and capture it. *After* you have exposed is the time to check your settings, and then you may be lucky enough to get a second chance. But don't risk missing the first one while you fiddle with the camera.

I don't like having children dressed especially for being photographed, and I always aim for them to act and feel as normal as possible, which is why I suggest that you photograph them in their own home or garden rather than in a studio. For the same reason I prefer natural light to flash or photoflood. But if a flash or photoflood is necessary because the natural light is completely hopeless, then the photoflood should be switched on well beforehand so that the children get used to the light. And if you are using flash you should make plenty of flash exposures before you actually start taking pictures of the children so that they get used to the flash. Incidentally, in this respect, it is far better to use bounce flash, as direct flash will very often be annoying to children and may make them frightened of the camera.

Frankly, I would go to almost any lengths to avoid flash of any sort where children are concerned.

When the children have become thoroughly used to you moving around and operating your camera—and that could easily take an hour or more—you can start moving in for some big close-ups. Once the novelty of the camera has worn off you can go in as close as you like and you will usually find that the children completely ignore the camera. Of course, a long focus lens is a great help, but even the simplest camera can give good close-ups by the addition of an inexpensive portrait attachment.

I always like to use the fastest possible shutter speed together with a high-speed film, because it's surprising how quickly youngsters move. Usually I load my camera with Tri-X and fit an 85 or 90mm $f2$ lens. With this I can cope with most normal lighting conditions.

You must be prepared to play games with the children at the same time as you are shooting. With very young children, peek-a-boo is a great dodge for getting a smile. And remember that, with patience, even the very beginner with the simplest camera can come up with a picture which will beat any taken by the most expert professional.

If I am shooting outdoors and the sun is shining, I often like to shoot into the sun so that the children are rim lighted and the light on their faces is soft and not ruined by harsh shadows. In these conditions focusing is not generally critical so you can set the distance at, say, nine feet, and then shoot most of your pictures without refocusing, so taking away one of the delaying procedures which might prevent you getting that shot-in-a-million.

However, when taking close-ups focusing must be fairly critical, and in this case you should always try to focus on the eyes. Even if your depth of field is so shallow that the rest of the child will be out of focus, it is the eyes which should be sharp. And if one eye is closer to you than the other—as in semi profile pictures—then it is the eye close to the camera that should be sharp.

But whatever else you may do, never, *never* try to pose children.

Having told you how the job should be done I wouldn't like you to get the impression that I consider myself to be faultless child photographer. I remember I was shooting

picture of my own two children in the garden recently, and I managed to disobey all the rules and hints which I have given. For a start I was doing it in a rush just before I left for Fleet Street, and I didn't have time to "allow the youngsters to get on with their own activities and then shoot discreetly without any attempt at posing".

I gave a fine display of lack of patience when they wouldn't get into the position I wanted. And just when they did get right for a moment, my two dogs decided that *that* was the moment to place their hindquarters right in the foreground. By the time I had sorted out that little problem and manhandled the children back into my dreadfully corny pose, one was on the verge of tears, and the other in full flood.

I gave the job up and went off to the office where I was given my first assignment of the day, photographing some children!

But this time everything went swimmingly. I didn't try to rush the job and made no attempt at posing. The result was a set of pictures I was more than pleased with. And when I dropped a complimentary set round to the young mother, she remarked that my own children must be among the most photographed in the world, and she imagined I must have some wonderful pictures of them. . . .

I don't know why it is, but I never seem to have any success when taking pictures of my own family. Maybe it's because I always like to have a definite object for my picture taking (generally publication in the *Daily Express*) and if I haven't got a purpose in view I look upon the photography as a chore. The result is that my children are the least pictured of any, and the only time they get photographed is when my wife makes threats about calling in a local professional, or taking them to a studio, if I don't do something about it.

More-or-less formal portraits

Again I prefer to work by natural light if it is at all possible. I like to use a medium telephoto lens with a wide aperture and move round my subject, shooting from different angles, usually carrying on a conversation at the same time. I use a wide aperture even if there is plenty of light because it throws the background well out of focus and concentrates attention on the subject. It also obviates the most common

cause of failure, which is camera or subject movement. Focusing should almost always be on the subject's eyes and if one eye is nearer to the camera than the other, this is the eye on which the camera should be focused.

Don't keep your subject in the same position all the time. Have him stand up, sit on a chair, change to another chair, sit at a desk, use a telephone, watch the television. Use plenty of poses. This is the secret of getting a good portrait.

If you are going to use some form of studio lighting, don't complicate yourself by using too many lights. Build up gradually, starting with your main, or as it is known, "key light". Conventionally, this is placed at an angle of around 45° to the subject and above his head. Having got this light right, and ensured that it does not cast any unpleasant shadows of the nose, the next light I like to arrange is the fill-in. This is placed close to the camera position and is used to reduce contrast and put detail into the shadows which are cast by your main key light. If possible it should be diffused, and in any case should be less powerful than your key light.

If your lights are of equal power, the fill-in can be turned round to shine on a reflector placed near the camera to give a diffused and lower powered light on the subject. Or it can be positioned farther away from the subject than the key light. Having got these two lights right, you should then arrange any special-effects lights which you want to put in. For instance, you may like to have a light behind the subject to light the hair. This should be a type of spotlight, or at least one with "barn doors" of some sort on it, to shield direct light from entering the camera lens and giving an overall fogging effect to the final picture. If you want to go further, you may want to light the background, and this should be the last light you place.

I believe that any more lights than the ones I have mentioned just complicate the whole set-up and make portraiture more difficult without necessarily improving the final effect. In fact, many studio pictures look very much overlit. I get the impression that the photographer has found himself with six or seven lights and feels he *must* use every single one of them. This is a mistake. Just remember the ones I have mentioned:

1. Key light
2. Fill-in light

For big close-up portraits it is better to use a longer than usual focal length lens to avoid the distortion which would be caused by having the camera close to the subject. This is actress Lesley Ann Down shot with a 100mm lens on the Minolta.

3. Effect lights (back or rim lighting)
4. Background lighting if required.

Of course you don't *have* to use all these lights, and some of my most successful portraits have been taken with one light only. This can be used directly, but you have to be careful of the harsh shadows it will cause, and you need to be able to visualise exactly what the final effect will be on film. Otherwise, another way of using just one lamp is by bouncing its light off a large reflector surface, such as a light coloured wall, to give a soft effect on the subject's face. This is by far the easiest form of lighting, but unfortunately it often produces a dull and uninteresting picture.

One pose which doesn't often get used, but can produce a very glamorous portrait of a girl, particularly if she has long hair, is to have her lie on her back on the floor, with her head also resting on the floor. If you now stand just beyond the top of her head, and get her to look up into the lens of your camera, you're in position for some very good pictures.

Of course her head will appear upside down in your view-finder, so you will have to twist yourself round in order to get an upright view. One of the big advantages of this pose is that the hair can be carefully arranged on the floor to form a frame to the girl's face. Additionally she is in a very relaxed pose, and will not worry how long you take getting everything just right. In fact if you take too long you will have to be careful she doesn't drop off to sleep!

It sounds an unlikely pose, and you may get a slightly startled reaction from your model when you ask her to lie on the floor, but it really does work. Try it. You'll be surprised at the results you'll get. Photographically of course.

Putting glamour into girl shots

I suppose more rolls of film are exposed on girls than on any other subject. Not only does the photographer get pleasure out of taking the pictures, but nine times out of ten the girl enjoys being photographed. However, although I am no expert on feminine psychology (what mere male is?) I am certain that if you want to please the girl, induce her to come to you for more pictures, praise you as a great photographer, and recommend you to other girls who will pose as unpaid models for you, then your pictures *must* be glamorous. They must flatter the girl and make her more attractive than she really is.

I prefer natural light when it is at all possible and for this picture of Lesley Ann Down I was shooting at 1/8 sec at *f* 1.4 on the Minolta in order to avoid flash or extra lighting. I wanted to keep the mood of the shot in low key.

The photographic highbrows may not think much of this philosophy ("It hasn't captured her character"), and you may not get the portrait hung in the London Salon, or at one of the other major exhibitions. But if it is full of character though not particularly glamorous, you will not rate very highly as a photographer with that girl. Believe me if you can make a girl look really attractive, she will think you are a camera genius!

I am not trying to start a discussion on the rights and wrongs of this. I am merely stating what I and other photographers who take pictures of girls have found.

Of course, you may say, its easy for the press photographer. He can call on glamorous professional models or film stars to pose for his camera. This is perfectly true, and let me admit straight away that the trained model can make even a beginner in photography look like a top photographer. But I also have to shoot attractive pictures of quite ordinary girls who have never modelled in their lives.

Agreed that some girls are completely hopeless so far as pure glamour is concerned, but almost every girl has some attractive features. Maybe her legs, perhaps her shape, her hair or her eyes. She may have a particularly attractive smile, or perhaps a soulful look that is captivating. You must look at her quite clinically, discover the attractive features, and then make sure that you capture them on film. Emphasise them in your pictures rather than the unattractive part of the girl; then the viewer will assume that the rest of her is just as appealing.

To give a rather obvious example: if your subject has long shapely legs, but a dull face, then you shoot from a low viewpoint as she leaps, stretches or poses, to give emphasis to those legs. Don't shoot close-ups which would automatically exclude the girl's photogenic legs.

Practice should be no problem. Walk along any beach and you will find plenty of girls worth photographing. Don't be afraid to ask strangers to pose for you—usually they will be flattered to know that you think they are worth photographing. I have seldom had a refusal, even when the husband or boy friend is present. But do make it quite clear from the beginning that you are taking the pictures for yourself, and that you are not in business to try to sell prints to them.

A classic glamour shot of Donna Reading. Notice how the thumbs, which appear to be pulling down on the lower half of the bikini, have given extra sex appeal to the picture.

134

The vast majority of pictures of girls in the summer are taken on the beach. And regrettably there are very few which are worth a second glance and which make even a naturally beautiful girl look glamorous.

This is entirely the fault of the photographer, and is probably because he doesn't know how to pose the girl. For glamour work you should discard some of the generally accepted advice about photography. For instance, it is quite permissible to pose the girl in what is really quite an improbable position, which she would not normally adopt. The only criterion is that she must look attractive. This is your entire aim when taking glamour pictures.

A good idea for those who are not sure of the way to pose a girl is for them to cut out about a couple of dozen professional pictures from newspapers and magazines, choosing those which show variations of pose. (Incidentally this can be quite a pleasurable task).

Next lay them all out against a plain background, such as a carpet, and shoot a picture of them. Make a ten by eight print, and you then have a reference chart of poses for when you run out of ideas. I would not suggest that you follow these in every detail, but let them be a guide. When you start your shooting session, hand them to the girl and ask her if any of them interest her. In aiming for a particular pose she might drop into an even better one.

When you are quite ready to make your exposure, it will often improve the entire look of the picture if you tell your model to take a deep breath. This will have the effect of giving a better bust line and will also flatten her waist. But do make your exposure immediately she has taken the deep breath. It is quite unreasonable to expect your model to maintain a steady, carefree smile, having held her breath for about thirty seconds while you make final adjustments to the camera.

Also make sure that she holds her head up proudly and keeps her shoulders back. Tell her she looks terrific. Make her feel that she is the best-looking girl on the beach. It will make an enormous difference to how she carries herself. Make her feel really proud of herself. And never, *never* talk about other girls whom you have photographed. Thats just plain bad psychology.

When a girl is in a swimsuit it almost always gives a better

Julie Ege, a superb model. I photographed her in natural light at her London flat. And practically every shot I took of her, both covered up and undressed was a winner. No skill on my part; she is just photogenic.

line to her legs if her toes are pointed. If she is standing up, then get her to go on tiptoe just for the moment you are taking her picture. But, as when you ask her to hold her breath, do take your shot immediately she is ready. She will get most uncomfortable if you keep her on her toes for more than two or three seconds.

The inexperienced model on a beach will often be happier with some sort of prop, such as a beach-ball, or towel, which she can hold above her head. And look around for natural props, such as rocks or boats which are on the beach and are useful for your model to lean against or sit upon.

Don't be afraid to try pictures with movement. Get your girl to leap about or come rushing in from the sea straight at you. I feel that most beach pictures should capture an atmosphere of a zest for life and exhilaration.

Harsh sunshine can kill glamour. This is one of those occasions when a flash can be really useful to fill in the deep shadows. But again, very often the most attractive picture comes from shooting straight into the light, perhaps using a fill-in flash, though this isn't essential. An objection to fill-in flash made by inexperienced photographers is often that the calculations for correct exposure are too complicated for them. My own recipe for combating this is very simple, and goes against all the rules of photography. I simply put a low-powered electronic flash on my camera and then forget about it, making all my aperture and shutter speed settings as if I didn't have a flash there. This is only possible, however, with a between-lens shutter, such as a Compur, which allows you to use an electronic flash at any speed.

If you happen to possess a very high powered flash and you are going to shoot close-ups using flash as a fill-in, you must cut the light down so that it does not become obtrusive. I have found the best way to do this is to put a couple of layers of handkerchief over the flash. You may require only one layer—it depends on how grubby your handkerchief is!

However, you will find that for the majority of your pictures you can do without any form of flash at all, and this is preferable, as you will not then be inhibited by having to wait for the flash to recycle or to replace a bulb.

Always aim to use your fastest shutter speed, so as to reduce the risk of spoiling your picture by subject movement or camera shake, and to allow you to use a wide aperture or

My all time favourite model, Penny
Brahms. I have probably had more
pictures published of Penny than of
anybody else. I think her secret is that
not only does she work hard but that
she enjoys it, and is not satisfied until
I am completely happy that we have
got the picture we were after.

your lens. This will throw the background out of focus and
concentrate attention on your subject still more.

You don't need to go through a lot of formalities getting
to know a girl if you see her on the beach and she is a com-
plete stranger, but you think she'll be a good subject for your
camera. The very fact that you have a camera in your hand
as you walk towards her will give her an idea of what you are
going to say. Simply come straight out with asking her if she
would mind posing for a few pictures for you, and im-
mediately offer to send her a complimentary set of prints if
she will. Don't go through any elaborate "getting to know
her" conversation, or she will think you are merely trying to
pick her up.

She will hardly ever refuse you, as few girls can resist
flattery. And the fact that you have selected her as a possible
photographic subject is flattery in itself. If she's with friends,
she just may put on an act of refusing, as she doesn't want
to appear immodest in front of them. In fact, very often the
friends will help you by persuading her to go ahead and have
her picture taken.

You should already have an idea of the background where
you want to shoot your pictures, so don't be afraid to ask her
to go with you to the location you have selected. She won't

mind this, but quite understandably she could object to having to go tramping about looking for a suitable background.

It is often a good idea to start by putting the girl on some prop such as a boat or a breakwater which is higher than the camera. This immediately gives you a good advantage by providing her with a plain background, and at the same time gives the girl a psychological feeling of being in some way superior. This also gives her apparently longer legs than she actually has, which can be very flattering if she is in some sort of standing pose. But don't use a wide angle lens for such shots. In fact I would go so far as to say that I would never use a wide angle lens for glamour pictures. Always at least a "normal" focal length lens or one slightly longer than normal.

If your model has a vivacious or energetic look about her, use a pose with a certain dynamic quality about it. Get her up on her toes, arching her back and holding on to a beach-ball, or whatever other prop may be handy.

Never, *ever*, shoot pictures of a girl when she is sitting down and her legs are closer to the camera than her body. This will inevitably have the effect of making her feet look over-large. And lets face it, even Miss World's feet could hardly be called the most attractive part of her body.

Don't be afraid to shoot pictures of your model in the water, but make sure she enjoys the sea first. If the waves are high and she is obviously a little nervous about it, this will come through in your pictures, and they will be spoiled. It's better, in that case, to avoid the water altogether.

Beach shots should have a happy, carefree atmosphere, so be prepared to laugh and joke with your girl. Be happy and carefree yourself and don't let it be very apparent that you are too serious about your photography. And *always* compliment the girl on her posing, even if she isn't doing too well. Once you start being critical of her you might as well give up and go home.

Don't be afraid to break the old established portraiture rule about never having the subject looking straight into the lens. Let your model look right into the lens of your camera—it will give a very personal feeling to the finished picture.

Always be on the look out for too much symmetry

This is not a pure glamour shot. I deliberately set out to make the model look sensuous and desirable. That is why I posed her like this and used the camera from above. It's a favourite with the men but I have not yet encountered any ladies who like this picture! Nikon with 58mm lens.

appearing in your pictures. For instance, you should have one leg slightly bent in almost all poses. Don't have the girl standing dead straight. Even her head is often improved by being leaned over at a slight angle. The two arms should be at different angles.

Where exposure is concerned, my personal tendency is to overexpose by a couple of stops and then under-develop, so giving me a soft negative with plenty of detail. Of course, with colour transparencies, you must get the exposure exactly right.

Whatever else you may forget, do remember to send the girl some of the best pictures you took of her. Don't send any

Penny Brahms in close up. The glamour model needs a flawless skin and impeccable make-up for such treatment.

which do not show her at her best. If she has provided you with some good glamour pictures you may be grateful to contact her again at a future date when you want to shoot pictures in some other location. If you have forgotten to send her those complimentary prints you cannot really expect her co-operation at any future time.

Incidentally, where models are concerned, some girls are "right" for some photographers but hopeless for others. I don't know the explanation—a sort of exclusive rapport I suppose. But if you have a girl with whom you just cannot get good pictures, don't blame yourself or her. You both might be better teamed up with someone else.

Throughout my press career I have photographed many hundreds of girls, and with all of them, as soon as I start, I can sense which ones will photograph well for me. With some models, something seems to click, while with others there is a deadness which comes through in the final pictures.

Lillemor Knudsen was one of my earlier favourites, and she earned quite a lot of bread and butter for me in my freelance days with pictures of her which I was able to sell. Margot Fonteyn was another, as also was Penny Brahms and Eva Rueber-Staier. These are names which spring immediately to my mind as some of the best I have photographed, but of course there have been dozens more.

I don't think this rapport can be deliberately cultivated. I have known girls who have openly flirted with photographers (and vice versa!), but unless that elusive atmosphere is there, that enjoyment of taking photographs and being photographed, it makes no difference. The model either hits it with the photographer or she doesn't. If she can hit it with *all* photographers she is a very lucky girl indeed, and will undoubtedly go right to the very top.

Jump for joy

I have always liked pictures with life and movement in them. By this I do not mean the horribly blurred photographs that have become popular with some of the so-called "with-it" magazines, but photographs that capture action and life—pictures with impact.

I have no interest in the chocolate-box type of picture (seldom without an obliquely lit white-washed cottage) that tries to compete with the brushwork of painters. It is for this

143

reason that whenever I have the job of picturing a pretty girl, I usually try to get some action into the photograph. It is these action pictures which are sure-fire winners for publication.

I remember when I was a freelance taking a picture of actress Shirley Eaton having a pillow fight with her young brother, Johnny. There was nothing special about the picture, except that it included a pretty girl and some amusing action. I had several publications at the time of that picture, and then I put it in the hands of an agency where it sold continuously in the years following. In fact I actually received a fee for its publication eighteen years after I had originally taken it!

Another of my favourite shots is one about which I have had my leg pulled on many occasions. It is the "Blackman Jump for Joy". The requirements are a low viewpoint; a little flash; plenty of frilly petticoats if they should be in fashion; and a long-legged, attractive girl.

I have used this idea of getting the girl to jump in the air in an exhilarating and dynamic pose on literally scores of occasions. And there are only one or two instances where I have failed to get a publication out of it.

I used the idea for a shot of Miss World some years ago, and the picture went half-page size in the *Express*. Unfortunately, although the frilly petticoats were in fashion at the time, Miss World had none of them with her, so I went out and bought her some. Having taken the photographs, I whipped the petticoats back from her and gave them to my wife as a present. But when I put in my expenses, I included an item: "To purchasing underwear for Miss World."

My picture editor called me over when he read my expenses and said, "Look, you can't have this in your expenses. You'll have to change it. Put in 'Special entertainment for Miss World'."!

Another occasion when I used the jump-for-joy technique was when I had been photographing actress Julia Lockwood. At the time she was only sixteen and I had been taking normal routine photographs of her for a story a reporter had already written. After the shooting session, Julia and I were having a cup of tea and chatting. During the course of our talk she mentioned that she was going to Paris the following week, and it would be the first time she had ever been there.

It was springtime, and my mind immediately went to my jump-for-joy picture. I could visualise this lovely young teenager on the Champs Elysee, doing a jump-for-joy which would epitomise all the poetic visions of springtime in Paris.

I told her of my idea and added that, of course, I would have to "sell it" to my editor.

"So that I can show him the sort of picture I want to take in Paris, let's do one now. No need to bother about any special lighting or background, I just want to show him the idea of the picture we'll do on the Champs Elysees."

Accordingly we took the picture in her flat, and I simply had a flash on the camera and a rather untidy window in the background. But I wasn't worried about the messy, badly lit picture, as this was merely to show my editor the sort of shot I wanted to do in Paris.

Back in the *Express* office I had a print made and took it to the picture editor, starting to explain my idea. But even before I got as far as mentioning Paris, he interrupted me, saying, "I like this. Yes, I definitely like it".

I said "Yes I agree, but my idea is that..."

Again he interrupted me. "I don't care what your idea is, I like this picture."

He took it away to show the editor, and in no time at all it was measured up and in the paper, exactly as it was. And bang went my trip to Paris!

If only I had known he was going to like that jump-for-joy as much, I would have put more effort into the taking of the picture, and got a better background for it when I took it. But it does go to show the power of this type of picture.

10

Focus on Royalty

Informal pictures of the Royal family are available to anybody at the Badminton Horse Trials. Here, the Queen was taking her own photographs with Lord Snowdon in close attendance.

The royal family don't often come before the lens of the amateur photographer. But photography of them does form a large percentage of the assignments which professional press photographers (particularly those from Fleet Street) have to cover.

Pictures of the royal family have changed drastically over the years. Gone are the days when editors were happy with formal pictures of the Queen making a presentation, shaking the hand of some dignitary, or cutting the tape in order to open an exhibition. The pictures they demand today are informal ones that are interesting in their own right, and not merely because they are pictures of a royal personage.

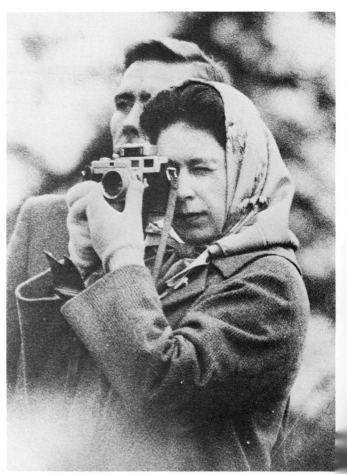

Here I should make it clear that I do not subscribe to the taking of sneak pictures of the royal family, which has been the speciality of one or two freelances. They try deliberately to catch members of the royal family on private occasions in embarrassing situations, and this form of photography is deprecated by almost all professional press photographers.

However, I can't do better than to quote my ex-colleague Bob Haswell, who specialised in photographing the royal family. In his book *The Royals*, it is said "In a world which is bubbling with pink-scented synthetic heroes and heroines, pop stars, screen and TV idols, all headed for the headlines, their images pressured into public notice by powerful publicity machines, the Queen and the royals she represents, face problems which it is not easy to resolve. How far can they concede to the demands of an age dedicated to advertising and public relations, and allow themselves to be exposed—and still retain the aura of majesty and mystique which has, until now, always clung to royalty in this country? To what extent can they allow themselves to compete with the popular idols of today, when they know that the popular idols are here today and gone tomorrow and are as good only as their next play, film or song? Whereas the royals are here for good."

Again "It should be remembered that Queen Elizabeth is not just the head of a State but the head of an organisation as well, a business, the royalty business—in which her husband, sons and daughter, her mother, sister, her cousins, aunts and in-laws all have stakes."

There is no censorship

Undoubtedly it has been a big problem for the Queen deciding what publicity should be encouraged (and undoubtedly the royal family does need publicity) and what restrictions, if any, should be placed on the photography of their activities. It is difficult to draw the line exactly when a member of the royal family is off duty. And anyway who should decide this?

Incidentally, this might be the occasion to clarify a matter on which I am frequently questioned. Pictures that we take of royalty are never censored by Buckingham Palace, the Government, or anyone else. The newspapers have complete freedom to publish whatever pictures they like of the royal family, the only restriction being the good taste (or

otherwise) of the editor. There is no outside censorship, or
weeding out, of any kind.

Difficulties and their causes

Photographing the royal family is often quite a difficult job,
requiring considerable ingenuity on the part of the photo-
grapher to get good informal pictures that are different. The
difficulties are not necessarily caused by the royal personage
herself, although some of them can be awkward on occasions.
But the problems normally arise from local officials and police
who are not used to meeting and dealing with royalty. They
often impose on the press quite unnecessary restrictions that
have caused considerable friction in the past.

These officials and police seem to forget that the press
are seeing and photographing royalty almost every day, so
they are completely unawed by what they regard as a
routine job, and are not liable to do anything silly. On the
other hand, local officials probably regard this as their one
big day, and make the most of it.

Regrettably, there have been several occasions when it has
been necessary for every photographer present at some royal
occasion to deliberately put his camera on the ground and
refuse to take a single picture because of the ridiculous
positions allocated by local officials. Often, when this has
happened, the member of the royal family concerned in-
tervenes and has things changed. Usually, if local officials
would only consult with the personal detective allocated to
the important members of the royal family, everything could
be sorted out to everyone's satisfaction beforehand. The per-
sonal detectives of the various members of the royal family are
well acquainted with the press and have established a good
relationship with them. It is the local officials who usually
cause the trouble.

Favourites of the press

Without the slightest doubt, the most popular members of
the royal family with the press are the Queen Mother and
Princess Alexandra. In fact, it has been said that anyone who
cannot get a good picture of the Queen Mother shouldn't be
in the business. She has developed the knack of standing
just the right distance from the photographers to make a
good picture, and is always facing in the right direction.

148

Again, should there be an obvious incident which would make a good news picture (such as a small child standing looking in awe at the Queen Mother), she will never fail to bend down and have a chat with the child, so making a good picture for the press.

Princess Alexandra is equally co-operative. She also always goes out of her way to be helpful to the press, though of course she cannot make it obvious that she is doing so. This helpfulness by Princess Alexandra resulted in a slightly embarrassing time for Bob Haswell when he was covering her honeymoon at Marbella.

Princess Alexandra pays an official visit. The Princess and the Queen Mother are firm favourites with press photographers.

Bob enjoyed a special relationship with the royal family, having photographed them so often, and during the honeymoon he managed to arrange with Mr. Angus Ogilvy to take some pictures of the couple on the beach. I should mention here that Bob has an extremely persuasive manner!

However, Mr. Ogilvy said that it would be improper for the pictures to look as if they had been arranged, so would Bob make them look as if they had been "snatched" without the royal couple's permission? Accordingly, Bob used a long telephoto lens and took his pictures of the royal honeymooners as if they had no idea that he was around. After this he took some private pictures for them on Alexandra's own personal camera, which had been given to her as a wedding present.

When the pictures appeared in the *Express*, another newspaper, obviously furious at the exclusive which the *Express* had obtained, attacked Bob for his intrusion upon the royal privacy. Unfortunately, Bob couldn't say a word in his defence, as it would have been unethical to reveal that the pictures were being taken with Princess Alexandra's permission, and indeed co-operation.

Covering the special event

The public don't realise the enormous amount of work a press photographer has to put in behind the scenes when he is covering a royal occasion abroad. Just as an instance I will quote the wedding in Athens of King Constantine to Princess Anne-Marie of Denmark. Before leaving on the assignment I had to make preparations, such as getting official accreditation from Greece, and renewing my Greek cable-card, which is a document permitting me to radio pictures from Athens to London "collect", the charge to be paid in London.

I flew to Greece a few days before the wedding, as I felt there might be some interesting pictures to be taken before the event. But as soon as I landed, even before I had unpacked, I set about the most important job on any foreign assignment: establishing lines of communication back to the office in London. The most brilliant pictures in the world are useless if you cannot get them back to London.

First I went to see the staff of a darkroom I had used in Athens before, to make sure they would be able to help me

When Princess Alexandra was on her honeymoon my colleague Bob Haswell snapped this and several other pictures of them but was criticised for them on the grounds of intrusion by an opposition newspaper. He could not confess that in actual fact he had arranged the pictures beforehand with the Princess.

150

with developing and printing. Then I went round to the main post office to check that there would be no snag when I came in with prints for wiring to London. Finally I checked on all the flights to London, so that I could air freight pictures. Because, if they can be got to London in time, originals are always better than radio pictures.

The next job was to get my accreditation checked, and start the fight for passes for a good position on the day of the wedding. "Fight" is the right word, because positions were limited, and there were far more pressmen from all over the world than there were passes. If you sat back and waited for a pass to be handed out, you would still be waiting when the royal couple went off on their honeymoon.

The Americans seemed to be under the impression that they should have the best of everything, and they were quite indignant to think that the British should have the temerity to expect positions as good as those they wanted. The only other British newspapers to send a staff photographer to cover the wedding was the *Daily Mirror*, and their cameraman, Freddy Reed, and myself spent hours arguing with officials about passes. Eventually we got good positions—and glares from the Americans.

Three days before the wedding, Prince Philip flew in with Princess Anne and Prince Charles, neither of whom had been in Athens before, as far as I could remember. So I thought there would be a good chance of their being taken to see the Parthenon on the Acropolis.

It is said that the best time to see the Parthenon is at dawn, so I decided that that was where I would be the following morning, just on the off-chance. Naturally, I didn't mention a word of my plan to Freddy Reed, as I didn't want him to get the same idea. Thus, the next morning, just as the sun was coming over the horizon, I was leaning against a two-thousand year-old pillar, waiting. Over the other side I could just discern someone else, also waiting. I stared hard, and as the light got brighter I recognised the figure—it was Freddy Reed. He'd had the same idea as me.

We laughed over our mild little deception and wondered if we would not have been better off back at our hotel eating our breakfast. For, as the morning went on, the temperature rose into the nineties, and there was no sign of the royals.

However, at about eleven, our patience was rewarded,

and we spotted Prince Philip, Prince Charles and Princess Anne arriving.

Our guess had come off.

I used a Leica with a 35mm lens for all my shots, but it wasn't easy, darting about between the boulders, and I had a sneaking suspicion that there would have been some hearty royal laughter if Freddy or myself had fallen flat on our backs while taking a picture. Incidentally, Prince Charles was taking pictures with an automatic camera.

Freddy and I were able to get our films on the one o'clock plane to London and, although they were too late for our first edition, the main run had originals of far better quality than a radio print would have yielded.

Call from London

An incident took place on this particular assignment which indicates how far-reaching are the tentacles of the London

The result of "doorstepping" at the Parthenon. I waited a long time to catch Princess Anne, Prince Charles and Prince Philip on a hunch that they would go there while in Athens.

newspaper offices. After the wedding itself had taken place, and I had got all my pictures wired to London, my reporter, John Ellison, and I, decided to relax by going along to Piraeus to have one of the famous fish dinners.

We told no-one of our intentions, and had both entirely finished the job, John having put over his complete story, and me having wired my final picture. We drove to the tiny fishing port and, after our meal, wandered along a jetty which was jutting out into the harbour. About halfway along, we came across a curious sight. On the ground was an ordinary telephone with its wire leading down into the water. There was no desk, table, office or anything else near. Just that telephone standing on the jetty.

"What a funny place to find a telephone," said John. And as soon as the words were out of his mouth the phone started to ring.

"Go on anwer it," I said. "They probably won't understand you, but at least it will stop it ringing."

John lifted the phone and said "Hallo".

A voice on the phone said to him "Oh, hallo. Is that you John? This is Nick, on the Foreign Desk in London. We've had quite a bit of difficulty in getting hold of you, but I'm glad we have got you at last. There is just one query we have got about your story . . ."

We never did find out how the office managed to trace us to that phone in the middle of nowhere. But it is said that if a pressman is in the middle of the jungle in Africa, and is passing a little mud hut, should the telephone ring, there is a good chance it will be his London office wanting to speak to him!

George's gaffe

Going back quite a few years to one of the first big "dress" occasions after the war, the Princesses Elizabeth (as she was then) and Margaret were due to be seen in public for the first time in long dresses, when they attended a big function at the Royal Opera House. Practically every photographer in Fleet Street had assembled outside the Opera House in a giant tier—including George Stroud, a colleague on the *Express* and one of Fleet Street's great veteran photographers.

George arrived late, and secured a low-angled viewpoint

Another of the informal shots obtained at the Derby with a prefocused 1000mm lens. Princess Alexandra discusses a point with a friend while her husband, Angus Ogilvy studies the card.

(the only one left) by wriggling between the legs of the other cameramen until he reached the front, just as the princesses were alighting from their car. Naturally, there were police everywhere, and George found two great, black-trousered legs blocking his view. Grabbing hold of one leg and giving it a tug, George, in his glorious cockney voice, shouted "Ease over a bit mate. I can't see a thing".

A voice from above said "Terribly sorry", and the leg obligingly moved over. When the princesses went in "Black Trousers" joined them—and George recognised their owner as King George VI!

When the royal party left the Royal Opera House, George was back there to take pictures of them leaving, and the King took the trouble to come over to George and ask him if his photographs had been all right.

Seizing the opportunity

The Badminton Horse Trials are always an enjoyable assignment. Not only is there the spectacle of the horses tackling that gruelling course, but it is here that the royal family are at their most relaxed. And some fine informal shots can be obtained by pressmen and amateurs if they are prepared to walk a few miles.

Because the royal family's visit to Badminton is an unofficial one, there is no set programme for them, and they move about the fifteen mile course as they please. This is fair enough, but it makes capturing pictures a matter of luck, persistence, and sheer hard work. However, the rewards are worth it in the form of royal pictures which are really informal, showing that the royal family can enjoy an outing in the country just like anybody else.

It has been argued that, as this is a private occasion, the press should not take photographs. However, apart from the informal pictures which we take being good for the image of the royal family (at least that is my opinion), there is the fact that, even if not a single pressman went to Badminton, there would be hundreds, if not thousands, of amateurs snapping away whenever the royal family appeared. So what would be the point of pressmen abstaining?

The royal family are fond of paying private, unannounced

The Queen and her two elder children seem to be puzzled by something on the Derby course. Lord Snowdon puts it on record.

visits to various functions, so the pressman has to keep his eyes open all the time for the unexpected picture which might occur. I remember one occasion when I was covering a routine assignment at the Royal Opera House. It was the dress rehearsal of "Cinderella", which was being danced by Margot Fonteyn. I suppose there were about a dozen cameramen from newspapers, magazines and agencies, shooting pictures of the ballet. I was using a Pentax fitted with 105mm lens, ideal for this job because of its wide aperture of *f*2.

At the end of the first act, I suddenly noticed, sitting in the centre of the stalls about fifteen yards away, Princess Margaret with her son, Viscount Linley. As this was the first time the little boy had been to a theatre, here was obviously a good picture. But the difficulties!

Flash was barred, and from previous experience I knew that the correct exposure for anyone sitting in the stalls was around half-a-second at *f*1.4 with 400 ASA film. And that was when there was a little fill-in light being reflected back from the stage. In this case the curtain was down and the lighting could not have been worse.

However with nothing to lose I set the 105mm lens wide open, the Pentax shutter on one second, focused as best I could, and pressed the release.

And that was the moment when the mirror of my Pentax chose to stick in the "up" position.

While I carried out delicate adjustments to free the mirror (thumping it bad-temperedly with my fists), the manager of the Royal Ballet, who had been sitting with Princess Margaret, came up to me and said "Her Royal Highness asks that you do not take too many pictures, so as not to spoil the performance for her and Viscount Linley".

This was a piece of priceless luck for me because the other photographers who had spotted what I was up to, and whom I was photographing, thought that I had been told that no pictures were being allowed, so they did not shoot any either.

I quickly dumped my Pentax and picked up a Nikon I had with me, and which was fitted with a 58mm lens. This I opened wide to *f*1.4, set the shutter to half-a-second and loosed off a couple of shots.

Although the distance was fifteen yards it would have

been impolite, to say the least, to have moved in close—and I doubt if Princess Margaret's detective would have let me get very far anyway. As it was, he came up after my two pictures and said to all the photographers, "That's enough; this is a private visit".

I wasn't worried about this as I had already got my two pictures, although I was relying on luck, having been shooting at half-a-second, handheld. However, my luck held, because the following day my picture went right across a whole page of the *Express*. And it was exclusive too. Apparently nobody else had risked such a long handheld exposure.

The value of research

Perhaps my favourite royal picture of all occurred at the wedding of Princess Margaret to Lord Snowdon. My position was on the "Wedding Cake", which is Fleet Street's slang term for the Victoria Memorial, opposite Buckingham

The Queen has a strong interest in racing and the 1000mm lens picked up many animated shots at that meeting.

Palace. I was there to shoot pictures with a long focus lens of the royal family, when they made their traditional appearance on the balcony after the wedding. Of course, I wasn't alone. There must have been at least fifty other photographers, all with long focus lenses, carrying out the same assignment.

I have always been a believer in thoroughly researching an assignment if it is at all possible beforehand. So before going on this particular one, I pulled out all the cuttings from our library at the *Express* on the wedding of the Queen to Prince Philip in 1947. Reading through them, I came across one tiny paragraph which stated that, as the royal couple left on their honeymoon, they were waved off from the quadrangle of Buckingham Palace by the entire royal family, some of whom threw rose petals at them.

Now I reasoned that, although I couldn't see very much of the quadrangle (only that small section which was visible

The shot that I obtained of Lord Snowdon and Princess Margaret leaving Buckingham Palace after their wedding. It was the result of research and patience.

through the main archway from the forecourt), there was just an outside chance that I would get a picture depicting the royal family waving off the honeymooners as they drove away. So, after the traditional pictures of all the royals and guests on the balcony of the Palace, while all the other photographers were packing away their long focus equipment, I left mine standing. Several of my friends asked me if I wasn't going to pack up too, but I simply replied "No, I think I'll leave mine until all the crowds have gone".

My research was rewarded, because when Princess Margaret and Lord Snowdon drove off, I was able to use my 1000mm lens to shoot through the archway into the quadrangle, and get a picture of the royal send-off which was completely exclusive and gave me a whole page in the following morning's *Daily Express*.

I think an amusing picture would have been the hectic efforts of my colleagues from the opposition, who were frantically trying to re-erect their long focus equipment when they saw the picture they were missing!

The Queen as a person

I cannot leave the subject of the royals without a special mention of the Queen. Unfortunately, in the past, officialdom at Buckingham Palace has done a magnificent job of completely obscuring the sort of person the Queen really is. They have adhered to old-fashioned ideas about keeping her remote, and never letting the public know anything about her, other than the image she presents on formal public occasions.

However, this attitude has changed in recent years; largely, I believe, owing to the direct influence of the Queen herself. We now have photographs of her, taken informally and showing her in her other role as wife and mother. There was also a magnificent television film made of her and her family; and because of this change of attitude, we have come to know far more about the job the Queen performs.

There is little doubt that the strains and stresses on her are enormous, and there are few others who would have the stamina to stand up to it. And yet, however difficult the occasion—and there have been one or two unfortunate incidents—she displays a grace and serenity which it is a pity is not possessed by some other members of her family.

I remember one occasion, when I was covering one of her

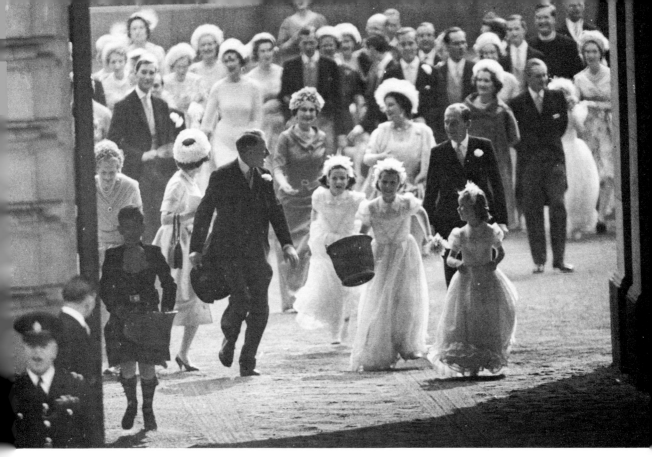

The sequel to the shot on page 159, taken after Lord Snowdon and Princess Margaret had left the Palace.

overseas tours, the crowd surrounding the Queen was so tightly packed that I was pushed closer and closer to her until pictures were quite out of the question, even with a wide angle lens. Suddenly there was an extra surge from the crowd behind me and I found myself literally putting my arms around her!

The crowd fell back and I was able to pull myself away, but I was feeling extremely flustered and rather embarrassed about the incident. But the Queen simply smiled calmly and said "Never mind Mr. Blackman" (how the devil did she ever know or remember my name?). "There's no harm done, and I know it wasn't your fault."

On that same tour—it was in Holland—there was one evening when the Queen was due to attend a banquet being given at the British Ambassador's residence. There was really no need for me to take any pictures, as the event was being covered by what is called a rota. For the benefit of those who don't know, I should explain that a rota is when just one or two cameramen are selected to cover a special event where space is restricted, and they then make their pictures available to all the other newspapers. The idea is that this prevents an unruly mass of cameramen spoiling a special occasion. However its disadvantage is that it does tend to produce rather dull and stereotyped pictures.

Anyway, as this particular event was being covered by a rota, I could really have taken the evening off. But I never like leaving anything to anyone else if I can do something about it myself. So I decided that I would try to get a picture of the Queen as she arrived back at the Royal Palace in Amsterdam from the banquet. Accordingly, at around midnight, I positioned myself at the front door. I should explain here that, unlike Buckingham Palace, there are no railings round the palace in Amsterdam.

In due course the Queen arrived, and quite literally posed for me as I shot pictures from a distance of about four yards. I was the only photographer there, as everyone else was relying on pictures taken inside the embassy by the rota men, and which should be far better than mine. But there had been a snag, and for some reason the rota pictures never did arrive. So nobody had any pictures from the banquet. I wired my pictures to London and was rewarded by a big display on page one.

From this you will see why I never like relying on anybody else if I can do the job myself.

11

Taking the Wedding Pictures

All of us who own a camera are asked at sometime to take pictures at a wedding. It might be a request simply to take a few snapshots, while a professional will be doing the official pictures. Or, if you are an experienced amateur, you may be asked to do the entire photography of a wedding. Let's first consider the former case, where you are simply asked to take a few extra snapshots.

What sort of film are you going to use? Well, here I suggest that you have a word with the bride and groom beforehand, and ask them whether they would like prints or slides. But in any case I think that you should shoot in colour.

For some reason which I have never been able to comprehend, the vast majority of professional wedding photographers take their pictures in black-and-white. This is quite remarkable when you consider that the general public are used to seeing almost all their films in the cinema in colour, television pictures in colour, and they even take their own holiday snapshots in colour. Yet the average professional wedding photographer uses black-and-white. It's amazing isn't it?

Anyway, as I said, your choice should be colour; and if your friend would prefer slides, I strongly suggest that you load with a film like High Speed Ektachrome. This will not produce the sort of quality which Kodachrome can give, but it will enable you to take shots in very poor lighting conditions, such as exist in the church, and at the wedding reception afterwards. If the couple want prints, then any of the well-known colour films will give you good quality results.

Looking for informal pictures

What sort of pictures should you aim to take? Obviously the ones that the professional is unable to take, such as those candid shots that occur while he is setting up his more formal pictures. Very often these "off-the-cuff" pictures have a lot more interest later on than the more formal poses that the professional will have been taking.

A good professional often has an assistant taking the informal shots. But the really interesting or amusing shot can arise and be gone again in a fleeting moment, so you have a good chance of getting some outstanding pictures that are

163

missed by the professional. These are the ones you should be looking out for.

It is important that you do not impede the professional in any way, or prevent him from getting his pictures by getting in the way when he is setting up a pose. He has been assigned the job of taking the official pictures and it would be most unfair of you to spoil his work.

Good pictures always occur after the formal ones have been taken and the bride and groom are walking towards the car. This is the time when confetti is thrown and there is a lot of gaiety and laughter from the guests. You should be ready at this time to shoot plenty of pictures. Don't try to focus accurately. Just fit a wide angle lens if you have one, set the camera on around three yards, and capture the moment rather than the technically perfect picture. Quite probably, your shots will not be enlarged beyond enprint size, so any slight imperfections will not show in the final result.

I mentioned taking pictures in the church. Now there is no hard rule that can be laid down about this. Some churches allow pictures to be taken during the service and even flash to be used. Others strictly forbid photography in the church during any part of the service. It largely depends on the vicar, and I strongly advise that you have a word with him beforehand concerning taking photographs in the church. In any case, he will almost certainly allow pictures to be taken during the signing of the register. Here again the professional will probably be taking pictures, so do not usurp his job. Bear in mind that yours should be the pictures which he cannot take.

As a press photographer, I sometimes have to take pictures where I have not previously obtained permission. I well remember attending a big society wedding and wanting a picture inside the church during the ceremony. Naturally, I had no intention of using flash, but I set my Leica to 1/15 sec at $f2$ and went and stood in the gallery amid the hundreds of guests. At the right moment I inconspicuously raised my camera and took my picture.

A quiet voice came from the lady at my side "The vicar is my husband, and if he sees you taking photographs he will be furious". I don't mind admitting that I blushed at that moment. Of all the places in the church, I had to pick that one right next to the vicar's wife!

However, the quiet voice went on "If you come and stand behind me and take your pictures he probably won't see you". I did just that, and left quietly, thinking how very kind and well thought of that vicar's wife must be. As I went out, I placed an extra large donation in the church collection box.

Another big Society wedding was once being covered by a colleague of mine on the *Express*, George Stroud. Having photographed the arrival of the bride, George decided to try and obtain a picture during the actual ceremony. Not wishing to disturb the guests (and get ejected into the bargain) George got down on his hands and knees and crawled up the centre aisle of the church with his camera held before him, just like a soldier on patrol in enemy territory.

When he had reached about the halfway mark, George was startled to see that every eye in the congregation was turned in his direction. He glanced behind and, to his horror, saw that he was the leader of a great crocodile of some twenty photographers, all on their hands and knees and following George up the aisle!

They were the opposition photographers from other newspapers and agencies, and had noticed George's strategy. So, determined not to be beaten by an inside picture of the ceremony, they got in line behind him as he crawled along and copied his tactics.

George said he did not dare stand upright in the middle of the service so he turned round, still on his knees, and crawled back down the aisle followed by the other twenty cameramen, also on their hands and knees.

"It was just like the conga," was George's comment on the incident.

Taking the official pictures

What if you are asked to take the official pictures of the wedding? If you are an amateur these are probably going to be the most important pictures you take in your career—at least, so far as the bride and groom are concerned. It is important to remember that a wedding takes place only once, so there is no possibility of a second chance if anything goes wrong. You can't re-stage a wedding because you messed up exposures, or your camera wasn't working properly. However don't let the responsibility bear down on you so much as to inhibit your photography. I have photographed

literally hundreds of weddings and so far haven't had a complete failure. It is simply a matter of planning and taking the proper precautions.

Which camera should you use? Without any reservations I state that this should be your normal camera. Don't go and buy or borrow a completely new or untried camera with which you are not familiar, simply because you know that you are going to do an important job. Stick to the camera you know. The mere fact that you have been asked, probably indicates that you are a keen amateur and have a fairly good camera. If yours is a very simple camera with not a particularly good lens, you should not undertake the job of taking the official wedding pictures.

Before going to take the wedding pictures, check that your camera is working properly. Without a film in it hold the camera up to the light and see that the shutter appears to be working properly at all speeds. Check that the aperture is

Bob Haswell grabbed this fleeting expression on Prince Philip's face during the service at Princess Margaret's wedding.

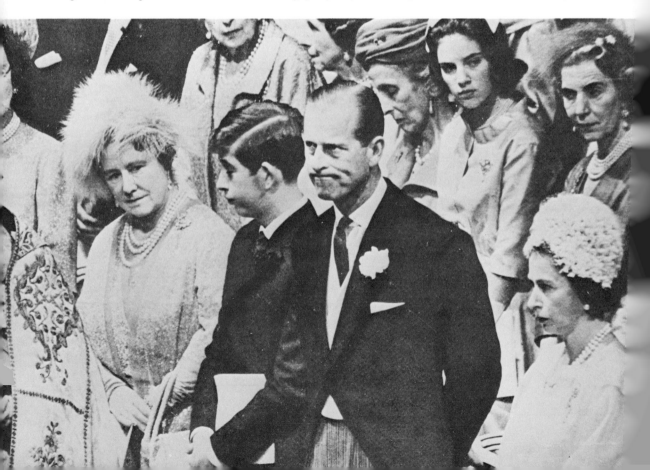

working correctly. And, most important, when you do load the film into the camera, make sure that it is winding on properly. Thousands of films have been ruined by photographers failing to check that the take-up spool is really taking up the film and winding it on properly. On most 35mm cameras this can be checked by seeing that the rewind knob revolves as you advance the first few frames.

Flash will be useful for some of your shots, such as the signing of the register, the cutting of the cake and, if the light outside the church is bright sunshine and particularly contrasty, as a shadow fill-in. Excessive contrast is a big

An unusual Royal Wedding picture as Queen mother Frederica directs operations at the wedding of her daughter Sofia and Prince Juan Carlos de Borbón.

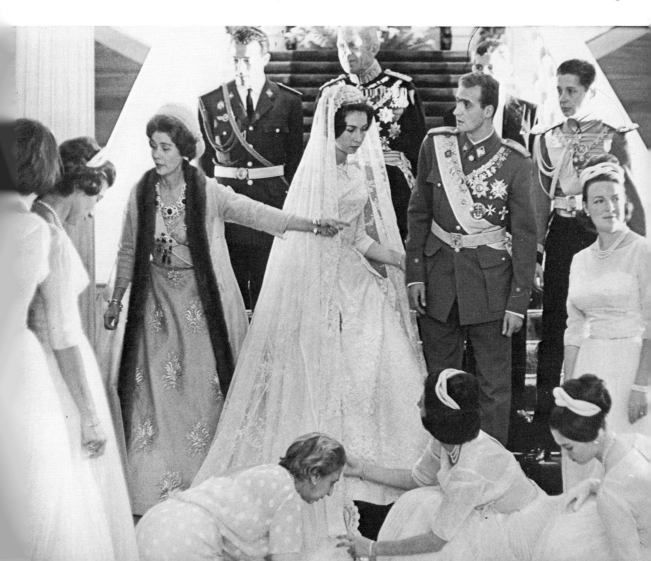

problem in formal wedding photography because the bride often wears white, and the groom a very dark suit. The way to overcome this is the usual one of giving plenty of exposure (I like to give two stops over the exposure indicated by my meter as being "correct"), and then reducing development later. However if you are shooting in colour, the correct exposure is the only one that you can use. In this case you can reduce excessive contrast caused by harsh sunlight by using fill-in-flash.

If possible you should have a friend who is also a competent photographer to take the informal shots that may arise while you are shooting the formal groups. It is most important that you tackle these formal posed groups in the right frame of mind. You might not consider them inspired photography or "catching that moment in time"; but these are the pictures that the bride, the groom, and their families, want to see and to have copies of in the future. Everyone enjoys seeing the informal pictures, but they also want those that show all the guests, bridesmaids, and so on.

For these pictures I have found a tripod invaluable. It performs two functions. it enables me to shoot at a fairly small aperture, using a slower speed (and therefore finer grained) film, without any danger of camera shake. But it also has a psychological effect. With a camera on a tripod in front of a group, the members are more inclined to be "disciplined" by the photographer than if he is standing in front of them rather informally.

For the big groups I like to use a small aperture in order to ensure maximum crispness from edge to edge of the print. A large group picture is one of the finest tests of a lens I know, because any imperfections show up in the faces of the people in the group, particularly those at the extremities.

If possible, I shoot a picture of the bride being prepared for the ceremony at home, usually by her mother. I then dash off to the chruch ahead of her to get the arrival of the groom, best man, and the guests. A popular picture here is one of the groom and best man standing outside the church door looking at their watches. If they're not doing it naturally, ask them to go through the action.

Guests and bridesmaids

To picture the arrival of the guests I usually position myself

on the path up which they will walk, and pre-focus on a distance about five yards away. Then as the guests pass this predetermined mark I take my picture. Some, seeing a camera levelled at them, tend to pose for you. If you see them doing this, call out to them to keep on walking and to ignore your camera. Then expose as they pass over your predetermined position.

A shot of the bridesmaids arriving is always important. However, you will have to do a little arranging here, because they will undoubtedly be in an untidy group as they arrive. I usually go up to the car as they get out and ask them to walk towards me with the smaller ones in front, and telling them to keep close together as they walk. I then get back to my usual position and shoot them as they pass over the pre-focused spot. For all these walking shots an exposure of 1/250 sec is about right if there is sufficient light.

The last picture you will take before the ceremony will be of the bride and her father arriving. You will probably be disappointed to see that her veil covers her face. But do *not* ask her to raise it!

Shooting the ceremony

If pictures in the church are not allowed you now have nothing to do until the couple go to sign the register. But if permission has been obtained—it is seldom refused in Roman Catholic churches—there are many pictures you can take during the ceremony. Even if you are allowed to use flash I would suggest that you shoot by natural light, because these pictures have far more atmosphere than flash shots.

If possible you should use a tripod, because you can then give a fairly lengthy exposure should the light be poor, or if you need to shoot at a small aperture to give increased depth of field. There is generally so little movement that even a one-second exposure can give you sharp pictures. One shot can be taken from the back of the church, perhaps up on the balcony giving a general view. Another can be taken from about half-way down the aisle showing the backs of the couple as they kneel before the priest. And then, if you are able, you should position yourself at the side, but slightly in front of the couple, so that you can shoot pictures of their

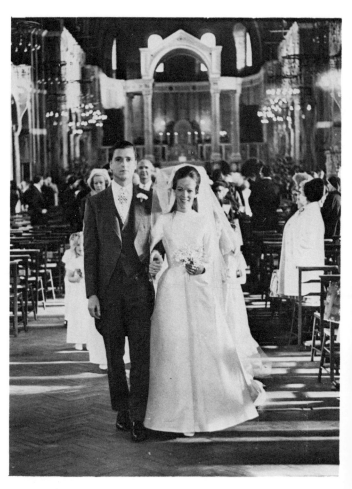

A typical wedding picture of the couple walking down the aisle. A slow shutter speed is possible and this was, in fact, taken at 1/30 sec with the Olympus 35ECR automatic camera.

faces as the service progresses. If possible, get a picture of the groom putting the ring on his bride's finger.

Then comes the signing of the register. Vicars are very used to photography here, and they will usually ask that the register be signed properly first, and then the couple pose for a signing picture. This is by far the best arrangement, and you should fall in with the wishes of the vicar in this respect.

After the ceremony

As soon as you have taken these pictures you should get out to the exit of the church as quickly as possible ready to shoot a picture as the couple walk slowly down the aisle. Although

they will be moving, you can still get away with quite a longish exposure. If the light is really poor, then a flash is permissible for this shot. However I still prefer to work even as slow as 1/15 sec, in order to avoid using flash and preserve the atmosphere.

As soon as the couple get outside the church you should authoritatively take over. You will previously, I hope, have planned the best position for your pictures, and you should quickly separate the bride and groom from the rest of the guests to take a picture of them together. This is a most important picture and you should be sure to get it right. Take several so you can be sure to get at least one with both their expressions at their most pleasing.

Normally the groom stands on the right of his bride, but sometimes he will inadvertently have got changed round while being congratulated by the guests. In which case put him back on the right side.

Once you have secured this picture you should shoot some of the bride on her own. Just ask the groom to stand aside for a short while and then take some pictures of the bride, having her turn slightly away from you, so that her body is in semi profile but her head is turned to face the camera. Shoot both close-ups and full-lengths of the couple and of the bride alone.

During all this time your assistant should be shooting candids. But now comes your job of setting up the groups.

The first group you will shoot should be of the bride and groom with the best man on the groom's right, and the bridesmaids on either side to make a neat picture.

Keeping this group as it is, you should then bring in the parents, having the bride's parents standing at her end of the group, and the groom's at his end. But don't just put them on the end leaving the group as it is. This would result in rather a long picture. Get the best man and the two fathers to stand back so that they are looking over the heads of smaller members of the group, such as the bridesmaids.

The last official group picture is one of the entire guests.

You should keep your previous group as it is and then ask all the guests to gather round them.

You will never be able to get them into a neat pose, so don't even attempt it. But do try to get every single person in the picture. An elevated position, such as on a wall, is of

enormous help in seeing every face. Take several pictures of this group because it is going to be the most requested picture of the whole session.

Getting everybody's attention so that they all look at the camera is not easy, but I have found it is largely a matter of a rather authoritative manner (not bullying though), and a clearly heard voice. Unfortunately, this also produces a rather stony stare at the camera. But I have often found that this can be broken by saying something like "Come on! Don't look so miserable. This is a wedding, not a funeral!" Having said this you should be ready to shoot *immediately*, as almost without fail, the group will break into laughter. This is the shot you have been wanting.

As soon as you have taken it you should dash down the church path and be ready with your camera focused on about four yards to shoot pictures of the couple as they go towards their car being showered with confetti by their friends. When they reach the car, stop them before they enter and take a picture of the bride with one foot on the sill of the car, just about to get in. Pose this up carefully, as it always makes a good picture, with the groom apparently assisting her.

Once they are in the car, nip into the seat next to the driver and, with a flash on your camera shoot a picture of the couple inside the car.

Say something like "Go on put your arm round her. You're married now!" and without any doubt the groom will happily oblige!

Shoot a picture of them smiling into the camera, and then you might like one of the groom kissing the bride. However, do not take a picture of him kissing her on the lips in the normal way. This is a most disappointing shot. Ask him just to peck her on the cheek. It makes a much better picture.

At the reception you should take some pictures of the bride and groom greeting some of their guests. And the next important picture you should take is the cutting of the cake. This should be posed carefully, with the bride and groom close together; the bride holding the knife and the groom's hand over hers.

I like to set this picture up before the actual cutting of the cake. And previously I would have put some bouquets on the table round the cake to hide the various pieces of cutlery

which are not particularly decorative. It also adds to the attractiveness if you get the bridesmaids in the background for this picture.

Finally comes the picture of the couple leaving for their honeymoon. Here you shoot the obvious candids, but one you might forget is of the back view of the car as it drives off. This is an important picture because it effectively rounds off the story of the wedding in pictures.

Coping with bad weather

One of the biggest problems you are likely to encounter in wedding photography is bad weather. However, even in the rain, it is possible to take good pictures if you can persuade the guests to stand while you take them. But obviously, you shouldn't spend too much time taking a lot of pictures. Just take the essential ones and be quick about it.

If the light is *very* bad, pictures are still possible, even if you have to give as long as a one second exposure. This is when a tripod is so vital. In this case you must explain to the guests, as you assemble them in their groups, that because of the light (which they can see anyway), you are having to give a long exposure, and you will have to ask them to stand still. They will not usually mind, and if you tell them "Right! Still at this moment", you can get your pictures quite satisfactorily. Certainly they won't have the spontaneity of pictures you would take with a shorter shutter speed; but you will have got your shots in the bag, which is the main consideration.

It is important not to get flustered and to panic when taking wedding shots. You should be calm, and not hectoring to the guests as you arrange the groups. But you should also look as if you know what you are about. So plan each picture or series of pictures beforehand, so that you know exactly what you have to do. Jot a list of the important pictures on a card, and don't be afraid to refer to it if you think you might forget any. That's what I did when I started. And, most important, know your camera thoroughly, so that you are using it instinctively, and not having to give a lot of thought to technicalities.

Of course, you can't have a trial run-through of your wedding beforehand, but you can go along to a couple of weddings at a church nearby and see how the professional

works. If he is a good professional you will be able to learn a lot from watching him.

Lastly, do present your pictures well when handing them over to the bride. You may have selected them yourself and made finished prints; or you may have made proofs, from which you let the bride and groom select what they want. But in any case, when you hand the final prints over they should be attractively mounted, preferably in an album.

Bear in mind that scores of people are going to look at these pictures. So it will be very flattering to you if they ask who the photographer was, and would it be possible for him to take pictures at *their* wedding.

12

From Starlet to Ballerina

Much of press work consists of showbiz photography, and paradoxically it is both the easiest and most difficult part of our work. Easy, because usually showbiz personalities are seeking publicity and are only too willing to go to a lot of trouble to help photographers take good pictures. Additionally they are used to being photographed, so there is very seldom any camera shyness.

The difficult part is that the photographer who aims to be more than just a hack snapshotter will be trying to get a picture which will be original and different. And showbiz personalities are so much photographed that the "different" picture is a very rare bird.

Interestingly, the freelance often has a better chance of getting good exclusive pictures of showbiz personalities and happenings than the staff man working for a big newspaper. This wasn't always the case, but it has come about because publicity men have, all too often, found to their cost that they have given exclusive rights to a particular newspaper to photograph some special sequence in, perhaps, a film. Then, because of pressures of space or other more important news occurring, the exclusive showbiz pictures never get published.

Building-up contacts

However, if exclusive rights are given to a good freelance, the publicist knows that the freelance will first attempt to sell his pictures to the big-circulation newspapers such as the *Express* and *Mirror*, and if he does not succeed here he will sell them elsewhere. But because he is making his living from the sale of pictures he will make sure they are published *somewhere*. Thus the publicist is guaranteed publicity for his film. The staff man can never give a positive guarantee of publication for anything. This situation has been exploited to a very high degree by such top showbiz freelances as Terry O'Neil, who makes thousands of pounds by the sales of his pictures to newspapers in this country and to magazines abroad.

I well remember Terry's early days when he was working on a small agency. Even then he had the idea of establishing contacts in showbiz for the future, and when we were on an assignment where there was a photo-call to take pictures of some star personality, Terry would go up to the star

afterwards and ask if he could call round the following day to do some special pictures for himself.

In this way, Terry established a personal contact with the star. He also built himself up a stock of exclusive pictures which he had been able to take at his leisure, and without the pressures there are during a general photo-call for the whole of the press.

Terry was also very skilled at spotting promising new-comers. He was one of the first to shoot good pictures of Raquel Welch, and to give her extensive publicity. Raquel never forgot this, and even to this day she will not allow any special picture sessions with any photographer other than Terry O'Neil.

But don't get the idea it is merely a matter of making contacts. Terry is a skilled photographer and is able to take very good pictures. He was also ready to diversify as soon as he saw that sports personalities were being elevated to become super-stars who also required publicity. Very soon he was selling pictures of these to the newspapers. Pictures which usually had a different angle, or a unique quality about them. Truly a great professional is Terry, with a very astute knowledge of the requirements of editors.

Early on in my freelance career, I also realised the importance of having good contacts in showbiz, as I saw that this could be a very lucrative form of photography for me. In those early years I formed several friendships with showbiz personalities which helped to provide me with many saleable pictures.

When Janette Scott was in her teens I was a regular visitor to her home, and not only for pictures either. Her mother, actress Thora Hird, recognised that I usually arrived on her doorstep with an empty stomach, and with typical Northern hospitality, always ensured that I didn't leave before I'd had a good meal!

The same with Shirley Eaton. Her mother also kept the wolf from the door (at least so far as food was concerned!) whenever I called. I think I did mention earlier that times were very tough for me in those early freelancing days, and it was only through the generosity of friends that I was able to eat at all regularly. And showbiz folk are, without doubt, some of the most generous people around.

Shirley provided me with many of my best early showbiz

When I look at this picture of actress Janette Scott I can still hardly believe it is the same little girl who used to be hanging around when I called at her home and was fed by her mother during my early starving freelance days.

176

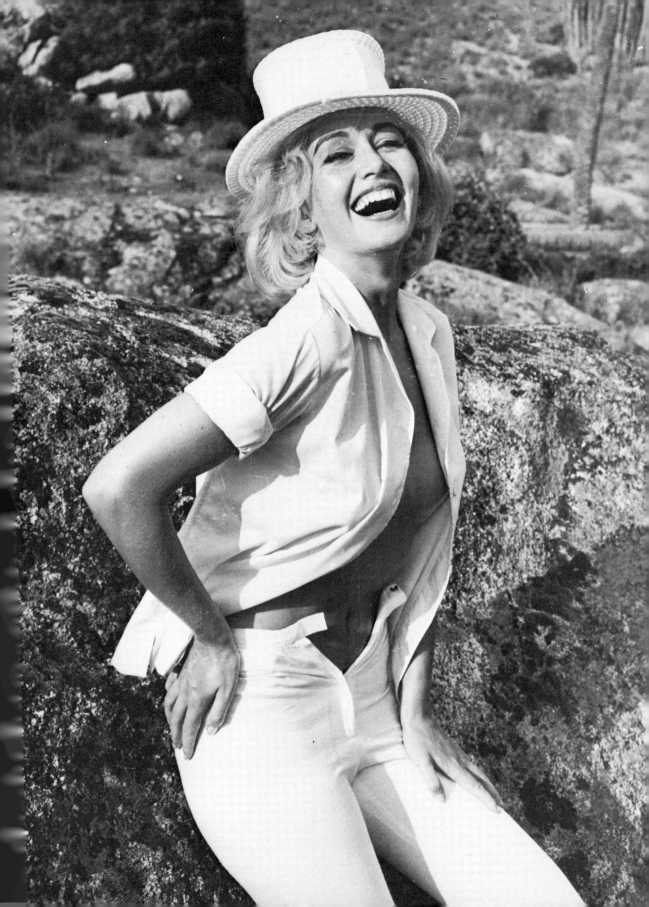

My Way with a Camera

pictures and I first met her when I was doing freelance work for the *Daily Sketch*. She was only eighteen at the time, and had just signed a £20 000 film contract. She was appearing in a pantomime at the London Palladium, and the *Sketch* picture editor had told me that if I liked to go along and see her I might just get a good picture.

"But don't pin too much faith on getting a publication," he told me. "We've got a very good picture of her taken by our chief photographer which is going in the first edition, and you'll have to get something really good to beat that."

This was the sort of challenge I loved, and I set off for the Palladium trying to think of a picture which would knock out the one the *Sketch* already had lined up. As soon as I was introduced to Shirley I discovered we had that magic empathy about which I have already written. She was ready to go to any amount of trouble for a good picture for me, and if I could only get the right idea I knew it would be in the bag.

I took shots of her with her contract, apparently signing it and looking happy, together with all the usual, routine, contract-signing pictures. But I still felt I hadn't got *the* picture I was looking for.

Then I had an idea.

"Let's go out on the stage, Shirley," I said. "And see if we can get a picture with some movement in it. I want to see you jumping for joy and waving the contract in the air, looking full of excitement and zest for life."

I placed a couple of stage hands in position in the background of my picture, eating sandwiches, and then got Shirley to do some spins and jumps in her long flowing dress. I think this was the first time I attempted my famous "jump-for-joy". She fulfilled it perfectly, waving the contract in the air. When I took it back to the *Sketch*, the picture editor took my print, and without hesitation, substituted it for the one which was scheduled for the paper.

This success was very gratifying to my ego, but I knew that I owed a lot of it to Shirley's patience and photogenic qualities, so I maintained my friendship with her for many years after that, during which time she provided me with dozens of publishable pictures.

A favourite personality

If I have to name my favourite showbiz personality of all

My first "jump-for-joy" picture. Shirley Eaton, on the stage at the London Palladium, waving the £20,000 film contract she had just signed.

179

time, I think it would undoubtedly be actress Adrienne Corri. I first met Adrienne when I was still a schoolteacher. I had won a contest which was being organised by the London *Evening News*, the prize for which was to escort a film-star to the premiere of a film called "Love Lottery".

The idea was that the twelve contest winners would each draw from a drum the name of a film actress whom they would escort for the evening. At that time I was not much of a filmgoer, and didn't really know much about any of the film stars. However, I *did* know that Diana Dors was one of my favourites, and hoped to draw her out of the drum. Instead I drew Adrienne Corri.

At that time Adrienne was *the* big name in the film business, having just had an enormous success in "The River", and a tremendous future was being predicted for her.

Because Adrienne was such big news at the time I, as her escort, was interviewed by the BBC, who asked me what I thought of taking out the new super-star. To my eternal shame, I'm afraid I replied that, in all honesty, I had never even heard of Adrienne Corri! What's more I had never seen any of her films, and somehow I must have indicated that I would have preferred to have had Diana Dors on my arm. Not exactly the finest way to start a friendship.

But somehow we did seem to get on well together, and later on Adrienne paid a visit to the school at which I was teaching. I also told her about my possible plans for going into press photography on a full time basis, but she advised me most strongly against this. As you know, in spite of her advice, I took the plunge. And that is when Adrienne showed her true qualities of great generosity. She was like an angel to me.

I should emphasise that there was never at any time any question of romance. Sounds corny, but we were truly, just good friends. But she seemed to feel that she had a special responsibility for me, as though she had been instrumental in me entering press photography as a profession.

During those hard, early times, I would very often, at the end of a long day, not having had a meal of any sort, call round at her flat in Lowndes Square. Whether she was in or not, I was able to get in by pulling the key, which was hung by string, through the letter box, and cook myself a meal in her kitchen. She still complains that she didn't mind me

eating her out of house and home, but she did wish that I had done the washing up after me.

Adrienne *never* sought publicity. In fact, whenever I suggested that we do a picture for publication she would more than likely say "Oh, don't lets bother about that. Lets have a drink instead". And that applies to this very day.

She is one of the greatest characters in showbiz, and certainly one of the best friends anybody could have. And I'll bet that if she ever reads this, she will make some remark, such as "What a lot of rubbish! All that flattery is only so you can get another free meal!"

A favourite picture

One of my favourite showbiz pictures was one which I took when I was in the bar of St. Martin's theatre one evening. Standing at the bar were Noel Coward, Vivien Leigh, Kay Kendall and Lauren Bacall.

I nipped behind the bar, and bouncing flash from the ceiling, took a picture which caught them with such wonderful expressions on their faces that the picture went over half a page in the *Daily Express*.

I mentioned Diana Dors just now, and she is a girl whom I have always admired. Even when she was at the peak of her fame as Britain's so-called sex symbol, she was always willing to help the lowliest photographer. I well remember once when she was attending the premiere of one of her films, there were fantastic crowds in London's Piccadilly and Haymarket to see her arrival, the streets being completely blocked, so great was her attraction. When she walked into the foyer everyone took their pictures, except me.

My flash lead had become loose and was giving trouble, so I was unable to shoot any pictures of her. The other photographers all left rapidly to get their pictures back to their respective newspapers, but I was still struggling desperately with my flash lead.

Diana was being urged inside by the publicity man, who was implying that I wasn't worth waiting for, as all the top photographers had already got their pictures. But Diana would have none of this. Although she was the star attraction, and the entire show was waiting for her, she insisted upon waiting while I dismantled my flash lead, put it

together again and got it working, so that I could get a picture of her. The fact that she, a great star, could deliberately hold up the whole proceedings so that I, an unimportant photographer, could get a picture, gives an idea of Diana's helpful nature.

Producing something different

In those days, film premieres, theatrical first nights, and receptions at hotels provided many glamour pictures for me of celebrities and starlets. At that time these were easily the most saleable commodities to magazines and newspapers. Before you jump in to deride my low-brow outlook, let me emphasise that my main ambition in those days was to eat. And in order to do that, I had to sell pictures. It's only when you have a healthy bank balance that you can be choosy about the type of pictures you take.

But to continue. One evening at the Savoy Hotel I saw a tall, attractive blonde, and took some pictures of her. The next step was to find a gimmick caption on which to sell the pictures. She told me that her name was Lillemor Knudsen, and that she was a dancer, but had also played in several films. Nothing there to give me much in the way of a caption.

Was she married to anyone famous? No, not even engaged. Then I had an idea.

"Lillemor. Didn't I hear that you were engaged to a millionaire in the shipping business?" Lillemor cottoned on to the idea, and answered "No. And I have no comment to offer on any names".

The next morning one of the pictures I had taken of her was published in a national daily newspaper (and also appeared in an evening paper) with a caption which read "Last night film-actress Lillemor Knudsen denied rumours of an impending engagement to a mystery millionaire shipping magnate. But when a certain name was put to her she turned away with the words 'No comment'!"

This was the start of a long partnership between Lillemor and myself which paid me handsomely in published pictures of her all over the world, while Lillemor herself achieved no small amount of fame. I photographed her in every kind of situation which would publish. Sometimes, when a big film premiere was coming up, my wife, Lillemor, and myself

Diana Dors at a film premiere. Another favourite girl who was always ready to help the photographer—even when his flash lead went on the blink!

would sit down and try to think of something that would give us a different picture from all the other photographers.

Once, my wife suggested that Lillemor should trip over as she entered the theatre for a premiere, and scatter the contents of her handbag. Naturally, I would be the only photographer in the right position for a good picture.

The night of the premiere it was pouring with rain. But with admirable courage down went Lillemor into the mud —and the picture went nearly half a page in one picture paper.

Lillemor had her revenge on my wife, however, when she suggested that my wife dance on the roof of a cinema dressed in Eastern clothing. My wife did it. I photographed it, and we continued eating.

The number of pictures Lillemor and I shot was countless. Anything from haymaking in attractive hot-pants to relaxing on the pier at Greenwich (with the mud carefully hidden from the camera) and a caption "'Its just like the South of France' said Lillemor".

She loved animals, so I photographed her, impeccably dressed, with all sorts of thoroughbred dogs, and the country magazines lapped up the pictures. Another time she owned a pet fox which was a certain picture-maker, time and again. Our partnership came to an end when I joined the staff of the *Daily Express*, and Lillemor married and started raising a family. However, we still see each other occasionally, although we have both left the days of quick-selling glamour pictures far behind us. But it was great fun, so if you want to try your hand at freelancing, just find yourself an attractive girl who is connected with showbiz, and get started.

Showbiz pictures for amateurs

Most amateurs are very restricted in the amount of showbiz photography they can carry out, as cameras are normally forbidden in the theatre. What a pity this is! With a little imagination, the management of theatres could run one or two special evenings (especially towards the end of the run of the show) where photographers are invited to attend and take pictures.

This idea would provide excellent opportunities which are not normally available to amateurs, and would also fill theatres which would otherwise be half empty.

The incomparable Margot Fonteyn at the Covent Garden Opera House. Taken in stage lighting with a 135mm lens on the Minolta.

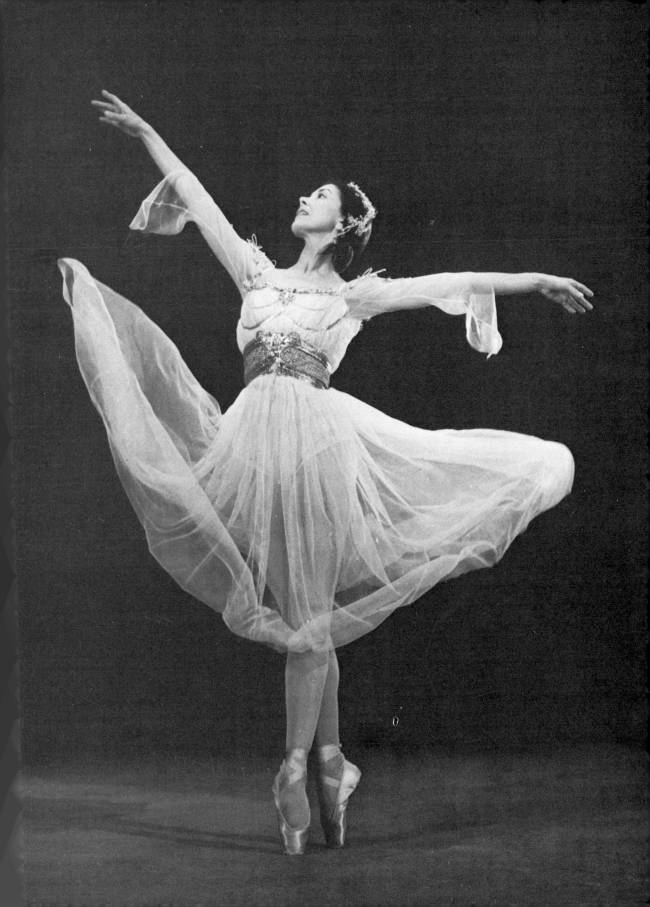

Nevertheless, many amateurs are called upon to take pictures of amateur productions, and it is usually better to take these at a dress rehearsal rather than during an actual performance. At a dress rehearsal, the photographer is able to move around and find the best position for each of his pictures. Whereas, during a public performance, he is much more restricted, as he should never interfere with the enjoyment of other members of the audience.

If you are doing this sort of photography I would strongly advise you to familiarise yourself with the production before the dress rehearsal. In this way you will have a good idea of what is coming and what will make the best pictures. You may also be able to make some tests with the lighting.

In amateur dramatics you will obviously not have the intensity of lighting which obtains in the big London theatres, although you will have the same sort of problems. Namely, that the lighting will inevitably be very contrasty. The general rule here is to give plenty of exposure, and then reduce development to keep the contrast down and to give you detail in the shadows. Use a standard focal length lens for the general views, plus a 135mm for close-ups.

For this sort of work I find a unipod very useful so that I can give exposures as low as 1/10, or even 1/5 sec should the lighting demand it.

Don't take pictures only of the actual production. Shoot portraits of the leading characters in conditions where you can have control over their pose and the lighting. But if you are aiming to get a picture published in the local newspaper it is almost always one giving a general view of the production, and showing as many of the cast as possible, which will be chosen by the editor.

Lastly, as I so often advise, do make sure that you give prints to the folks whom you have photographed. You never know, one of them may be a future world-famous star. And think what would have happened if Terry O'Neil had failed to give any prints to Raquel Welch, the first time he photographed her. He would never forgive himself now!

The challenge of ballet

I rate ballet as one of the most interesting, exciting, and satisfying subjects there is in photography. It is a subject which has just about everything that photography has t

offer: action, movement, technical problems in the way of changing lighting, beauty, and the requirement of a thorough knowledge of your own technique in exposing and processing to get the utmost out of your particular film. Above all it is always a challenging form of photography which, if everything goes right, can give you some of the most beautiful pictures possible.

Of course I am lucky, and am able to photograph the top ballerinas, but this does not mean to say that amateurs cannot go in for ballet photography. There are scores of good dancing schools throughout the country which are constantly putting on shows, and which would welcome photo-

Margot Fonteyn always knew what would make a good picture—of the dance—and often gently urged me away from the lower viewpoint that would have made a better press picture.

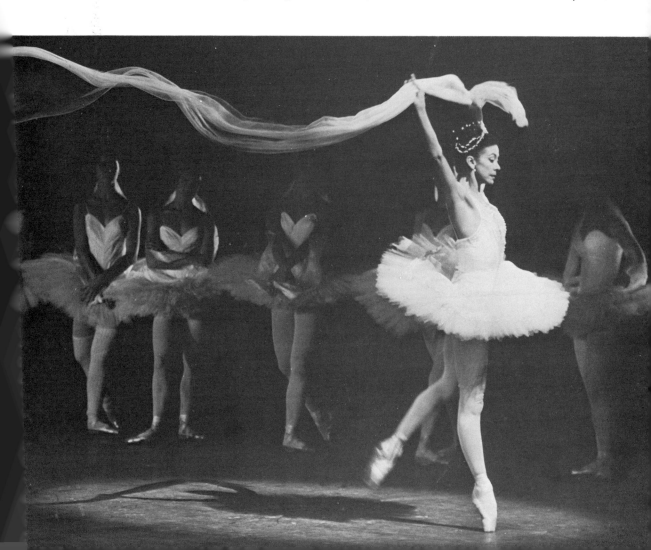

graphers who would take pictures and let them have prints afterwards.

The best time to take pictures is not when the public are present, but during a dress rehearsal. I seldom, if ever, use flash for my pictures. Anyway, I don't think Margot Fonteyn would be very happy about a flash going off in the middle of one of her dances!

Lighting changes continuously, so it is not possible to give any guide as to exposure. However one of the great enemies is excessive contrast, so development must be kept to a minimum when you are shooting black and white.

Dancers I have enjoyed photographing particularly are Antoinette Sibley, Annette Page, and my all-time favourite, Margot Fonteyn. In all the years I have been photographing Margot, I have never seen her show temperament or the slightest bit of awkwardness. Certainly she knows what makes a good photograph and what makes a bad one, from a dancer's point of view. For instance, when I was photographing her practising one day, I was crouching down for a low viewpoint. But she wouldn't have this at all, and insisted that my pictures should be taken from waist level.

"Otherwise it makes the legs look far too long and out of proportion," she told me.

I didn't agree with her, but I had to bow to her wishes. Of course the difference was that I was shooting pictures for a newspaper and knew the sort of pictures I wanted; whereas she wanted to show pictures of the dance to its best advantage.

What I have particularly liked about Margot through the years is that she has never deliberately aimed to get publicity for herself, but has often tried to push other people forward to get the attention of the press rather than seek any personal press coverage. She has provided me with some of my finest ballet pictures, and I shall always be grateful for the help she gave me during my early years in Fleet Street.

When I am shooting pictures at Covent Garden Opera House, I usually use a 90mm or a 135mm lens shooting from the stalls. Anything longer becomes an embarrassment because the great enemy is the lack of light. And as you are going to keep development to a minimum you must have plenty of exposure on your negatives. So long-focus, small-aperture lenses are out.

A multiple exposure shot of the great Spanish dancer Antonio. For this I set the camera on a tripod, and with the stage in total darkness, got Antonio to do his leap while I used a repeating stroboscopic flash to make the exposure.

If you are shooting a ballet school production you will probably be able to move in much closer than I am able to at Covent Garden, so you will then be able to use one of your normal focal length lenses with its very wide aperture.

Films should obviously be the fastest available, such as Tri-X or HP4.

13

Shooting Animal Pictures

There are four things you require in order to take successful pictures of animals:

1 An ability to focus extremely quickly, and to shoot the moment the right picture occurs. This means knowing your equipment inside out, and using it as an extension of yourself.
2 Extreme patience. You will never get good pictures of animals in two or three minutes. You have to be prepared to wait and wait until the right picture occurs.
3 A genuine love of animals. Almost all animals have an instinct for knowing if anyone is "anti" them, and if this happens you will seldom get good pictures.
4 A packet of sticking plaster! Actually this isn't a joke. You'll really need it, because some strange animals can be just a little scared of you at first and you may get the occasional nip from them.

Of course, it depends how big the animal is as to how serious is the nip you get. I was once photographing a former Miss World, Eva Rueber-Staier, with some four-month old lion cubs in a cage. Eva was sitting in the middle of the cage when one of the cubs got behind her and climbed up on her back, inflicting some rather nasty scratches. However, she was a good sport and I did get some dramatic pictures out of this incident. But I think she is still not entirely certain that I did not prearrange this little happening!

In the tigers' cage

Wild animals have always fascinated me, right from the time I first went into a cage in which were four fully grown tigers. I had been trying to think of a different picture to do at Bertram Mills circus, just before Christmas, and I went along to talk to Alex Kerr, their wild animal trainer. I suggested that I might get a picture different from those taken by anybody else if I went into the cage with him. He asked me to come to the circus the next day and we would talk about it.

I went along the following morning and we talked about everything *except* me going into the tiger cage. But Alex told me at lunchtime that what he had really been doing was assessing whether I was the sort of chap who would panic if anything went wrong. Alex may know animals very well, but

An ordinary picture of half-a-dozen greyhounds was turned into a successful feature shot by having an assistant give a sharp whistle at the side and out of frame. I shot my picture as soon as all the dogs had turned in the direction of the whistle. It then only needed a separate picture printed at the side of this one of a French poodle tied with ribbon to make a humorous situation.

he doesn't know humans. Because I can tell you that if anything *had* gone wrong I should have been scared stiff and panicking like the devil!

"But," he told me, "you've got nothing to worry about. You can always tell when tigers are getting angry. When the whole tail swishes gently from side to side, I reckon you have got about five seconds left before the tiger springs. And then when the tail stops, and just the tip flicks to and fro, you have just about two seconds left. And when that stops—you've left it too late!"

With this reassurance I went into the cage with Alex, and I don't mind admitting that I was scared stiff as I looked at the four massive tigers. He had marked out a line about five feet from the nearest tiger, and emphasised that, on no account, must I step over this line, as it would put me within range of their claws. He need not have stressed the point as I had no intention of stepping over that line.

"If anything does go wrong," he said, "not that it will, but *if* it does, whatever you do, *don't run.*"

Where did he think I was going to run to?

"Just take one step backwards and I will step in front of you and take over. So there is nothing at all to worry about."

As I am writing this you will know that nothing untoward

did happen, and I got the pictures I wanted. I don't think they were particularly great pictures, but they *were* different. And they did give the *Express* the excuse to show one of their photographers in a tiger's cage.

Yes, the picture editor had sent down another photographer to take pictures of me inside the cage. And what unnerved me a little was that I knew exactly what was going through that photographer's mind, and why he had been sent down. I know he was hoping for a really dramatic picture of me!

When we came out of the cage I noticed that Alex was limping a little, and I asked if he had ricked his ankle, as I hadn't noticed the limp before.

"No," he said, "I didn't want you to see it before as I didn't want you to get nervous. But a few months ago one of the tigers did have me."

"But what about all that stuff you told me about the flickings of the tail and so on," I said.

"Well, really it was my own fault," said Alex. "You see, in the cage there is one tiger and three tigresses. On this particular occasion one of the tigresses was 'in season', and was playing up a bit. So I went over to give her a quiet telling off."

I should explain here that Alex really was a unique trainer. He never struck an animal, and always believed that animals should be allowed to retain their dignity. He was able to speak to them in a guttural, animal-like voice, which was really very close to their own language.

"Anyway," he went on, "I was standing there giving her my little telling-off when, without any warning, the male tiger sprang at me and grabbed me by the leg. Fortunately he still had enough respect for me not to go for the back of my neck, which is the normal place for a tiger to attack, or I would have been a goner instantly. But as it was, I managed to get my stick in his mouth after a while and get him away."

"The only explanation I can think of is that, because the tigress was in season and I was speaking to her in an animal voice, he was actually jealous of me. But what really annoys me was that the whole thing was quite unnecessary. Because I can tell you, I certainly had no intentions on that tigress!"

General advice

When you use flash while photographing any animal do not mount the flash close to the camera. If you do, and the animal looks at the camera, the light goes straight into its eyes and is reflected back from the retina, making it appear that the animal is blind or has something wrong with its eyes. Keep the light source at an angle and well away from the camera to get rid of this unwanted effect.

If you are photographing the family pet, whether it be a cat or a dog, it's a great help to have somebody fuss him. It always puts the animal in a good mood, and also helps to keep it in one place while you shoot your pictures.

If you are taking pictures at a zoo, a long focal length lens used close to wire netting will often render it virtually invisible.

But never let your enthusiasm run away with you when dealing with wild animals. The regulations laid down are there specifically for your own safety. So stick to them.

In the various animal parks you are warned against opening the windows of your car, and this is advice that you should take. Those great lions may look very sleepy and tired, but they can move like a flash of lightning, so don't take any chances. I have taken several pictures while walking about Windsor Safari Park, but always in the company of one of the game wardens who understand the animals. Even so, I don't mind admitting I don't feel the bravest man in the world when I am standing there with dozens of wild animals around me!

If you pop along to Trafalgar Square in London and buy a few penceworth of corn (they sell it in the Square), you can guarantee some fun pictures with the pigeons. Just sprinkle a little corn on a friend's head, and very quickly he will have dozens of pigeons scratching amongst his hair for the corn. Put some in the hood of a camera and pigeons will soon find it and be looking down into the camera. There are literally dozens of picture situations which occur every minute in the Square with the pigeons. Well worth a visit for fun pictures.

Lastly, if you are ever asked to photograph a pedigree animal owned by a skilled breeder, do take his advice in every respect, and don't just try to get the most appealing picture. This is really a specialised field of photography and

With a pretty girl and an appealing pet, how can you go wrong? Jenny McAdam, Miss United Kingdom 1972, in Hyde Park with her pet dog.

194

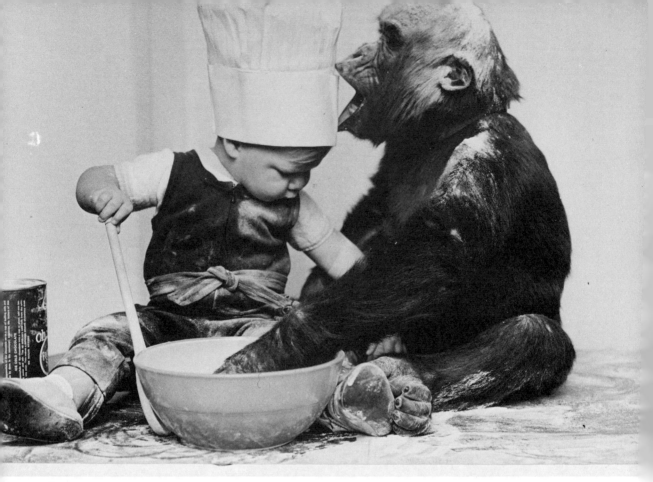

Put children and animals together and you have real scene-stealers. Give them something to make a mess with and you have the ingredients for a picture. My *Express* colleague Ron Dumont took this one.

you need to know the good points of the animal you are photographing in order to show them. If you are not knowledgable in such matters, you must follow exactly what the breeder tells you. Otherwise you may produce a picture which could make the animal appear imperfect.

14

Camera in
the Air

As far back as my memory goes it was always my ambition to be, not a photographer, but a pilot in the RAF. Throughout my schooldays I had no room for any thought other than flying a Hawker Fury (jets, and even Spitfires, were unheard of in those days); and when, in my early teens, my myopic vision spelled *finis* to my ambition, my disappointment was so intense that it left an imprint which has never gone. The result is that since becoming a press photographer, I have seized every possible chance to do all the flying assignments.

Fortunately this was not too difficult as there has not been exactly a rush from other photographers to fly with the various aerobatic squadrons. And I am lucky enough to have one of those stomachs which remain unaffected by being thrown all over the sky at four or five hundred miles an hour. Yet it was only by chance that I started on the aerobatic assignments.

Chance assignment

I was sitting at the picture desk in the *Daily Express* one lunchtime, around 1960, and could vaguely hear the picture editor talking to someone on the telephone about medical examinations. I wasn't particularly interested, but he suddenly looked up from the telephone, saw I was the only photographer sitting there, and asked me how my stomach was. Rather surprised at this sudden interest in my health, I replied that it was all right so far as I knew, but if he would like to treat me to a good lunch it would undoubtedy be even better. I never miss an opportunity to squeeze a free lunch out of my boss!

Frank Spooner, who was picture editor at that period, said he would love to buy me lunch, but unfortunately there wasn't time. I was to go straight round to the RAF Aircrew Medical Centre to be examined. If passed fit I was going to be the first press photographer from Fleet Street to fly with Treble-One Squadron, the famous "Black Arrows".

"And make sure you pass," he shouted as I went out. "The *Chronicle* are on to this too, but we are a day ahead of them."

I needed no second bidding, and that was how it came about that I started to cover all the aerobatic flying for the *Express*. Sheer luck that I happened to be the photographer sitting there at the right moment, although in any case I

think I would probably have wangled some aerobatic flying at a later date.

Somehow I passed the three-hour medical, and the next day I was introduced to the Hunters of Treble-One and to Peter Latham the Squadron Commander. Peter asked me if I had done any flying in jet fighters before, and when I replied that I hadn't he said he had better demonstrate the ejector seat to me.

He sat me in the aircraft and pointed to a handle above my head.

"When you pull this, it draws a blind down over your face and at the same time fires an explosive charge under your seat," he said. "This will fire both you and your seat out of the aircraft. Then the seat will automatically detach itself from you, and at a predetermined height your parachute will open and, with a bit of luck, you'll land safely."

"I see," I said, "but what's the blind for?"

The famous Russian Roulette manoeuvre by the Red Arrows. The speed of the planes relative to each other is 1200ft per second. To get them positioned correctly on the film, the moment of exposure must be judged to within 1/100 sec. This is no job for the three-exposures-per-second motor drive.

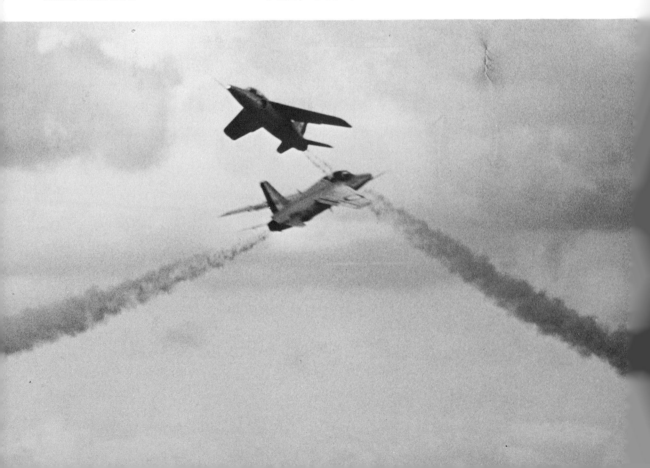

"Oh, thats just to hide the sight of your legs being mangled as you are shot out of the cockpit," he said with a chuckle. "And by the way, if I ever *should* yell 'Eject!' to you while we are up, it's no good you turning to me and asking what I said. Because if you do, you will find that you are talking to yourself!"

But everything went well; I got those first pictures and found that I thoroughly enjoyed aerobatic flying. From that day on nothing could keep me from visiting Treble-One's base at Wattisham on every possible occasion, just to fly with them. In fact I became such a regular visitor that I was made an unofficial honorary member of the Squadron. And that was quite a night!

When the Black Arrows gave up being the official aerobatic squadron (they were being converted to Lightning Fighters) I went up to fly with them for the last time. Unbeknown to me, Peter Latham had worked out a little

Another version of Russian Roulette. This manoeuvre was dropped from the Red Arrows repertoire after two planes touched and crashed during a display. I used a 400mm Novoflex on the Minolta with a 1/1000 sec shutter speed.

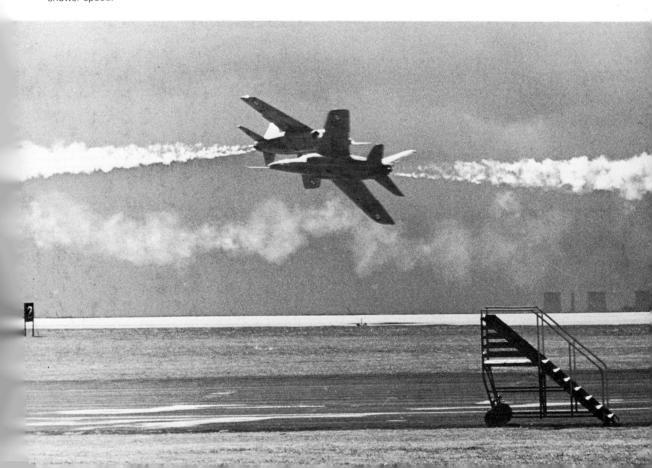

plan for me with the other boys before I arrived. As I have said, I am lucky to have one of those stomachs which are unaffected by aerobatics and large "G" forces, but the lads were determined to make me ill on that last occasion.

We took off, and then I was put through the most violent aerobatics I have ever endured. Peter tried everything, throwing the aircraft all over the sky, going through loop after loop after loop, putting enormous "G" continuously on me. But it was all to no avail. I wasn't sick. What I didn't tell him though, was how close he had come to succeeding. When we landed I remember thinking that if he had had enough fuel for just about one more high speed loop he would have beaten me!

Equipment and technique

For most of my air-to-air pictures I like to use a camera with a wide angle lens, as usually when flying in formation the aircraft are very close together.

Shutter speeds can be relatively slow for this work as, although the aircraft are moving at hundreds of miles an hour, their speed relative to each other is practically nil, so there is no blur due to movement.

For some technical reason which I have never been able to discover, I have found that when shooting through plastic canopies of cockpits (and this applies equally to shooting through the windows of airliners), a wide-angle lens gives less distortion and deterioration of the image than longer focal length lenses. Using anything above a standard focal length seems to cause a lot of trouble with blurring of the image. When I took the shot of the Red Arrows which earned me the title of "Colour Photographer of the Year", I used a 28mm lens. Subsequently this picture was enlarged to 20 × 16, and it still looked as crisp and clear as though it had been taken from an open cockpit, although it had been shot through the canopy on one of the Red Arrows' Gnat aircraft.

For air-to-air pictures I don't employ any special technique, shooting just as if I were taking pictures down on the ground, but giving one stop less exposure than I would have done on the ground, to allow for all the extra light from the sky which is around me.

Perhaps my most successful air to air shots have been taken with the Red Arrows, and this is one I took as we were coming out of a loop. I used the Nikon with a 28mm lens and the comparatively slow shutter speed of 1/250 sec. It wasn't necessary to have a higher speed because, although we were doing about 500mph, our speed relative to each other was practically nil.

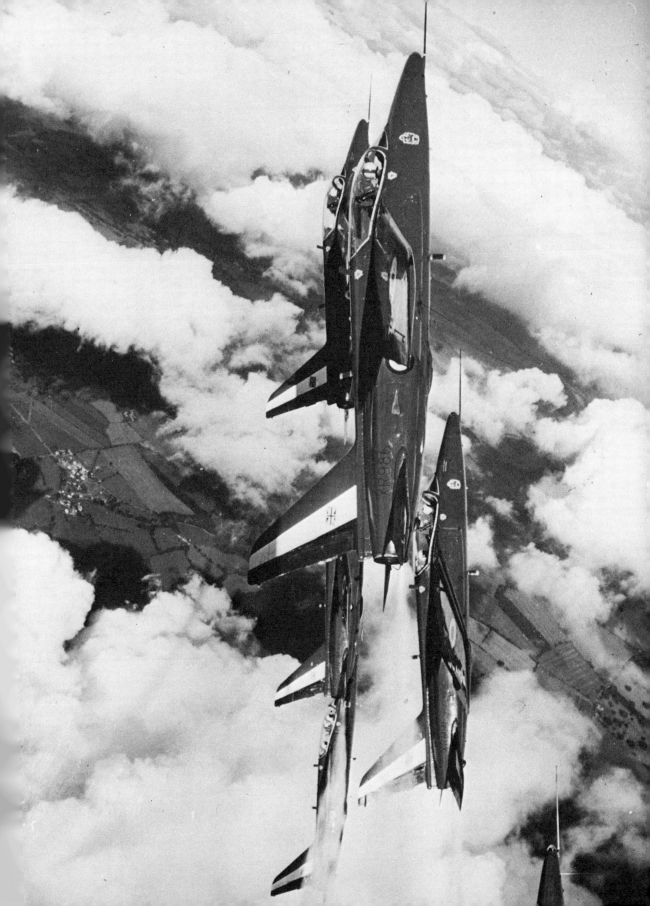

Quite frankly, however skilled a photographer you are, it is really in the pilot's hands as to the sort of picture which you will get. I freely admit that any success I have had with aerial pictures is due in only a tiny part to any skill of mine, and almost entirely due to the work of the pilot of my aircraft. It is his skill in correctly positioning the aircraft, and then getting the wing out of the way at just the right moment, which enables me merely to click the button.

But of course you must have a discussion with him beforehand and tell him the sort of picture you want. Then he can tell you if it is at all possible. Pilots of aeroplanes are not at all happy to be asked if they can move sideways (or even backwards!) as has happened on occasions when photographers forget that they are in an aeroplane in the excitement of trying to get a particular angle for a shot.

If you are in a light aircraft and shooting pictures of another aircraft flying near you, try to include either the ground or the horizon in your picture. This gives an indication that you are at height and will add depth and more interest to the shot. Big, fluffy, cumulus clouds against a deep blue sky also make a good background.

I have usually found it better to use an aeroplane which has a high wing, such as a Cessna. These aircraft are particularly suitable for aerial photography because they have a side window which can be opened completely, and which then stays open, being held in position by the slipstream of the aeroplane.

You should sit well back from the window in order to ensure that no part of your camera pokes out into the slipstream. Otherwise you will get too much camera vibration and movement which will give you blurred pictures.

When shooting air-to-ground pictures the great enemy is over-exposure. My usual technique when shooting black-and-whites of objects on the ground (and this is the sort of photography I do regularly for the *Express*) is to take a meter-reading of the ground from the aircraft, and then deliberately underexpose by two stops.

Later on I give exactly double the development I would give for a normal subject, and I find that this gives me the sort of negative I prefer. The reason for this technique is that generally, a view of the ground from an aircraft is very low in contrast and flat. So to get a negative that you can print on

I have always been a believer in ignoring rules, and in this particular picture I ignored the one about never having the sun actually in the frame of your shot. I used a Leica M2 fitted with a 35mm lens for this picture of the Lightnings of 56 Squadron and deliberately included the sun in my shot. Without it the dramatic quality would have been entirely missing.

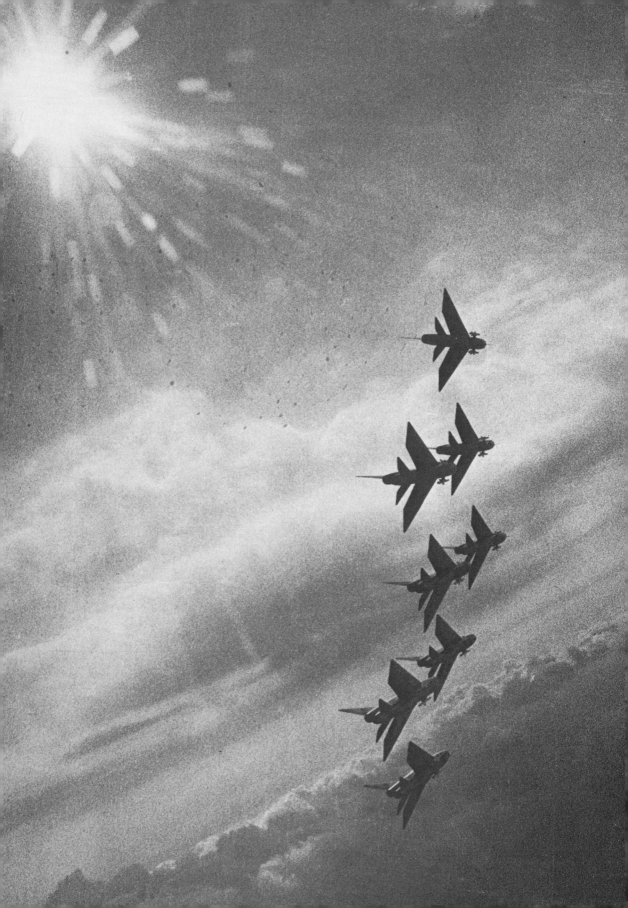

normal paper you must increase the contrast, which you do by extra development. But if you have exposed normally this extra development would give you a dense and unprintable negative. Hence the reason for reducing the exposure by a couple of stops.

A further advantage of this technique is that you can employ a slower, finer-grained film than you would normally. Very often I use Plus X, which has a recommended speed rating of 125 ASA, but which I use at a rating of 400 ASA for my aerial pictures.

Parachute jumping

Before the various free-fall parachute teams started carrying cameras with them, and so taking pictures which were un-obtainable by non-jumpers such as myself, I used to do a lot of parachute photography.

Most of my pictures were taken from the rear of an RAF Beverley aircraft, and they are not quite so simple to take as would appear. I remember one occasion when I was photographing six parachutists going out of the back of the aircraft with their arms linked. The snag with this sort of picture is that, when the parachutist drops off the "sill" at the back of the aircraft, he steps straight into space. Contrary to what you would expect, he is not carried back by the slipstream immediately, but drops vertically for quite a few seconds.

If I were standing safely back from the edge, by the time the parachutist appeared in my sight he would be too far away to make a good picture. So the only way to get the picture is to stand chest-to-chest with the parachutist and then, as he steps back into space, I lean forward and shoot directly down.

This isn't as dangerous as it sounds. They do give you a parachute, but they also give you a safety harness which goes round your waist and is clipped to a strong-point on the floor of the aircraft. So to take these pictures, I would be leaning out against this safety harness, shooting straight down as the parachutist left.

On this particular occasion there were two of us taking pictures: myself for the *Express*, and Horace Tonge for the *Sunday Times*. With about a minute to go before the parachutists stepped off into space, the sergeant despatcher

came across and yelled "Sorry, but it's just regulations. Would you please check your safety harness."

I turned round, gave mine a pull, and of course it was quite all right. Horace gave a pull on his, and the whole lot came right out of the floor! If he had not checked it beforehand, when he leaned forward to take a picture of the parachutists, he would have gone with them and I would have had a darned good picture! I could have killed that sergeant despatcher.

Shooting from airliners

If you intend taking pictures from an airliner when you are going on holiday, I should warn you that they will usually be very disappointing when processed. The detail on the ground from the height at which modern jets fly is so tiny as to be virtually indistinguishable. However, some good shots can be taken when the aircraft is low, or there are clouds nearby.

A mass parachute drop by six instructors from No. 1 Parachute School at Abingdon. They left a Beverley aircraft together, with arms linked, at a height of about 12,000 ft. The only way to get this shot was by leaning over the edge of the aeroplane as the parachutists left, and shooting straight down. If my memory serves me faithfully I used a Robot camera for this picture. The modern SLR motor-driven camera had not yet appeared on the scene.

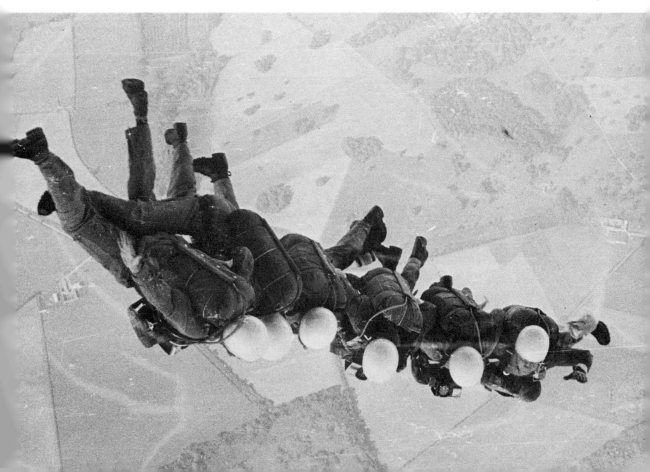

In choosing your seat it is worth bearing in mind the time of the day and the general direction in which the aircraft will be flying. If you are flying south and your flight is in the morning, bear in mind that the sun will generally be on the left of the aircraft (remember it rises in the east). So if you get a seat on the right of the aircraft you will have the sun behind you, which will give you far better visibility of the ground.

Sometimes you may get an invitation to go up on the flight deck of the airliner, and here a wide angle lens can be invaluable—the widest you have. Also, it will help you to get a better picture of the cockpit if you use a fill-in flash, as there will be very strong light coming through the front from the windscreen, but very little from the back where you will be shooting your pictures. Rather than get a picture of the back of the heads of the pilot and co-pilot, get them to turn round and perhaps make some adjustment between them.

A ground-to-air picture of the Lightning fighters of No. 56 Squadron doing a horizontal bomb burst. This was taken on a Nikon with a 135mm lens.

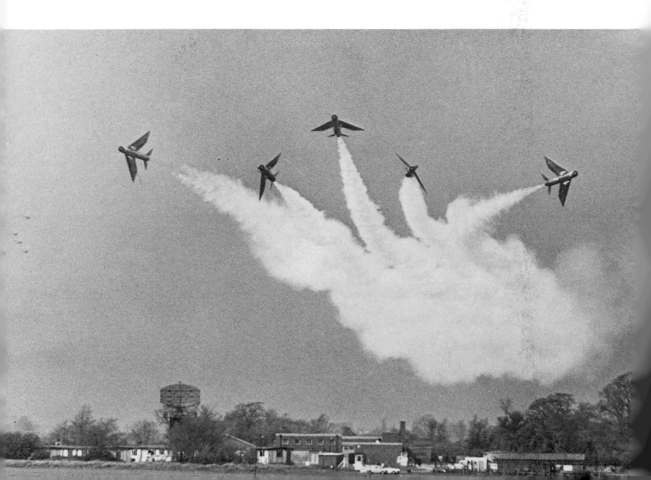

Then you will have their faces in shot when you take this sort of picture.

Shooting and flying

In the early sixties I at last realised my life's ambition and became a qualified pilot myself. Since then I have done a lot of the flying for the *Daily Express*, and thus have been able to amass a respectable total of hours. I am often asked if, when I do aerial pictures, I do the flying myself. The answer is a most definite no. However skilled the pilot might be, it would be highly dangerous for him to take his attention from piloting the aircraft in order to take pictures.

If you have learned to fly, you should on no account attempt to take pictures while you are flying the aeroplane. One of the basic rules you learned right at the start of your flying training was that you should always keep a good look-out. And this is quite impossible if you are looking at some subject through the viewfinder of a camera.

Filters for aerial work

If there is enough light, and you are shooting black and white, a yellow or even an orange filter does help enormously to cut through the inevitable haze which is visible when the ground is viewed from an aircraft. A filter is also useful when you are shooting air-to-air pictures, as it will darken the blue parts of the sky and make the pictures look more interesting.

If you are shooting colour, I would rate a UV filter as an essential, but even this will not cut out completely the general blueness which is caused, both by the haze and the amount of ultra violet light around. You could experiment with polarising filters—I have had a certain amount of success in this direction—or with some colour-correcting filters, but they will not guarantee success. There is no rule for getting rid of the blueness which so often appears in colour aerial pictures. The only real solution is to choose a day which is sunny and when there is a minimum of haze. Then shoot from a fairly low altitude.

15

Sporting Action

There are very few sports that do not provide opportunities for good action photographs. And, as most of them are carried on at local or amateur level as well as national or international professional events in large stadia, the opportunities are open to all. Specialised equipment is sometimes an advantage but never absolutely necessary.

Cricket

Do you ever wonder how those great cricket pictures are taken, with bails and stumps flying through the air, caught by the camera at just the right moment? Do you imagine a cameraman, eagle-eyed, sitting behind a 1000mm lens, watching every ball and waiting to capture that magic "moment in time"?

Well, some undoubtedly do work like that. But one veteran who specialises in cricket photography, and has taken some of the best action shots I have seen, let me into his secret. He told me that he sets up his "long tom" camera so that it is focused on the batsman taking strike. Then with his finger on the cable release he can lean back to have a gentle doze, just "coming to" each time an over is called so that he can refocus on the other end.

He told me that it was quite unnecessary to follow the game all the time, because he had trained himself to press the shutter-release automatically at every "Howzat!" call. Working this way, he said, he had never missed getting a broken wicket, and it seemed that the "Howzat!" reached him at just the right moment for the best picture.

I asked him if he had ever thought of designing an electronic machine which would automatically respond to the shout, and trip the shutter without him having to do anything. But he said he wouldn't consider such an idea.

"It would take all the skill out of the job," he said. In all seriousness too.

I haven't had a lot of experience of covering first class cricket matches. But I do remember that when I was assigned to shoot pictures of the West Indies Test series in Barbados some years ago, I discovered that I needed a lens of at least 500mm focal length for my 35mm camera in order to get a good-sized image of the batsman at the wicket. That was the longest lens I had with me, and ideally

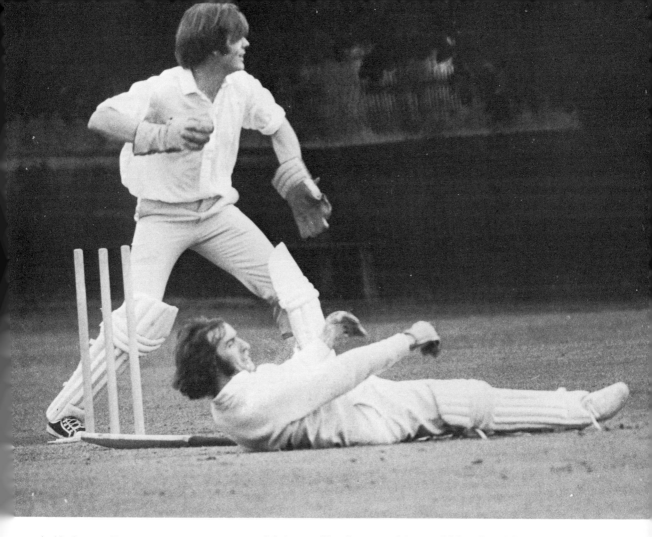

Jackie Stewart "in a spin" while batting for the Grand Prix drivers in a charity cricket match.

World Champion driver Jack Brabham was great in a car but his prowess with a bat would not really have got him into the Australian Test Team. Taken during a charity match after the British Grand Prix. 400mm lens on a Nikon.

would have liked something within the 800 to 1000mm range.

Even with village cricket matches, which are played on smaller pitches, I like to have the size of image which a 400mm lens can produce. Anything too short means that to get a reasonable picture you have to intrude on the pitch, to the annoyance of spectators and players alike.

There's a lot of argument as to which is the best position to shoot cricket from: broadside on; behind the wicket; or facing the wicket. Personally I let this sort itself out by choosing anywhere which will give me an elevated position. Nothing is so frustrating as having set yourself up in what you consider to be an ideal position on the ground, and then having a fielder come up and stand right between you and your subject. So go for an elevated position every time.

If you haven't got a very long focal length lens then you cannot expect to do the impossible and get good close-ups of the batsman being bowled out. In this case you should go for the interesting pictures which can be captured by your

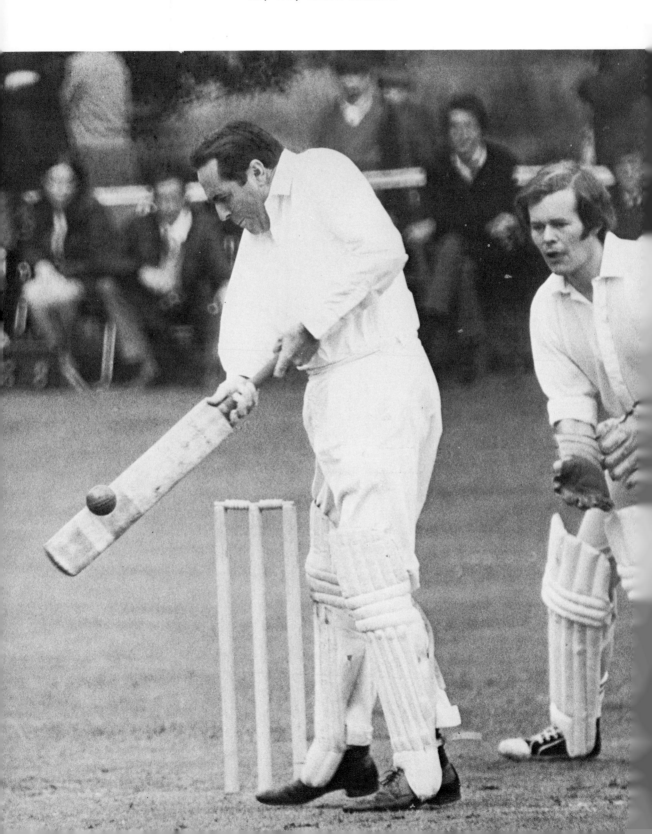

shorter focal length lens. For instance, when the fielders are attacking a batsman and the field is fairly closely bunched around him. Wait for the magic "Howzat!" and press the button. This sort of picture is often more satisfying to the players than close-ups of the batsmen in action, as they can all see themselves, and will probably be pleased to have prints from you.

Your shutter speed should be the highest one you can give, with due regard to your maximum lens aperture and the amount of light prevailing. Ideally, I would go for 1/1000 sec if this is possible.

But if such a high shutter speed isn't possible, don't give up and say that you can't take any pictures that day. As I

Christine Truman playing at Wimbledon at the height of her fame. A tennis player's swoop on to the low ball frequently makes a good picture. Leica with 135mm lens.

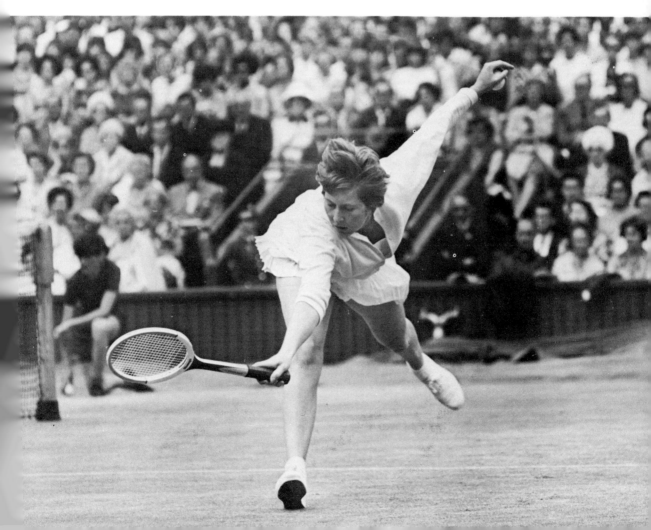

have emphasised all the way through this book, be prepared to have a go. Even if you can only give 1/100 sec, take some shots. You never know, one of them might be a real winner.

Tennis

This is a subject which can provide some superbly exciting action pictures. You may not be able to get a photographer's seat in the front row of the Centre Court at Wimbledon, but tennis is going on everywhere, and it is a subject which almost anybody can have a shot at. Take a trip to the local tennis club, or even the nearby park, and you can have action galore—and maybe even picture a future Wimbledon champion.

Each year, I spend several days at the Wimbledon Championships, and although the conditions there are somewhat different from those you encounter in the local park, I suggest

Top tennis players usually provide the best pictures because they put more into the game and are therefore more likely to give plenty of action. Shots like this can be taken by any amateur who goes to Wimbledon during the first week. Leading players are then on the side courts as well as the centre court, and so are within easy access of members of the public without special passes.

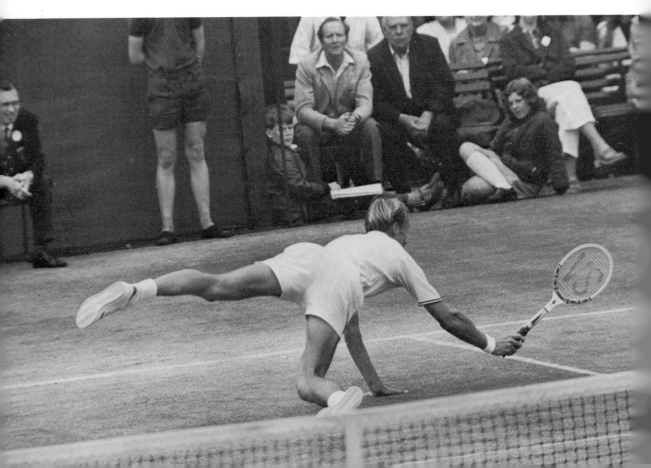

that my shooting technique could be followed almost anywhere.

I usually have a seat at the side of the court low down and as near to the net as possible. If I can get right opposite the net it is ideal, as it enables me to cover the players on either side.

Backgrounds can be an annoying distraction if they are too sharp, so it is best to use a very wide aperture or a long focal length lens—or both. Tennis is one of the subjects for which I always use a 1/1000 sec shutter speed, should the light permit, as this allows me to open up the aperture and blur the background. It is also essential in order to stop the very rapid movement. Again, you shouldn't give up just because you can't shoot at a 1/1000 sec or your camera hasn't got that sort of speed. Good pictures have been taken at shutter speeds much slower than this.

At Wimbledon, we usually find that a 100mm lens, or thereabouts, is about right for a 35mm camera. But of course we are kept a fair distance back, whereas at a local tennis club you may be able to get much closer to the net, in which case a standard focal length will probably be quite satisfactory. In fact, when we are shooting pictures on the sidecourts at Wimbledon (which approximates to taking pictures at an ordinary tennis club), we often do use a standard focal length lens.

I suggest that this is one of those occasions when, if the light is good enough, you depart from the practice I advocate of sticking to one film. If you load up with a very slow type you will be able to open up your aperture wide, and so throw the background well out of focus.

If you are using a single lens reflex camera, you will find it far better to have some sort of open frame finder fitted into the accessory shoe so that you can see what is happening outside the frame of your picture. Only in this way can you anticipate the exact moment when the ball is going to hit the racquet. The most impressive action shots almost always occur when a player comes close to the net to volley. It is important to try to press the shutter just a fraction *before* the ball hits the racquet. If you wait until it has actually struck the racquet, no matter how quick your reactions are, more often than not, there will be no ball in your picture.

I have found that, as the players are usually dressed in

white and there are not any shadows to worry about, I can safely rate my film at twice its recommended speed. Thus I usually set my meter for 800 ASA when I am shooting Tri-X.

When you are shooting pictures of a doubles match you will usually find it better to get an elevated position behind one of the base lines, and then concentrate on the pair who are facing you at the other side of the net. You are not after individual shots here, but the confusion and action which often ensues between the two players.

Incidentally, don't forget to give some good enlargements to the club where you have been taking your pictures. In all probability they will put them up on the notice board, and you could get some worthwhile commissions in the future to take pictures for payment at club tournaments.

Football

There are so many ways of taking soccer pictures that it is impossible to pinpoint any one as being the best. Many photographers sit on the goal line about ten yards from the goal using a standard, or slightly longer than standard, focal length lens. This is focused on about 30 ft, and they then shoot all the action which comes within their zone of focus. Interestingly, the actual scoring of a goal seldom makes a very good picture from this position. It is the player coming in to score, and who is tackled, which makes the good action shot. Or two or three players going in the air for the ball; or the goalkeeper jumping up to punch away a clearance, or diving to clear a shot. These are the pictures which are really interesting and full of action.

For a picture of an actual goal being scored to be interesting, more of a general view is required. For this sort of shot I like to position myself at the side of the pitch about half-way down, and generally in an elevated position so that players will not get in between my camera and where the action is in front of the goal.

A fairly long focal length lens is necessary, preferably something in the region of 300mm. You will not be going for individual action shots as you were when you were at the side of the goal, but you will be aiming for a more tactical picture which shows what happened as the ball entered the net. This is what you must be ready to shoot as soon as it happens.

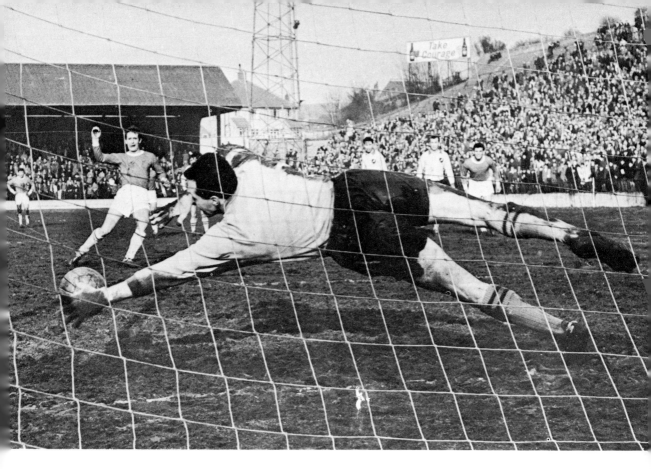

Pictures through the goal net are not common in football. But they can produce spectacular effects when penalty kicks are taken.

Of course if you are shooting a school football match, it is very unlikely there will be any stands from where you can get an elevated shot, so you will have to shoot from ground level and hope that nobody gets in your way at the vital moment.

And don't despise those school matches. It so happened that I once photographed schoolboys playing rugger, and the resultant picture was runner-up both in the British Press Pictures Contest and in the World Press Pictures Contest (Sports Section). Which just goes to show that it is not necessarily the top names which always make the best action pictures.

Another camera position which often provides very interesting pictures is immediately behind the goal, shooting through the netting, and this can often give an excellent pic-. ture when a goal is scored or when the 'keeper makes a great save. Of course, if the goal posts are not fitted with a net, you are taking quite a chance with yourself and your equipment if the goalkeeper isn't quite as good as he might be!

Floodlit football is not a subject which will usually come within the scope of amateur photography, but it is one which pressmen have to cover quite extensively. Quite obviously, we use our fastest lens and films, and then give extended development in one of the high energy developers, such as Microphen.

215

No set exposure can be laid down, because the lighting in different grounds varies enormously. For instance one of the very best is Chelsea, where it is possible to work at an exposure of 1/500 sec at *f*4; whereas at certain other grounds—they had better be nameless—you are lucky if you can get a decent image at 1/125 sec at *f*1.4.

Oh, and that reminds me, before leaving the subject of soccer, I have found that the best shutter speed is 1/500 sec (1/1000 if you can make it). But yet again I must emphasise that if you cannot give a 1/500, don't give up. You must be prepared to have a go. Pressmen are not always able to give the shutter speed they like, yet they still have to take the pictures, and some great ones have come out of fairly slow shutter speeds.

When the weather conditions are really foul, and it has been pouring with rain making the pitch like a quagmire, is *not* the time to pack up and go home. This is the very time when some very interesting pictures can be taken as the players skid through the mud. When the ground is dry and hard, they are not so prepared to take the chance of breaking their legs, so the action is not nearly so dynamic as it is when conditions are soft and muddy. That is the time when you should be looking for pictures.

When going to cover a football match, unless you can be certain that the weather is going to be good for the whole match (and who can, in Britain, anyway), you should be prepared to protect your camera should it rain. The finest protection I have come across are the plastic food bags you can buy at any grocers. The camera can be wrapped in one of these with just the lens poking out and an elastic band holding the bag tightly over the camera. A small hole can be cut for the viewfinder and you are in business with your camera fully protected against the rain.

The camera will still get a certain amount of moisture on it from condensation, but I have never found that this has done any harm when it is allowed to dry out naturally back at home after I have finished using it.

Athletics
There are so many variables here that it is totally impossible to lay down rules for the ideal lens in any particular circumstance. It depends on the sport, the sort of picture you

want, and the position you are able to get yourself in. In fact, athletics is one of those rare subjects where a zoom lens is helpful if you happen to have one. But unless you are trying to take pictures at the big national or international meetings, where the only photographers allowed near the competitors are the professionals with their special passes, you will be able to get most of your pictures with a standard focal length lens, preferably backed up by something in the region of 135mm. Film should be your usual one, with which you are well familiar.

A really interesting shot is always a head-on picture taken just a few yards before the winner of a race crosses the line at the end of a fairly long-distance and strenuous race. If you can get this absolutely crisp, the expression on his face, or that of any other runners near, almost always makes a great shot.

For sprints I like to get a side-on view, which again I take

Mary Rand, our great Olympic athlete, pictured on the Kent coast where we went to spend a day. I used a 135mm lens for this one to avoid getting my feet wet.

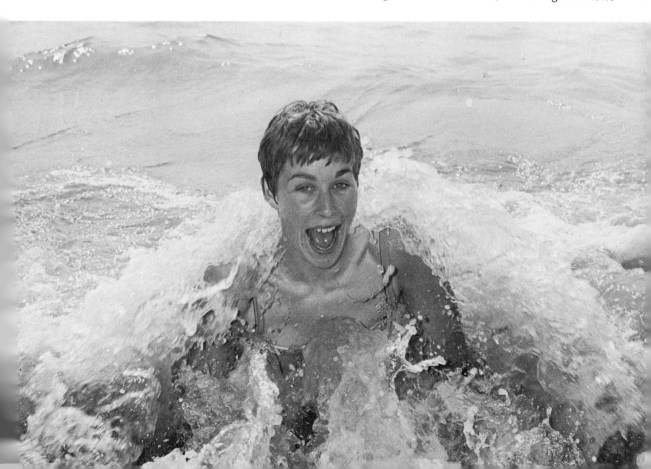

a fraction of a second—and I *mean* a fraction, something like a 1/100th of a second—*before* the winner breaks the tape. At this moment he will be straining his utmost to get to the tape before his nearest rival, who almost inevitably will be very close to him.

The conventional high jump usually makes a good picture, although it has been done many times. You can use the normal focal length lens for this provided you can get close enough. But the more recent Fosbury Flop is very difficult indeed to photograph successfully.

In fact I once spent nearly a whole day at the Crystal Palace athletics ground photographing the famous Barbara Inkpen, who is a specialist at this particular jump, trying to capture it on film. But I never did get the picture I was after. If I shot from above, it appeared that she wasn't at all high; whereas if I shot from below all I saw was her back. Head-on pictures were equally unsuccessful. I am convinced that somewhere there is a good picture of this jump, but I haven't seen it yet.

There is no doubt that my all-time favourite subject in athletics was Mary Toomey (formerly Rand *née* Bignal), MBE.

I first met her when she was Mary Bignal (before her first marriage), and when she was already being hailed as the "Golden Girl" of British sport. I had been sent out to photograph her training, and we hit it off immediately, as often happens with a photographer and a particular subject. Whenever you do find a subject with whom you seem to gel in this way, you should stick with her (probably it will be a her and not a him!), as you will undoubtedly produce much better pictures than with someone who does not seem to have that special understanding with you.

But back to Mary. As I said, we got on well together, and this was very good for me as a newspaper photographer. Mary was an international figure, always in the news, and pictures of her were in constant demand. One of my best scoops came when she secretly married oarsman Sydney Rand. Because of our friendship, Mary told me she would let me take the pictures of the wedding exclusively for my paper. This was a great feather in my cap so far as the *Daily Express* was concerned, as nobody even suspected that Mary had become secretly engaged.

The wedding was to take place at Marylebone Register Office, and we were in great trepidation in case one of the other newspapers discovered it. On the day of the wedding I picked up Mary and took her to the flat of one of our reporters, Ann Kenney, where she changed into the clothes she was to be married in. Then I drove her to the Register Office, and after the wedding we nipped off to the reception, which was held strictly for her immediate family and close friends.

Somehow we managed to keep the whole thing a secret, so that when the *Express* appeared the following morning with the pictures, we had a good scoop over the rest of Fleet Street. Not only that, but we were also able to get pictures of Mary and Sydney on honeymoon, much to the chagrin of our rival papers.

I sometimes wonder if getting such scoops means very much to the readers of the papers. But even if it doesn't, it certainly means a lot in Fleet Street, and we were well pleased with this particular one.

I saw a lot of Mary during the years that followed, and was the first to photograph her back in training after she had had her baby daughter, Alison. Then she went to Tokyo for the Olympic Games and picked up no less than three medals, including a gold. Obviously it was going to be big news when she came back to be reunited with her baby. Again I hoped for an exclusive on this reunion, and Mary was most helpful in this respect when she got back to England.

When she arrived back from Tokyo, I was at London airport to meet her, along with about fifty other newsmen. I remember that her 'plane touched down at five-twenty in the morning, which did not endear me to athletics in general! But I must offer a word of thanks to the nearby Ariel Hotel. The manager laid on breakfast, not only for the returning athletes, but also for the press, and refused to take a penny from any of us.

I was pleased to notice that her great success had not made the slightest difference to Mary—she was still the same modest, carefree girl I had always known. Of course, the picture that everybody wanted was of her being reunited with her two year old daughter, Alison. And, remembering old friends, Mary told me she would let me have the exclusive pictures of her first meeting with her daughter.

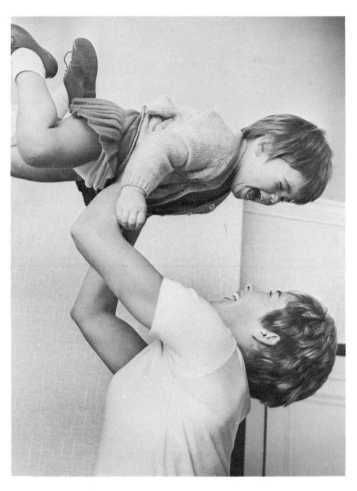

The exclusive picture that I obtained of Mary Rand greeting her baby for the first time after her return from the Tokyo Olympics.

As she was now a world-famous figure there was no way I could stop other papers from getting pictures of her with Alison, but I was going to be able to get the very first pictures, and this pleased me, as I knew they would have a natural spontaneity which would be lacking in posed shots taken later.

We arranged that Mary would meet up with her baby a couple of days later. This gave her a break to settle down after all the excitement of the Olympics. Unfortunately the rest of the press were also after this first reunion picture, and were watching the place where baby Alison was being looked after.

We then had one of the greatest car chases in journalism. One of our reporters picked up Alison and the friend who was looking after her and tried to elude the pursuing opposition, while I had Mary in my car also being chased by my rival pressmen.

We had a secret rendezvous where we were going to bring the two together, and we hoped that we would shake off the opposition when we reached it. But in spite of some rather, to put it mildly, "exciting driving", it wasn't possible to get rid of the opposition. However, I was able to slam the door in their faces when we reached the rendezvous, and so managed to get my exclusive pictures of the first reunion.

Unfortunately, when Mary's marriage to Sydney was dissolved and she remarried to American athlete Bill Toomey, it meant that she moved to live in California. So I lost, not only a good friend, but also a good subject. But I do still see her occasionally when she visits this country, and then we chat about old times, and the excitement of the various pictures which we took in the days when she was our greatest athlete.

Swimming

I have always found this just about the most difficult subject of which to get good pictures. The trouble is that the swimmer's body is almost entirely hidden under the water. Usually only the face is visible, and then only for a second or so when a stroke like the crawl is being swum.

I don't like flash pictures of swimmers because it gives an unnatural look to the water, which appears to be inky black. On the other hand a fairly fast shutter speed of around 1/250 sec is generally required, and the lighting in indoor swimming pools is not always particularly bright. Therefore I tend to use a lens of only moderate focal length so that I can have a fairly wide aperture, then I shoot when the swimmer is quite near to me. But these pictures are seldom exciting, and I have found that some of my most interesting pictures have been taken under water.

There are now many swimming pools with facilities for viewing swimmers under water, and this was the technique I used when I was once assigned to take pictures of our Olympic Gold Medallist, Judy Grinham, when she turned

professional and joined my newspaper as a writer on swimming.

Of course, if you are athletic, you may prefer to go in the water with the swimmer and use an underwater camera such as the Nikonos, or a conventional camera with an underwater housing. I have tried this technique, but have found it very difficult as I myself am not a particularly good swimmer.

I do remember on one occasion when I took both Judy and Mary Rand (who herself is an outstanding swimmer) to a swimming pool at Margate and shot underwater pictures of them there. Against my better judgment I let them lure me into the pool where I was completely helpless against these two superb swimmers. The less said about that particular assignment the better for my personal dignity!

But whether you are taking pictures in the water itself, or through a window which looks under the surface, you may have problems with focusing. Because of refraction, objects underwater always appear to the eye and the camera to be much closer than they actually are. Therefore it is necessary to focus differently.

For instance, if you are photographing a swimmer underwater who is actually twelve feet from the camera, you should set the focus, not to twelve feet, but at about eight feet. The use of a coupled rangefinder or SLR focusing system automatically takes care of this problem. The angle of view taken in by the camera lens is more restricted than it is when the camera is used under normal circumstances. So it is better to use a wide angle lens for underwater shots than one with a normal focal length. I have found that a lens of about 35mm focal length will give me approximately the same coverage underwater as a 50mm one will out in the open air.

Contrast is very low under water and you must beware of over-exposure. My technique has always been to give a stop or a stop-and-a-half less exposure than that indicated by the meter or through-the-lens metering system. Then I give extra development later to build up the contrast.

Diving

This is a much better subject for pictures than swimming, and some very spectacular shots can be taken if you are able

to work in an open air pool where there is plenty of light so that you can use a fast shutter speed. But even this subject can have problems if you are after a picture which is out of the ordinary—and that is what newspapers always want if it is at all possible.

Have you ever had one of those exasperating, niggling problems, to which you know there is a simple answer, and which you, as a professional in your particular field, should be able to answer? I had one such problem just before the 1972 Olympics. I was going to photograph our champion diver Helen Koppell doing one of her exhibition dives. I knew exactly the shot I wanted; one big picture showing Helen just before she left the diving board, then several separate shots as she went through her various manoeuvres in the air until she finally entered the water cleanly. All to be on the one print.

There was one certain way to achieve this with the minimum difficulty, and that was the method I had adopted some years previously when I had photographed the Spanish dancer Antonio. It involved having the entire room in total darkness and using a repeating stroboscopic flash to illuminate the subject at different stages of its movement, while keeping the shutter of the camera open. The only snag with this method, where diving is concerned, is that it is impossible for a top diver to perform perfectly—if at all—in complete darkness. I imagine it would be even worse with a rapidly repeating flash going off during the dive. So that one was out.

I did experiment with the idea of having the indoor swimming pool lit entirely by green arc lamps and putting a red filter over my lens, then using the stroboscopic flash for my pictures. But the filter over the lens cut the light down so much that pictures simply weren't possible at the distance from Helen that I would have to work.

I decided that the only way was to take pictures on separate frames and paste them on to one large picture of the swimming pool. The snag here was that none of the motor drives I had with me gave enough frames-per-second to cover the dive and give me all the attitudes I required in my finished print.

I could, perhaps, have used our Hulcher camera, which takes 70mm film and can shoot up to 20 frames a second,

but there was even a snag here. Helen was a very busy little schoolgirl and in the midst of taking goodness knows how many A levels. Therefore she couldn't spare the time to get from her Leicester home to a suitable open-air high diving board where there would be enough light for the Hulcher, so we had to do the pictures at her local indoor swimming pool. And though there was quite a lot of ambient light, there was certainly not enough for exposures short enough to stop her movement as she went through the air. Therefore I *had* to use flash.

As I drove up the M1 to Leicester, I was still turning the problem over in my mind, and feeling that somewhere, somehow, there *must* be a simple answer to it. The way I finally accomplished my picture was rather clumsy and not exactly as I had envisaged. I persuaded poor Helen to perform numerous identical dives, during each of which I used a Rolleiflex to take a flash picture of her in a slightly different position.

Afterwards I took one single shot of the diving board from the position I had used for the individual pictures of Helen. Then I carefully cut out each action picture of her and stuck it on the background print. This I then copied, to give me a final negative.

Everyone at the *Express* thought the picture was good and worthwhile, but I was not happy with it. I knew it did not depict one complete dive by Helen, and therefore, to the practised eye of another expert diver, the combination might appear to be rather an odd sort of dive.

If you are shooting diving pictures at an outside swimming pool, you will usually find it better if you take them when the diver is using one of the lower boards, or a springboard, as it is best to show some background to your shot. This gives the viewer of the final print some idea of the attitude of the diver, and this would be impossible if he or she were against a plain sky.

Ice skating

If it is at all possible I prefer not to use flash for this subject as the background then becomes inky black and uninteresting. But it all depends on the lighting conditions at the rink.

For many of the spectacular jumps you can get away with quite a low shutter speed of around 1/125 sec if you catch the skater at the peak of his movement. For this you need the co-operation of the skater, and you need to arrange for the action to take place at a certain distance on which you have pre-focused. If the skater then does the particular exercise which you want to photograph, you can expose just as he reaches the top part of a jump, and is virtually motionless in the air for a tiny fraction of a second.

There was one occasion when flash was the only answer. I was going to photograph one of our Olympic stars, Caroline Krau, a month or so before the Games commenced. I arranged to meet her at Queen's Ice Rink in London, and just to warm up and to get the feel of the photography, I took some of the conventional and rather corny ice skating pictures. These were the ones so often taken by most photographers, such as split-jumps, bunny jumps, stags, and so on. I had no intention of using these, but took them simply so that we could get to know each other while I took the shots, and I could see whether a good idea would come out of them. We spent about an hour on them, and towards the end I had the feeling of the picture I wanted to take. But by then the public was being admitted to the rink and it wasn't possible for me to set up the picture I wanted, so we arranged to meet the next morning.

I was using a Rolleiflex, and I put this down on the ice, then laid down myself to look through the viewfinder, focusing on a distance about three yards away. I had one flash (covered with two layers of grubby handkerchief) on the camera and an extension flash to one side. I then persuaded Caroline to skate straight towards me at full speed. When she was about four yards away, she went into a skid stop, and just as she was on my pre-focused three-yard mark I pressed the shutter release. So I got a picture of her with plenty of action and impact, together with a great spray of ice coming from her skidding skates. It was just the picture I had wanted; different from all the rest, and with all the action and feeling of speed and power.

Back to the *Express* I went with my pictures, where I processed them and was delighted with the results. But the one which was printed in the paper was one of these corny split jumps which I had taken in the beginning. The editor

told me it fitted the "hole" they had in the paper better than the one which I had worked so hard to take!

If you are photographing exhibition skating I would definitely advise against flash. Make use of the spotlights that are invariably used, and don't be afraid to shoot straight into them, as their rays of light can add greatly to the pictorial effect of your shots and a backlit skater with a rim of light around her can make an excellent picture. Quite slow shutter speeds can be used to capture some of the graceful moves of the skaters.

Professional photographers are often able to get on to the ice in order to shoot their pictures when there is a rehearsal for an ice show, but this can be a very precarious business, especially for a non-skater such as myself. Usually it is better to work from the side and use a medium telephoto lens such as a 90mm. Don't worry too much about getting your exposure dead right. Get a shot in the bag and then make adjustments afterwards if you think you have got it wrong.

Motor racing

I have a special affection for motor racing, not just because it was the subject which started me off on full time press photography, but because I rate it as the most exciting sport in the world.

It has also provided me with some of the most thrilling and dramatic pictures I have taken. For instance, back in 1962 when I was at Goodwood racing circuit, I was able to shoot a sequence of Stirling Moss having the crash which put him out of motor racing. Later I pictured Peter Proctor, enveloped in flames, leaping from his burning car. And of course shots of crashes of all sorts, with cars leaping, somersaulting and flying through the air at different angles. This might be the time to make it clear that I never *wish* for a crash to happen. That would be inhuman. All I hope for is that if there *is* going to be an accident, then I shall be in a position to photograph it.

For years I photographed racing accidents in a coldly professional way, and took pictures of horrific crashes without being affected emotionally by what was happening to the driver. But gradually my attitude changed. Because I was so closely involved with the sport I inevitably became friends with many of the drivers. And as the number of those

226

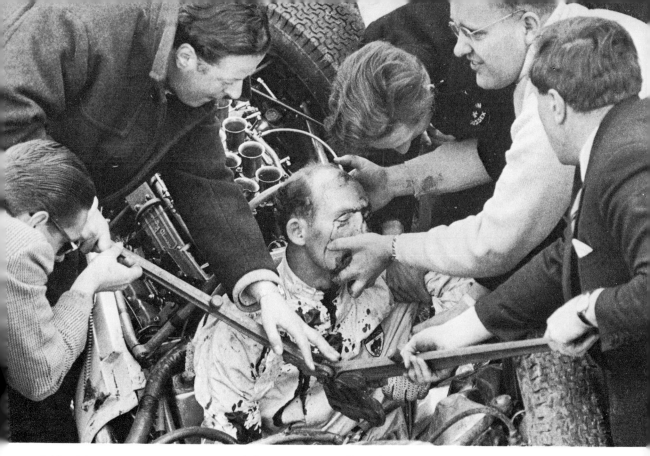

Stirling Moss being cut from the
wreckage of his racing car after his
130 mph crash at Goodwood in
1962. Nikon with 85–250mm zoom.

I knew personally who were killed or dreadfully maimed
grew, so I found myself being emotionally affected more and
more.

Curiously enough the drivers themselves never seemed
to object to the fact that I was taking photographs of their
accidents, though there have been protests from members of
the public. Actually, I have found myself being told off by
drivers for *not* having taken a crash picture. Graham Hill did
this twice when he crashed, and I failed to get a picture of the
crash.

But for me, I think the crunch came when Piers Courage
was burned to death in the Dutch Grand Prix. I was there at
the time and had been chatting to Piers only a few minutes
previously. When this accident occurred I was sickened by
the whole business and wanted to have nothing more to do
with motor racing at all.

Later I thought it all over carefully, and of course I
couldn't withdraw from motor racing. It was my specialist
subject. But I made a resolve that I would not get myself
personally involved with the drivers in the future. I do have
several close friends in motor racing, but I am trying not to
make too many new ones. In this way I hope I may regain
the impersonal outlook which I once had about racing
accidents.

227

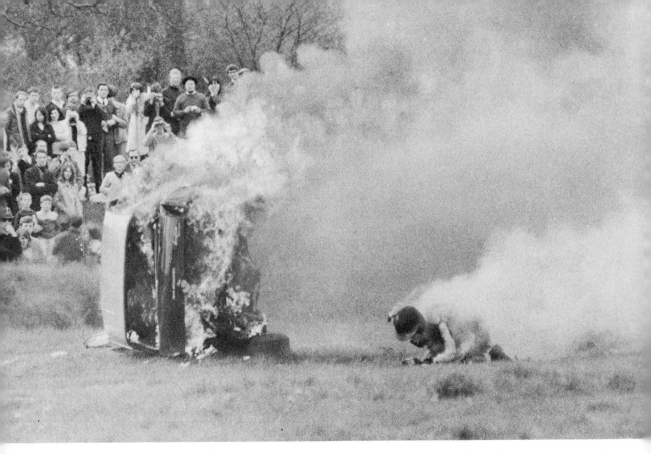

The crash at Goodwood in which Peter Proctor was trapped in his blazing car. He eventually got himself out while still on fire and miraculously recovered. I used a 300mm lens on a Nikon.

But it hasn't all been tragedy. There have been amusing accidents, such as when one driver, Albert Gay, driving a Peerless car at Brands Hatch, came round Paddock Bend, obviously going too fast to make the curve. I was using a Leica M3 fitted with a 135mm Canon lens, and when his car hit the banking it broke up completely, throwing Albert out during the process.

It looked as if he must certainly have been killed, for there was hardly anything left of the car. But when we ran over to him, we found Albert sitting on the grass shaken, but apparently completely unhurt, without having suffered even a scratch. He wore spectacles, but these were unbroken, and I thought this such a miraculous escape that I wanted a picture of him smiling and waving.

So I said to him "Your wife is worried about you. Give her a wave."

Albert, still a little dazed by the crash, sat up and waved, and I took my picture.

Then he turned to me and said "But I'm not married!".

Horrific as they are there is no doubt that racing car crashes do make spectacular pictures. If you aim to capture any of these then you must be on the constant look-out for any untoward movement of the racing cars. Accidents usually occur on the exit of a bend but this is not an invariable

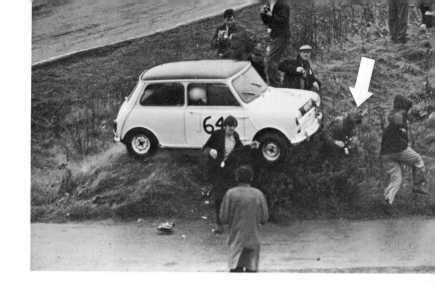

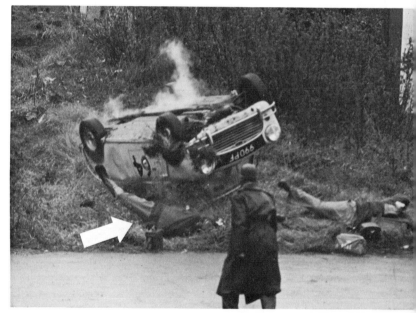

It is not always the racing drivers who come off worst. I was run over one Boxing Day and suffered a broken leg. Then in 1968 I was again run over by the crashing car in these pictures. That earned me three or four broken ribs. I knew what the drivers felt like then as I was carried away on a stretcher and my "friends" were saying "Come on Vic. Give us a smile and a wave". I could have killed them!

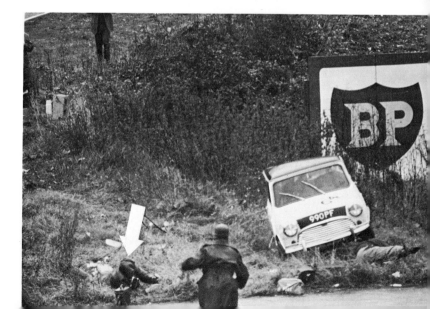

rule. Collisions, or failure of any part of the car, can happen at any part of the circuit. But in general you will stand more chance of getting a crash picture if you are somewhere at the exit of one of the bends which follows along the straight.

After standing for a while at one of these bends you will develop an instinct for the speed at which cars can safely get round, and experience will tell you when a car is going too fast to get round the bend. This will give you a chance to get your camera ready. But things happen very quickly with racing cars travelling at speeds of well over a hundred miles an hour, so your reaction time will have to be swift.

When an accident occurs you will have no time to focus or make any settings. You shoot *immediately*. What you must *not* do, on any account, is to get in the way of rescuers or ambulance men. I have no time at all for photographers, whether they be amateurs or professionals, who go in too close and hinder the operation of rescuing a trapped driver.

One of the most horrific pictures I have ever taken. It was at Monaco when Bandini's Ferrari crashed and literally exploded into flames. The car landed upside-down with Bandini still in it, and it was a long time before they got him out. He died later from his burns.

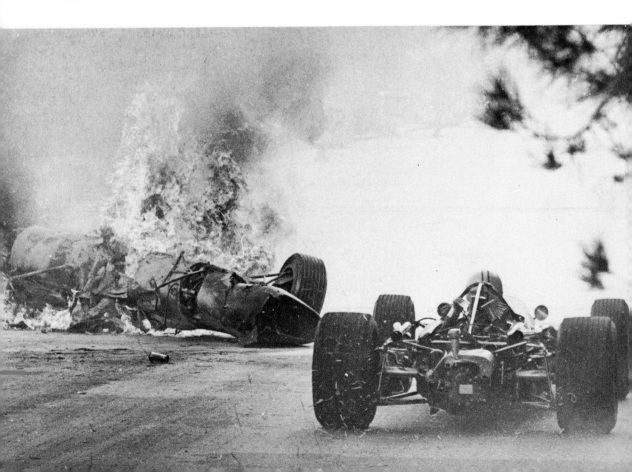

North Tower Crescent, Crystal Palace. At the start of the race you must always be watching for incidents which can easily occur as the cars are closely bunched and fighting to gain a lead, particularly at the entrance to a bend. Notice again that it is because you can see the driver that this picture has real interest.

But enough of the crashes. Fortunately they don't form a major part of motor racing, and many of us like to take pictures which will be of interest, not merely because some unfortunate driver has made a mistake and provided a dramatic picture.

I know that many amateurs are envious of press photographers with their privileged positions on the inside of the circuit, and certainly we are not hemmed in by a jostling crowd. However, many of the best action shots of motor racing can be taken from the outside of the circuit, where the public normally stands. A longish lens is best for motor racing action shots, and I would suggest a 135mm or even longer, if you have one.

A picture which has a lot of impact is one taken from a position at the exit of a bend, just as the car reaches the apex, with the nose pretty well pointing straight at the photographer. But for this sort of shot a really long focal

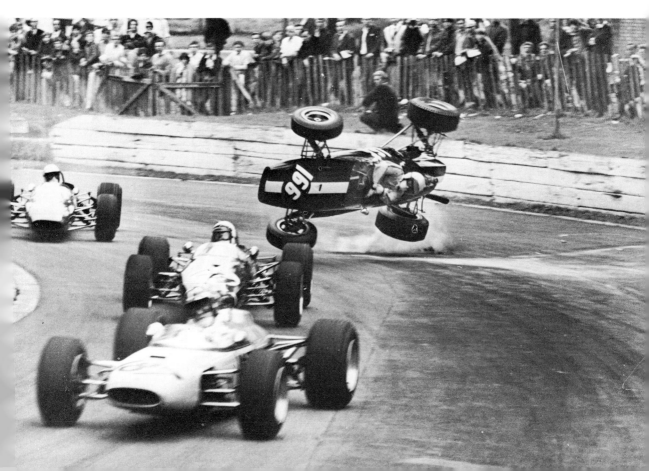

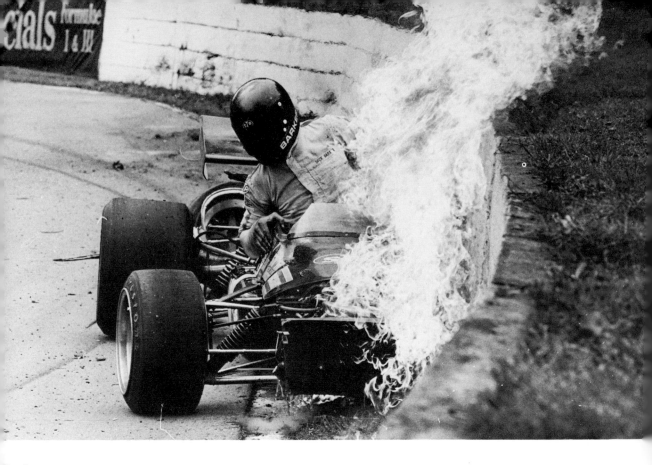

North Tower Crescent at Crystal Palace motor-racing circuit gave me my first ever racing car crash picture, but this is the last one I took there before the track was closed. Although it appears so horrific, the driver, Dick Barker, actually suffered very minor burns and was comparatively unharmed. Minolta with 135mm lens.

length lens of around 400mm would be required. If you haven't got such a long lens, it is still a good position for pictures at the early stages of a race when the cars are bunched together.

Another good position is at the entrance to a bend and some very close "dicing" can be captured on film as this is the most common place for one car to overtake another.

For good side-on pictures of racing cars it is absolutely essential to pan the camera, and for the beginner this requires a little practice. Fortunately it can be obtained on any main road. Pick up an approaching car in your viewfinder when it is about fifty yards away and hold it in the viewfinder by swinging the camera smoothly as the car gets nearer. And then, a moment before the car is level with you, press the shutter release *while continuing to swing the camera.* This swing must not be stopped as soon as you have taken the picture—follow it through, just as a good tennis player does with his racquet after hitting the ball.

Naturally, you should have prefocused on the spot where you anticipate the car will be when you make your exposure; and you should have been standing facing this spot before you swung from the hips to face the oncoming cars. With this method you can get a pin-sharp picture of a car doing

Jim Clark just before a Grand Prix. The expressions on the faces of drivers just before a race can often provide more interesting pictures than the race itself as they show the tension which is building up in them. Nikon with 135mm lens.

ninety miles an hour at a shutter speed of only 1/60 sec. In fact, the slower the shutter speed the greater the effect of speed in your picture, so long as you have made a good pan.

But don't confine all your pictures to the cars racing around. Remember, people like people, and with modern cars there is very little of the driver to be seen. Some of the best human-interest shots can be found in the paddock, and few of the top drivers will mind posing for a picture for you. However, I prefer to take candid pictures, and many pleasing shots can be taken when the drivers are having their cars adjusted or set up for a particular race during the practice sessions.

233

At these times I seldom speak to a driver, even if he is a close personal friend, as I know they like to keep their entire concentration for the job in hand. Not unnaturally they resent anyone coming up and chatting to them about inconsequential things when they are tensed up with trying to get a car ready for a race.

If you have just a simple snapshot camera then you can't expect to exceed its limitations and get good pictures during a race. But you should be able to get good shots in the paddock, and these will often prove far more popular with the friends to whom you show them than actual racing pictures.

And if you have a good camera, but don't possess a long focal-length lens always remember that a slow fine-grained film which can later be enlarged far more than one of the coarser-grained, fast films, can give you exactly the same effect as if you had used a telephoto lens.

If you have asked a driver to pose for a picture for you, do have all your settings made and the focus adjusted before you say to the driver "Ready!". Graham Hill once told me that nothing was more annoying than for a photographer, whether he be professional or amateur, to ask him for a picture and then say "Ready" as a signal for a smile, whereupon the photographer still fiddles with his camera. Meanwhile, Graham told me, his smile is getting more and more fixed, stony, and glassy. So have all your settings ready, and then when you say "Right" and the driver puts on his smile, or wink, or whatever you have asked him for, shoot immediately without hesitation.

16

Breaking into Press Photography

There is no doubt that many amateurs, particularly youngsters, have ambitions to become press photographers. This is understandable, as they look at the pictures in their papers and think of the glamorous, exciting and adventurous lives which press photographers apparently lead. There is certainly a lot of glamour and excitement—danger too at times—but there is also a lot of routine work which is very dull and boring.

As a press photographer you spend many hours waiting in pouring rain and freezing cold to photograph a politician who, for reasons best known to himself, does not wish to be photographed. In the end you may get a picture and, just about six inches from death's door, you stagger into your newspaper's darkroom and get it processed. Only to be told by the picture editor that your photograph is no longer required. The frustration this sort of situation engenders must be endured. It is part of the job. What you must *never* let it do is to discourage you so much that you don't do your very best on the next assignment you carry out.

I like to look upon every fresh assignment as a completely new start. I never consider that the day before I might have been frustrated and had a good picture which was "spiked". Yesterday's pictures are done and gone. I think only of the new ones.

To be a successful press photographer you must be enthusiastic, always looking for the good, the different, the original picture. You must also be competitive, so that you try to beat the opposition at every opportunity. Obviously you will not always succeed, because they are trying to beat you too, but you must always be trying.

I must emphasise that technical expertise in photography will not automatically make you a budding pressman. I am quite certain that there are many amateurs with far more photographic knowledge than I have, and who are capable of taking pictures technically superior to mine. But this does not mean that they could become successful press photographers. Press photography requires an instinct (I don't think it can be learned) for knowing what makes a good newspaper picture and what does not. It requires a man who will make his own decisions and whose decisions are the right ones—at least most of the time.

Evidence of ability

Fleet Street doesn't give two hoots whether a man has been a sanitary attendant or a professor of physics. All the picture editors are concerned with is whether a man is a good press photographer or not. There is certainly no bar against educational distinction, as to my knowledge we have had at least four ex-university men working as photographers on the *Express*. Only one thing counts: ability to do the job.

Daily newspapers lean heavily on their staff, and give them a lot of responsibility. They are expected to take this responsibility and have the ability to work on their own without supervision.

Newspapers cannot be expected to take a chance by giving work to someone whose worth is completely un-known. Editors want evidence of ability, and that evidence does not consist of success at photographic exhibitions, or letters after one's name, but of *published* work. That is the only criterion.

What you have had published is evidence of ability. Which means that you must either freelance, or work for a local newspaper, as did almost everyone I know who works for the national dailies. Only in this way can you gain experience. After all, you don't expect to step into any top job without experience, and the national papers are far too busy to train people. They pay good money, and for it they want ready-made press photographers.

I myself started by freelancing. I knew no one, had no contacts, and no experience of press work. But I found my own stories and pictures, built up my experience, got more and better pictures published, until, one day I was *invited* to join the staff of the *Express* because my work in other papers had been noted.

Value of an enquiring mind

How do you find these pictures and stories to start you off freelancing? Well, the fact that anyone asks this shows that he is not a born pressman. They have to be sifted out from local papers, radio stories, personal contacts, and even gossip. One of the essential qualities for a press photographer is what polite society would call an enquiring mind. I call it plain noseyness, and it has been responsible for my getting many unexpected pictures. For instance, a

few days before the funeral of Sir Winston Churchill, I had been on an all-night job, and I didn't leave the *Express* until about five in the morning. I have always felt that this is a good time to be up and about. Apart from the feeling of superiority you have over the sleeping population, there's always the chance of coming across an unusual picture.

On this occasion, as I drove down Whitehall, with the intention of crossing Westminster Bridge on my way home, I noticed what seemed to be an extraordinary number of police about. Poking my nose in, I asked one of them what was going on. He told me that the rehearsal of Sir Winston's funeral procession was about to take place, complete with the gun-carriage. I quickly parked my car and, armed with my Leica M3 fitted with a 35mm lens, went over to the Houses of Parliament to see what was doing. There were no extra lights but I could faintly see that there was a lot of activity in the Palace Yard, so I walked round till I found a good view through the

Rehearsal for Sir Winston Churchill's funeral procession. The exclusive picture I obtained by being inquisitive during the drive home after an all-night job. I gave a 10 second exposure at *f* 1.5 with the camera pressed against the Palace Yard railings.

railings. Then I shot pictures with an exposure of ten seconds at *f* 1.5, using my usual Tri-X.

There was not another soul about, so I had it exclusively. This is a demonstration of being inquisitive, and also of taking a chance technically. Of course, I didn't hand-hold the Leica for ten seconds, but wedged it firmly against one of the railings surrounding Palace Yard.

The market is the test

Every now and again I am sent a selection of pictures by amateurs who hope to enter press photography, with a request for my frank and candid comments on them. I wish they wouldn't do this, because it places me in an intolerable position. If the pictures are unsuitable, I either have to write back and say so, probably making an enemy for life; or I have to tell a deliberate lie, and say they are quite good. Normally I risk making an enemy and tell the truth. But there is a much better test of your capabilities than sending your pictures to me. Simply submit them to newspapers and magazines and see if they get published. If they don't, then, whatever you or your friends think of you as an embryo press photographer, it is certain you are on the wrong lines.

Don't get me wrong. I am not implying that press work is a superior form of photography, but it does require a particular type of thinking. I have no doubt that very many amateurs are far better photographers than are many photo-journalists; but this does not mean that they will automatically get their pictures published. A press photographer trains himself always to look for the shots that will have a wide appeal. He develops an instinct for the type of pictures which will get published. Photographic ability is certainly necessary, but it must be remembered that this is only a part of the work. The real essential to earning a living, is to know the market for pictures, and then to supply that market.

Knowing the market, does not mean saying "Yes, well that's a travel picture, so I will send it to a travel magazine" or "That's a good feature shot, so I will sell it to the newspapers". Intense study of the various publications is required to see exactly the type of picture each prefers.

Even the national newspapers vary in the pictures they publish, and a photographer working for the *Express* has a different approach to certain assignments from one working

for the *Mirror*, who again is different from a *Sun* cameraman, and so on. The good photojournalist knows these subtle differences, and this helps him to place his work properly.

Making a start

If you feel there is no other life for you but press photography, and you aim to work on one of the big national newspapers, you've got a long, hard, road ahead of you. The trouble is that there is no accepted method of entry to Fleet Street. With local newspapers it is different, but most national-press photographers started by freelancing. That is, finding your own pictures and stories, and then selling them to the papers. This is excellent training, and gradually, if you are any good, your name will become known to picture editors. Then *maybe*, one day a staff job will be offered. In the meantime you will work all the hours humanly possible. Sometimes you will nearly starve, and you will suffer innumerable disappointments and frustrations—then you still might never make the grade.

Perhaps the best advice I can offer the youngster who is really keen, is to take a job, either in the darkroom of a local paper, or in one of the agencies as a runner (as we call lads who rush prints round to the various newspapers). Save up your money, get yourself a camera and start to freelance in your spare time. In this way you will learn something of the job and also have regular money coming in each week. But there is no positive guarantee that you will ever become a press photographer.

To make the grade you must not only be skilled in the taking of photographs, but you must be able to find your own stories; you must be able to come up with a constant supply of fresh ideas for pictures; you must know exactly the type of pictures preferred by different newspapers; you must have the initiative to work entirely alone without reference to higher authority and without being able to call on help; you must not be a clock-watcher, but must be prepared to give all your time to the job; and you must be competitive-minded, trying to beat the opposition at every opportunity. If you can do all this you *might* be offered a staff job, but this doesn't mean that you can then sit back and relax. You will always have to be on your toes and prepared for plenty of hard work.

The story behind the picture

People who know nothing about press photography often say that some of the pictures they see published appear so simple that any ordinary amateur could have taken them. What they don't realise is that there is far more to press photography than the actual taking of the picture. To illustrate this I will tell you the story of how I covered the news of a Dutch ship which was in collision off Bremerhaven some time ago. It was fairly routine, but what made it a good story was that all the passengers had to take to the sea in life-boats.

I arrived in the *Express* office just as the news broke, and the picture editor immediately asked me if I could charter a plane to fly over the scene, then land a couple of reporters in Germany, and fly back to England with my aerial pictures. A simple straightforward job one would think, but experience teaches that such jobs are seldom as straightforward as they look. My diary, which follows, will tell you how this one worked out.

Contacted aircraft hire firm, who agreed to have an aircraft ready for me to fly to Germany within the hour. Motor to airport, join up with two reporters, and then encounter first snag. Aerial photography over Germany forbidden without prior permission; and anyway it would be too dark for pictures by the time we reached Bremerhaven. Phone office for instructions and told to go anyway and try to collect pictures possibly taken by passengers. Am given phone numbers of contacts in Germany who might help.

Arrive at Bremen airport. Reporters leave immediately for Bremerhaven to interview captain and passengers. I phone my first contact, get a wrong number. Phone second contact—get no answer. Phone third contact in Hamburg; his son answers, but cannot speak English. I cannot speak German, but fortunately find someone who can, and he elicits the information that our contact is already out on the boat story. Decide to forget outside help and work alone.

Drive into Bremen, leave bag at hotel, and go looking for passengers. Find them scattered in various hotels, and collect three rolls of film taken during the evacuation of the ship. Knock up a commercial photographer and persuade him to hire me his darkroom. Develop the passengers' films and find they are all useless—ruined by the fog that caused the collision.

240

Telephone local newspapers and get phone numbers of their photographers. Phone *Express* in London to check on the pictures they had already received from the international agencies, as I do not want to buy pictures from a German photographer at a high price, only to find that German agency photographers have sent better ones to London. I also call Hamburg and get permission to go to the public picture-transmission station in Bremen (where pictures can be radioed to all parts of the world) and see the pictures that one of the big agencies have wired. Do not impress me, and neither do the ones taken by the local photographers, which I have eventually tracked down in various parts of Bremen.

By now it is past midnight and I call London. They rather acidly remind me that so far they have not received a single picture from me, and am I enjoying myself? I give a reply which is not printable, for, having not eaten since breakfast, I am not in the best of tempers. I hang up. One of our reporters now gets a message to me about a certain girl-secretary being the heroine of the disaster, and out I go to get a picture of her. Find her and get my pictures. Then knock up the commercial photographer again for the use of his darkroom. It is now 2.30 a.m. He uses some German words which are not in the dictionary, but I manage to pacify him, get my film processed, and make a print of the best picture. I take it to the picture transmission station and find it is closed—no pictures can be wired after midnight.

Telephone one of our foreign correspondents permanently based in Germany for help. He gives me name of German reporter in Bremen. I telephone him and tell him I cannot get pictures wired to London as Post Office transmission closed. He says he will see what he can do and will phone me back at my hotel in ten minutes time. After half-an-hour no word from him so I go to bed. Five minutes later phone goes. He has persuaded a picture transmission engineer to open up the station for me if I will collect the engineer in a taxi and then take him home again afterwards. Within three minutes I am on my way—shoeless. When I went to bed I put my shoes outside the door and they were promptly collected for cleaning. However, all now goes well, and at 3.45 a.m. (European time) my picture is "rolling" and is being received simultaneously in our London, Manchester and Glasgow offices.

After a coffee with the engineer, I return to hotel and

crawl into bed at 5 o'clock. At 8 a.m. I am up again to fly back to England. Make a last check-call to London in case there is another assignment for me in Germany. They tell me that my picture went on page one in the very last edition. I arrive home and a neighbour tells me how lucky I am to go abroad on jobs which must be like holidays. I do not bother to answer.

From all this you will see how much can lie behind the simple picture of a girl which appears in the newspaper. It is not always as complicated as this, but it does indicate that there is more to press photography than just a knowledge of photography.

Preparing the picture for publication

After shooting the pictures the photographer returns to his newspaper office if the assignment has been within a reasonable distance, and he processes his film. (Sometimes he will have had with him a portable darkroom and equipment for wiring pictures, complete with a photo-technician and a wireman, if the assignment is urgent and some distance from London).

After developing his films, the photographer selects the negatives he wants enlarged and then, closely co-operating with the darkroom technician, these negatives are blown up to whatever size the importance of the job warrants. Usually these are 15×12in prints, but sometimes 20×16in are made. The prints are captioned on the back by the photographer, who passes them on to the picture editor.

The picture editor discards any he thinks are unsuitable, compares them with any agency pictures there might be of the same subject, and assuming (as he always hopes) that the staff man's pictures have beaten those of the agency (although this is not always the case) they are taken to the editor of the particular section of the paper to which they are most suited. This might be sport, feature, general news, diary, city, and so on. On the more important jobs, the editor of the paper himself will make the decision where and how pictures are to be used. When the size and shape of the final picture has been decided, an art editor measures the print and rules it up for the block makers.

The print next goes to a retouching artist, who prepares it for the coarse, half-tone reproduction used by newspapers.

An air-to-ground picture of all that was left of the Trident Papa-India, which crashed near London Airport in 1972. Minolta with 200mm lens.

In the meantime, the darkroom technicians have made a smaller print (usually 10 × 8in) which is sent by wire simultaneously to the Manchester and Glasgow printing offices. This wiring of a print takes under ten minutes. At last the original picture goes to the block makers, who etch it on to metal, and the block goes down to the "stone" to be used for making the final mould for the plate from which the newspaper is printed.

Dealing with the big event

The pictures you see in your newspaper are chosen from some four hundred which arrive on the desk of every national newspaper editor every day. So you can see the sort of competition you are up against when you try to get pictures published in a national newspaper. In spite of this, many amateurs do get their pictures published and make large sums of money doing so.

The money-making pictures are usually of big news happenings—regrettably they are often tragic—which amateurs take pictures of before the staff and agency photographers can arrive on the scene. These early pictures are usually better than those taken by the professionals, who are late arrivals. However I am constantly surprised at the number of big news happenings which occur and which produce very few pictures from the public, although amateurs could earn themselves hundreds of pounds, if they had shot pictures at the time.

The reason is, of course, that they do not carry their camera with them at all times. And I cannot stress too strongly the importance of always having a camera with you. Even if you do not aim to take a great news picture, there is always the possibility of a prize or award-winning one which occurs when you are out. And if you haven't got your camera you will never be able to recapture that particular moment.

How should you set about taking pictures of a big news-happening if you are at the scene and you do have your camera with you? Well, for a start, don't let the thought of a possible small fortune stop you from remembering that you are a human being. If there are people suffering, as happens after a train or air crash, and there is nobody else around to help to rescue them, then I would certainly never advocate that you take pictures.

Air-to-ground pictures of disasters are routine assignments in press photography. This particular picture was taken when a train crashed near Eltham in 1972.

At the time of the historic Lewisham train crash, the *Express* had a very early tip-off that it had occurred, and as I was living only five minutes away from the scene, I was the first pressman there. I didn't bother to take pictures, but joined in helping with the rescue work and carrying the dead bodies down the embankment. I only stopped doing this and started taking pictures after it became clear that there were more than enough rescuers on the scene, and my help was no longer needed.

But assuming that there are enough helpers at the scene of a big disaster, you should set about taking your pictures without getting in the way of the police or rescue services. Always try to include people in your pictures. Remember faces are far more interesting than places. But don't forget either, that a good general view of the whole scene will also be valuable to the picture editor.

You may be too busy to get any names for captions, but if this is at all possible you should note them down.

Your next job is to telephone the picture editor of the newspaper to which you have decided to offer your pictures. Wherever you are, there is no need to pay for the call. The *Express*, and probably most other national newspapers will almost always accept reverse-charge calls. When you get through, ask for the Picture Desk, and then tell them exactly what pictures you have taken.

If you simply say "I've taken some pictures of that train crash at Mudthorpe" the picture editor will have no idea whether your pictures are any good, or if he has some pictures coming from another source which are better than yours. Try to tell him exactly what your pictures show. For instance, you might say "My pictures show rescuers carrying people out of the carriages, and I have a general view of the whole scene. I also managed to get a picture of the engine driver".

In this way the picture editor will have a pretty good idea of what your pictures show. What you must *not* do, under any circumstances, is waste time by processing the film yourself. There are two reasons for this: firstly, if you are going to sell your pictures exclusively (and this is certainly the best method for getting the most for them) and you present the editor with negatives, he will not be quite sure that there are not some other prints which have been made from

these negatives, and which might find their way into the hands of rival newspapers. So, to be on the safe side, he might prefer to use pictures which are similar, but have been taken by another amateur.

The second reason is much more important. It is a question of time. In newspaper work time counts for everything, and the earlier your pictures are on the picture editor's desk, the more chance they have of being given a big display.

If the picture editor does want to see your pictures he will tell you the best way to get them to him. This might be in a variety of ways. He could have a despatch rider on his way to collect them from you. Or a staff photographer. Or there could be a local photographer whom he would assign to

The *Texas Caribbean* sinking in the Channel. A zoom lens on my Minolta enabled me to frame the shot closely from a light aeroplane just before the ship went down.

contact you and collect the pictures from you. Or he might ask you to put them on a train, and he would tell you which train and which station. The important thing is that he will know how to get the pictures from you to him.

At this stage there is no point in discussing fees with the picture editor. No editor will agree to buy pictures, sight unseen. He will want to see them first. And neither should you feel that you have to bargain and haggle over price once the picture editor has agreed to use your pictures. You will find that the popular national newspapers are very generous indeed where amateurs are concerned, and you will be amply paid for your pictures. This isn't because picture editors are benevolent old gentlemen who want to help you out. It is pure, hard, business thinking.

They know that, if you are the type of man who has taken one good set of pictures of a news incident, then you probably carry your camera around most of the time and it is quite likely that you will come up with another good news incident some time in the future. The picture editor doesn't want you feeling that you have been hard done by, so that next time you will go to a different newspaper. Therefore, you will find that picture editors of national newspapers are inclined to be quite generous in their payments.

If your pictures are likely to be of use to magazines, particularly those of other countries, he might ask you whether you would like the newspaper to syndicate your pictures. It is almost always worth agreeing to this, as newspapers have special syndication facilities and contacts for reselling pictures after they have finished with them. If the news-happening you have photographed is one of international interest you could make a very large sum of money; syndication sales can be as great as, or even greater than, the original sum paid by the newspaper.

The most important points to remember are:

1 *Always* carry your camera. You can't take the greatest news picture in the world if you haven't got your camera with you. Obvious, I know, but so many people seem to forget this.

2 Never try to process the film yourself, but contact the newspaper of your choice and ask the picture editor if he will be interested in your picture.

Lastly, don't forget those four hundred prints which land

A typical air-to-ground news shot showing the flooding which took place in the West Country after a particularly heavy rainstorm. Minolta with a 200mm Rokkor.

on the picture editor's desk every day, so don't be too disappointed if your picture does not get published.

Incidentally, if you are giving any instructions to the darkroom, it is no good specifying a particular type of developer. Newspaper darkrooms usually have just two or three types of developer, and they may not have the one which you have specified. Nor is it helpful to say "Pictures taken in poor light". This tells the darkroom technicians nothing, as pictures might have been taken in poor light but still be properly exposed. Far more helpful to say "Pictures under-exposed by a couple of stops". Or "Pictures normally exposed". They can then adjust the development to suit your film.

Working for the locals

Your local paper is an excellent place in which to get your pictures published. But don't think that any old picture will do, just because it's for the local paper. Provincial and weekly papers are now becoming quite discerning where pictures are concerned, and they realise their value. So they want only good ones.

Look carefully through your local paper and see the type of picture the editor likes to use. Then keep your eyes open

as you travel about your district (naturally you should *always* have your camera with you) and snap up any pictures which you see and which you think might be of interest to other people in the locality.

You should also make contact with one or two of the local dramatic societies. When they are preparing a new production you will be almost certain to get a picture published in the local paper of the rehearsal.

What clubs are there in your area? There must be many dealing with a variety of activities, and an alert photographer can usually get an interesting picture out of them for publication. The clubs themselves will be grateful too, for the publicity which your pictures will give to them.

For instance, there might be a model aircraft flying club near you. Make contact with the secretary and find out who the youngest member is. Shoot pictures of him building his newest model-aeroplane, and also flying it.

Have you a friend whose daughter has just won some contest? It might be one for cooking, secretarial work, typing, beauty, dancing, horseriding, or any one of scores of activities. It doesn't matter where the contest took place. Provided the winner lives in the district covered by your local paper you have a good chance of getting a publication if you take an attractive picture of the girl.

Note that I said "daughter". The old adage still applies, that a girl has far more chance of being published in the paper than a boy. Unless of course the boy is small and appealing.

And that brings me to another point. Always keep an eye open for the largest, smallest, youngest, oldest, most beautiful, fastest or slowest, item or person. These are the subjects which give you a hook to hang your pictures on. When submitting them, don't forget to give a full caption. Ideally, this should be stuck on to the back of the print and also enclosed as a separate sheet. The caption should give details of what the event is, why it is taking place, and who appears in the picture, together with their addresses, and if possible, their ages.

Prints need never be larger than 10 × 8in. In fact, whole-plates are quite satisfactory. They should be glossy, but it is not necessary for them to be glazed. Nor is it necessary for them to be more contrasty than normal. A print for publica-

tion in a newspaper should simply be a good quality print with a full range of tones. It is no good producing an extra contrasty print, because this means that certain tones will be missing. And however skilled a blockmaker might be, he cannot put in tones which are not there in the first place.

If you are writing a caption on the back of a print this should be done lightly, so as not to leave an imprint of your pen or pencil which will show through on to the surface of the print.

Do remember that the caption must give facts. It should tell the editor when, where, who and why. These are the important questions which should always be answered. It is important to confine yourself to facts in your caption, and not to personal comments. It is also often useful to the editor of the paper if you can supply him with a telephone number (besides your own) of someone whom he can contact in connection with the story, in order that he can get fuller details if he should require them.

Payment for pictures published in local newspapers will not make your fortune. I used to be paid one pound a published picture when I was working for a local paper. The fees are probably higher than that now, but I shouldn't think they are very much more. Your main pre-occupation as an amateur may be to see your work in print, so you might not worry too much about the size of the fee. Nevertheless, I am firmly against letting pictures be published without any payment at all. For a start, this cannot give you anywhere near as much personal satisfaction as knowing that an editor has been willing to pay for your picture, however small the fee. Secondly, it is unfair to professionals who are trying to make a living out of selling pictures to newspapers, if amateurs are letting papers fill their space with free pictures.

Of course there are exceptions to this payment rule. If you want your local paper to give publicity to some event or organisation of which you are a member, you might be prepared to forego a fee in order to get the publicity which will accrue by having your picture published. This is something that can only be judged in the circumstances prevailing.

You need send no covering letter with your pictures except a note on the back of the prints saying "For reproduction at your usual rates" or specifying the amount you have

in mind. An exception might be if you are offering pictures exclusively to one paper. In that case you might put in a note stating the fact, and the minimum fee you expect to receive, but this does not really apply to local newspapers; as they are not in the habit of paying a specially high fee for exclusive pictures.

However, local papers will prefer that you do not offer an identical picture to several newspapers which cover the same area.

There's no rule about this. But when you offer a picture another time, if the editor thinks that you might have sent an identical picture to a rival local paper, he might not be quite so willing to use yours. Certainly you could send pictures on the same subject, but they should be different pictures.

I have said that the fees which you will get from a local newspaper will not be high, but the contact you have with the paper is extremely valuable. Should you become a regular contributor, they may, perhaps, be prepared to give you some interesting assignments which will provide picture-stories which you will be able to sell to the bigger newspapers after the local newspaper has used them.

And when you become fully established, the local paper might be prepared to let you have some of the valuable passes for functions and sports events which come their way. But don't expect this in the beginning. Before they do anything like this they will want to be certain that you are reliable, and can produce good work consistently.

Doorstepping frustration

Here is a true story to illustrate the sort of situation you could well find yourself in if you ever do become a staff photographer on a newspaper.

Some time ago two photographers, one from the *Express* and the other from the *Mirror* were doing an early morning "doorstepper", which is newspaper jargon for the unenviable task of waiting for some person who is in the news to make an appearance, so that pictures can be taken for the newspaper.

These doorstepping assignments can often go on for hours in the freezing cold (I once did eighteen hours waiting, without a break of *any* kind), and one of the most dreaded

doorstepping locations is Downing Street, lovingly known as "Pneumonia Corner". Why do political crises always seem to occur in the depth of winter?

One of the basic rules for all journalists is that they must keep in contact with their offices. Usually this means a quick phone call, which often goes like this.

"Picture desk? Len here—just making a check call".

"Len? Oh, yes. You're waiting outside Lady Dogsbody's house. We're still checking whether she is inside or on holiday in the Bahamas. Stay with it".

"O.K. Not that I'm complaining, but I've been here for ten hours. A policeman has already asked me if I am trying to establish squatter's rights, and its six degrees below zero".

"I know how it is". (Liar, you think; he's never doorstepped in his life). "I'll get a relief to you as soon as somebody comes. The trouble is that I had to send two photographers out to cover that champagne party".

Does the swine have to rub salt in? The final straw is when you get back to your doorstepping post to find the bird has flown, and all the opposition have a picture of her. And the picture editor just never believes that you didn't get a picture because you were talking to *him* at the time. I don't myself as a matter of fact, when I am working on the picture desk and listening to reasons put forward by photographers as to why they missed a picture.

But to return to the stalwarts I started this piece with. After a couple of hours, they thought it was time they made a check call to their offices. They decided to do it together, so that, if the subject did come out, they would both miss her, instead of one of them trying unconvincingly to explain to his editor why the *Express* or *Mirror* had a picture while he hadn't.

Round the corner they went to the nearest phone booth, made their calls, and had a quick cup of tea while they were there. Then back into position, cameras at the ready.

They noticed that while they had been away, a post office mail van had been parked so that it blocked one of their cars, and after a while they were beginning to wonder where the postman had gone. Then they noticed that the van was smashed in, as if it had been broken into. Just at that moment, an agency photographer came along.

"This the place?" he enquired.

"Yes, that's the house there, but she hasn't come out yet," they replied.

"I don't know what you're talking about," said the agency man. "I mean the mail van. Isn't that what you're on?"

And then it all came out. Apparently, in the short time they had gone off to phone their offices, the mail van had been ambushed and robbed, and the driver taken away to hospital, right on the spot where, for two hours, they had been waiting with cameras at the ready.

An odd experience

There is one fascinating aspect of being a press photographer: from one moment to the next, you never know what fate has in store for you. But surely one of the oddest experiences happened to one of my colleagues on the *Daily Express*, Ron Dumont.

One dull and rather boring evening, Ron was sitting in the darkroom when, suddenly, in burst a well-known society columnist employed by us at that time.

"Quick, Ron!" he shouted. "Can you help out? I've got an exclusive piece of news and want a picture to go with it".

"OK," replied Ron. 'Where is it?'. In seconds, the reporter, his girl-friend who happened to be around, and Ron were speeding to Mayfair where they pulled up at a block of luxury flats. They had been in so much of a hurry that the reporter had not so-far told Ron what the story was all about, and before he could do so he dashed into one of the flats with his girl-friend. A few minutes later she poked her head out of the door and beckoned Ron inside, where he saw the reporter talking to a very attractive girl.

Assuming this must be the subject he was to photograph, Ron sorted out his camera, flash and extension unit, then started shooting away. But before he had taken more than a couple of shots there was the sound of a key in the door. Ron's subject whispered "It must be Daddy", whereupon the reporter and his girl-friend vanished down the fire escape leaving Ron trapped by all his photographic equipment! The girl whom Ron had been photographing, bundled all his camera gear and flash units into his arms then thrust him through another door. But this was not another exit. Ron found he was standing in a small, pitch-black, broom-cupboard!

Still not knowing what the job was about, he stood still and hoped that somehow it would all end right. But suddenly, without warning, the door was flung open and Ron, festooned with equipment, found himself face to face with an irate gentleman, obviously an ex-general at the very least.

"What the devil are you doing?" he bellowed.

Ron nearly replied "There's nobody here but us brooms," but decided that whatever he said would sound just as ridiculous. So he just stared back at the man who, after a minute or so, peered closer and asked "What the devil's that contraption round your neck?"

"Camera equipment," said Ron rather weakly.

After another uneasy silence, the ex-general type, getting just a little exasperated, demanded "Well sir, what *are* you doing in my cupboard?"

At this point the whole ludicrous situation proved too much for Ron, who just collapsed in laughter. Fortunately for him the daughter returned and explained that she had invited Ron in to take some pictures, at which her father seemed to be satisfied. She didn't mention they were press pictures and Ron left as quickly as he could. He says that he is sure to this day that that father is still vaguely wondering what he was doing in the cupboard.

How to get published

I now present the "Blackman Crash Course on Journalism". Or "How to get that First Publication".

First, select your publication. And here I would suggest that you make your local newspaper the target. I will assume that you are fairly competent with your camera, and that you possess one capable of producing sharp pictures. You do not need to be a photographic expert, but you do need to be capable of taking a sharp, properly exposed picture, and of producing a good quality enlargement.

Drill it into your mind that, for a newspaper, be it a national or local, it is the *subject matter* which is of paramount importance. Although the occasional pastoral scene does get published in a few papers, it is strong human interest which almost always counts. People want to see people.

Now look carefully through the current edition of your local paper and study coming events. Garden fetes, school

sports days, beauty contests, or anybody winning any sort of title at all—these are your meat. But don't be too optimistic about the big events, for these will probably be covered by the paper's own staff photographer.

Let us imagine that you have selected a small garden fete. Go along very early and first take a look at the folk running the stalls. Ignore the local councillor, however important he might think he is. See if there is a particularly attractive girl running an interesting stall. There usually is, at least one, but don't shoot candids of her. Ask her if she will pose for you, and try to take a glamorous picture with the stall as a background. If she has good long legs, then make sure your shot shows them at their best. If her face and hair are her strong points then do a medium close-up—not too close as you must retain some atmosphere—and make sure she looks happy in your shots, as these are the sort of pictures that papers like.

Having taken your pictures, make sure to get the following details for your caption. Name, including christian name (this is essential); home address which preferably should be in the area covered by the paper; age, normal job; recreations; and a quote from her as to why she was doing that particular job at the fete. Her phone number is not essential, but that is up to you!

You can often ignore the official opening, unless the person concerned is particularly important. And in that case the paper will probably have its own photographer there. As the fete goes on, look around with the camera slung round your neck ready for instant use. Carried in this way, people soon become used to it, and will not notice it when you raise it to shoot.

Look out for amusing situations involving children or girls. I am sorry, gentlemen, but you are just not good subject matter!

Don't be afraid to pose a picture if you see what seems like a good shot but are not able to capture it. Always look out for the incongruous, such as the tiny boy trying to wield the "try your strength" hammer. Or the pretty girl shying at a coconut. Move in close to shoot these pictures, so that the principal subject has plenty of impact, and always be looking for (or arranging) the incongruous. Most important, make sure that you get the caption details that I have already mentioned.

With any luck you should end up with four or five good pictures, although you will naturally have taken more. If you have only one good picture it doesn't matter—better to submit one good picture than half-a-dozen shoddy ones. When you get home, make prints, at least whole plate size, from your best negs on glossy paper, remembering what I told you about having a good tonal range.

Next, caption each print on the back with the details you wrote down at the time and, on a separate sheet of paper, write (or preferably type) a short covering caption, stating where and when the fete was held, who organised it, what it was in aid of, and who opened it.

Finally, get your prints to the offices of the local paper as soon as possible. If it publishes on Friday then the Thursday before is too late for your "feature type" pictures. Wednesday morning would be an absolute deadline but Monday would give you the best chance of all.

Don't forget to put your name and address on the back of each print, together with the inscription "For publication at your usual fee" or whatever you think your work is worth.

But at this period of striving to get one's first picture in print I would accept the usual fee. Later on if you think you are *that* good you can ask for more, but at this early stage don't feel hurt if the paper refuses to publish your pictures at a high fee. Remember that the value of any article is what people are willing to pay for it; not what you *think* it should fetch. But do not allow your pictures to be published for nothing.

Well, there's my recipe for instant success. Follow it, and I will almost guarantee publication, as it is the method which I used to get my bread and butter in my early days. I have suggested a garden fete as an example, but this applies to almost every function. Pretty girls, small children, incongruity, full captions: have a go—you can't miss! If you do fail the first time, or the second, don't give up in despair. Any form of press work can be the most frustrating occupation ever. But it can also be the most rewarding and satisfying.

17

In Conclusion

As I indicated at the beginning of this book, my philosophy towards photography is that technicalities should always take second place to picture-taking. That is the main object of photography in my opinion, and that is what we should all be concerned with.

I believe photography should be fun and exciting. You should always be searching for something new and different. If a subject looks absolutely impossible, if all the rules and theories say it cannot be done, then have a shot at it. Of course, you will frequently get failures. But every now and again you will have the satisfaction of achieving the "impossible".

Don't be hidebound by so-called rules of photography and composition. Always be prepared to have a go. And please, whether you be amateur or professional, don't make hard work out of photography. If you are an amateur it should be enjoyable, and above all immense fun. If you are a professional, then you are lucky, as you should be able to get equal enjoyment and fun out of your photography, even though it is also earning you your living. I certainly do.

After all the years I have been involved in photography I still get an immense thrill out of seeing the first contacts and prints which are made from a set of pictures I have taken. Often I am intensely disappointed with the results, but they always teach me something. I look at them carefully to see where I went wrong, what I could have done better, and how I can make a better job of a similar subject next time.

If you have several hundred pounds worth of equipment, then you are lucky. You will be able to attempt subjects which are beyond the range of more humble cameras. But even if you have quite an inexpensive camera, there is a whole exciting world before you. Take advantage of it. Go out and shoot plenty of pictures. Don't overload your mind with technicalities, and so make photography a labour. I am all for automatic cameras which work well and can cut out some of the thinking and technical fiddling. All that counts is the subject and the final picture.

I hope in this book I have given a few hints which will help to give you fresh enthusiasm for your photography. Maybe you have learned just a little about some of the subjects I have covered. Certainly you will now have a better

258

In Conclusion

idea of the sort of work a press photographer carries out. But above all, I hope I have shown you what an exhilarating hobby photography can be.

So now, pick up that camera and go out and enjoy your photography. Good shooting!

Index

Index